REVOLUTION

A PHOTOGRAPHIC HISTORY OF REVOLUTIONARY IRELAND 1913–1923

Pádraig Óg Ó Ruairc

MERCIER PRESS
Irish Publisher – Irish Story

For Tom Toomey
– one of nature's gentlemen and a constant source of encouragement and advice to a younger generation of historians.

And

For Cyril Wall
– a great friend who kept me on the straight and narrow during my time in Dublin.

MERCIER PRESS

Cork

www.mercierpress.ie

© Text: Padraig Óg Ó Ruairc, 2014

© Photographs: copyright holders individually referenced underneath image

ISBN: 978 1 78117 288 9

10 9 8 7 6 5 4 3 2 1

A CIP record for this title is available from the British Library

Contents

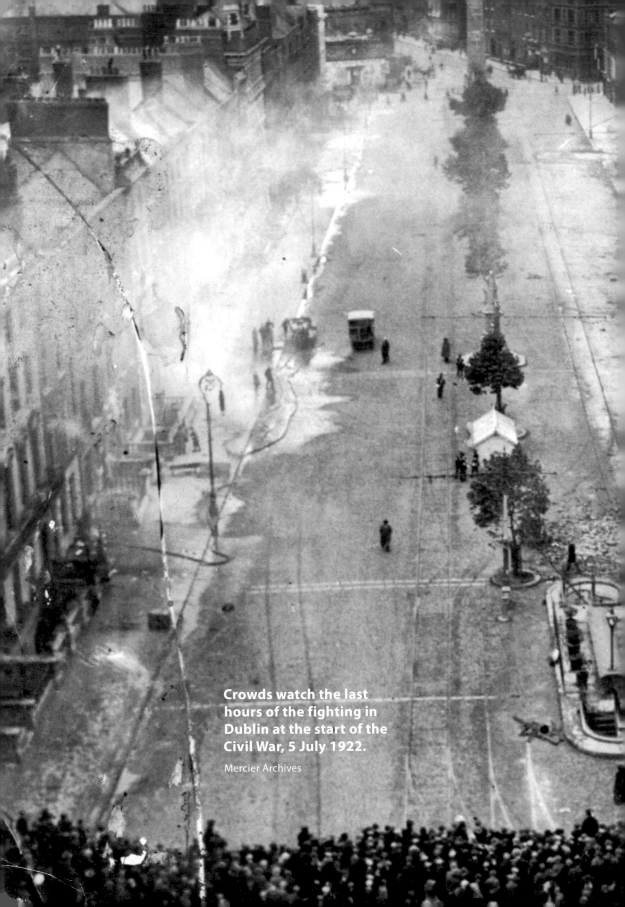

Crowds watch the last hours of the fighting in Dublin at the start of the Civil War, 5 July 1922.

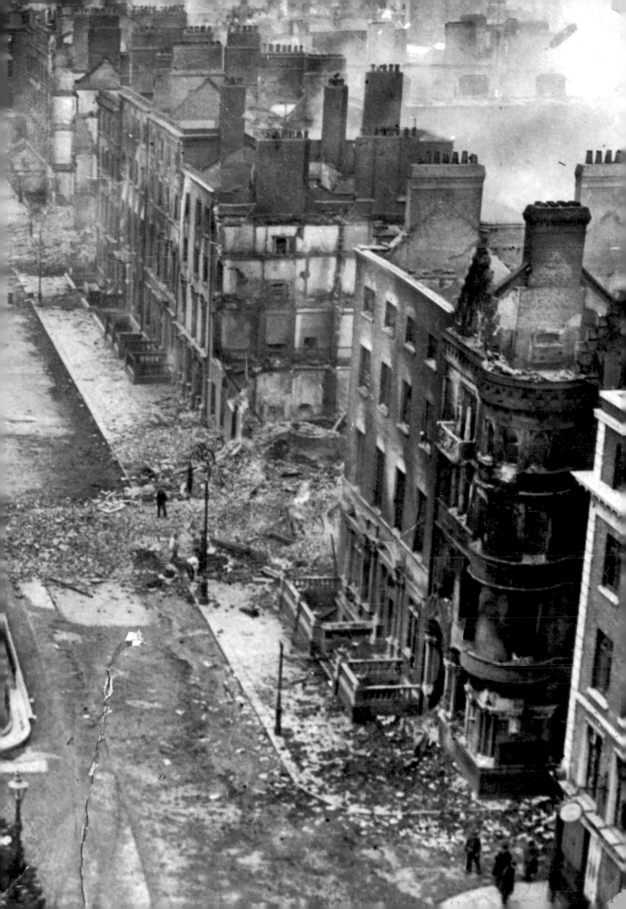

Introduction

There will be in the Ireland of the next few years a multitudinous activity of Freedom Clubs, Young Republican Parties, Labour Organisations, Socialist Groups, and what not; bewildering enterprises undertaken by sane persons and insane persons, by good men and bad men, many of them seemingly contradictory, some mutually destructive, yet all tending towards a common objective, and that objective: the Irish Revolution.

Patrick Pearse, *The Coming Revolution*, November 1913

The decade from 1913 to 1923 has had a profound influence on the shaping of the Ireland in which we live today. The disappearance of Home Rule from the Irish political agenda, the struggle for women's rights, the birth of Irish Trade Unionism, partition and the creation of Northern Ireland in 1920, the Anglo-Irish Treaty of 1921, the Civil War and the transition of the southern Irish state from British dominion to independent Republic all had their roots in this decade. The period weighs so heavily on the Irish psyche that the memory of 'the men of 1916' is still frequently invoked in Irish political debate today.

The period of 'the Revolution' is still the source of much discussion, controversy and disagreement among historians, academics, politicians and media commentators. And, although a raft of new books of widely varying quality have been published on the period in the past few years, much more research still needs to be conducted into the War of Independence at a local level and the Civil War as a whole.

This book is not intended to be a definitive history or complete study of the Irish struggle for independence in the decade from 1913 to 1923. Such a slim volume could never do justice to, or describe in sufficient detail, all of the dramatic and historic events that transformed the nature of Irish society in that decade. Instead it gives the reader glimpses of what happened and what life was like during the Irish 'Revolution'.

Photography played an increasingly important role as the Irish struggle for

The "Sinn Féin" REVOLT ILLUSTRATED.

PRINTED AND :: :: :: ::

PUBLISHED BY :: :: ::

HELY'S LIMITED,

DAME STREET & :

ACME WORKS, DUBLIN.

PRICE ONE SHILLING.

O'Connell Bridge & Sackville St. Dublin.

independence took hold. The demand for memorabilia in the wake of the Easter Rising led to a number of souvenir photographic booklets being published. These ranged in price and quality. At the lower end of the scale was *The Sinn Féin Revolt 1916* published by T. J. Coleman & Company, Dublin, which contained twelve photographs of the ruins of Sackville (now O'Connell) Street with brief captions, but provided no other text or information. At the upper end was *The "Sinn Féin" Revolt Illustrated*, published by Hely's Ltd and sold for one shilling. This booklet was illustrated with photographs, a map of Dublin city centre and facsimiles of captured Republican documents. It also contained brief biographies of the executed rebel leaders and a largely accurate narrative of the Rising written by J. W. M. which can probably lay claim to being one of the first proper histories of the 1916 Rising.

Photographs of Pearse, Connolly and the other Republicans executed in 1916 played an important propaganda role in the aftermath of the Rising and were sold as postcards and framed prints. These quickly replaced the pictures of the Manchester Martyrs, Daniel O'Connell and the leaders of the 1798 rebellion which had hung in pride of place alongside religious icons in many Irish homes. This reflected the political shift from the politics of Home Rule and the Irish Parliamentary Party to support for the new Sinn Féin movement. Throughout the War of Independence, attacks on these photographs were a common way for British soldiers and members of the RIC to vent their frustration during raids on the homes of Republican sympathisers. The discovery of such an offending photograph often gave the British forces an excuse to mistreat those present or serve as a pretext to burn the house.

During a British military raid on the Blasket Islands, Peig Sayer's husband implored her to hide photographs of Thomas Ashe and the leaders of the Rising that were hanging on the wall of their home:

'Hurry and take down those pictures on the wall!'

'Musha, defeat and wounding on those who felled them!' said I. 'They felled them without mercy and they alive, and it seems I have to hide the pictures from them now, and they dead! May I be dead and as dead as a stone if I'll take them down in fear of any stranger wretch! And another thing, that big picture is so secure that Oscar[1] couldn't pull it down, the strongest day he ever was.'

'Take it down!' said he, angry.

'I couldn't, I say. It will have to be left where it is, and if it's the cause of our death, it's welcome. They fought and fell for our sake, and as for Thomas Ashe's picture,' said I, 'I can't hide it from anyone.'[2]

The British soldiers arrived to search their house whilst the argument between Peig and her husband was still in full flow and apparently they left after a half-hearted search.

In August 1920 thirty Black and Tans went on a drunken rampage through Limerick after the IRA held up and disarmed two members of the RIC. Whilst searching houses that night the Black and Tans resorted to their usual tactics of assaulting homeowners, smashing their furniture and attacking framed Republican photographs. According to Hugh Martin, an English journalist who witnessed

1 Oscar – a hero from Irish mythology associated with Fionn Mac Cumhal and the Fianna.
2 Peig Sayers, *An Old Woman's Reflections* (Oxford University Press, Oxford 2000), pp. 118–19.

the destruction, the British forces were so accustomed to attacking photographs that any picture they found became a target regardless of its subject. 'Countless china ornaments of the sort with which the Irish poor crowd their shelves were broken and pictures destroyed … In one cabin a young Irish ex-soldier, who had fought all through the war showed me – marvel of marvels – how a picture of the King had been dashed to pieces.'[3]

Photographs not only had a propaganda value during the War of Independence, but were also of vital importance in 'the intelligence war' fought between the IRA and the British. Photographs were used by the British forces to identify Republican suspects for arrest and internment. Detective Officer Samuel Nixon set about supplying G Division of the Dublin Metropolitan Police with photographs of IRA suspects. An expensive camera with a high shutter speed was bought for this purpose, but the scheme floundered when Detective Eamon Broy, who was secretly working for IRA intelligence, was given the task of taking the photographs:

> We were told that the camera was for the purpose of photographing Irish Volunteers and Sinn Féiners when walking in the streets, as photographs of disloyal persons found in raids on their houses or offices were usually of the posed variety and were not very helpful in identifying extremists in the streets.[4]

Broy sabotaged the project by tampering with the camera, deliberately making technical mistakes and by getting the chemist developing the images to deliberately spoil them.

Frustrated by Broy's apparent lack of success, Nixon himself took charge of the camera:

> Nixon was again sent out with the new photographers and on one occasion took up a position on the east side of O'Connell Bridge just in time to see the late Henry Dixon about to approach there from Purcell's tobacco shop. When halfway across the road the wary old Fenian spotted Nixon and the camera, about which he had been warned by the Volunteer intelligence department and acted as one of the detectives said: 'like a suspicious woodquest on seeing a fowler with a gun'.[5]

Given the numerous failed attempts at using the camera to take surveillance photographs, the plan was soon dropped by the DMP. Broy later claimed credit

3 Hugh Martin, *Ireland in Insurrection – an Englishman's Record of Fact* (Daniel O'Connor, London 1921), pp. 61–2.
4 Eamon Broy, Bureau of Military History Witness Statement (WS) 1280, p. 58.
5 *Ibid.*, pp. 62–3.

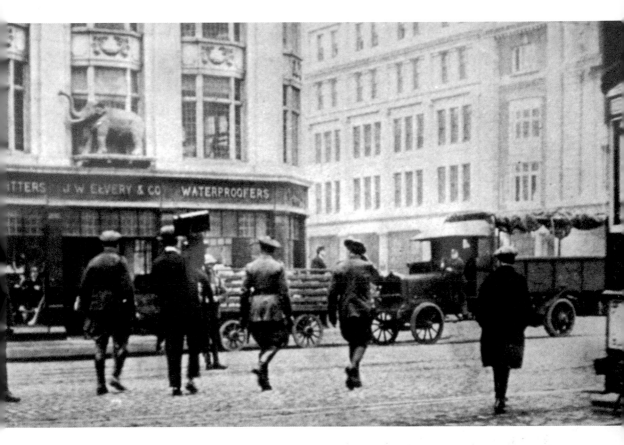

RIC Auxiliaries arresting a photographer in Dublin c. 1921.

Courtesy of Kilmainham Gaol Museum

not only for the scheme's failure, but also for supplying IRA intelligence with photographs of British intelligence officers:

> Not a single photograph of a nationalist had ever been furnished to the [Dublin] Castle people over a period of two years, but, on the contrary, some excellent photographs had been obtained of important British officials and sent to the Irish Volunteer intelligence department.[6]

Although British intelligence officers routinely took photographs of captured Republicans such as the photograph of Thomas Malone (*page 138*), they seem to have been hindered by a lack of photographs of wanted Republicans. The photographs included in Lieutenant J. B. Jarvis' intelligence dossier (*pages 104–5*)

6 *Ibid.*, p. 63.

show that the British forces remained overly reliant on the type of captured studio photographs described by Broy, which were not very useful for identifying leading members of the IRA such as Richard Mulcahy, Dan Breen or Michael Brennan. In August 1920 the British army's 6th Division, based in Munster, set up their own Photographic Bureau attached to their intelligence branch. Whilst the British army had no difficulty getting cameras for the Photographic Bureau, they seem to have experienced the same problems the DMP encountered in trying to find competent and reliable photographers: 'The photographer and apparatus were provided by the Chief of Police, but after a few months the former absconded, and took the latter with him.'[7]

IRA intelligence were equally quick to realise the valuable role that photography could play in the intelligence war as Frank Thornton's intelligence dossier (*pages 143–5*) clearly shows. This led the British authorities to ban the use of cameras in public without a permit in counties that had been declared a 'special military area'.

At the beginning of the Civil War the Brunswick Press published the *Souvenir Album of the Dublin Fighting, 1922*. This booklet, sold for one shilling, was largely a propaganda effort in support of the Free State – hardly surprising given that the booklet stated: 'All photographs and letterpress appearing in this Album have been passed for publication by the Military Censor.' However, the Civil War, unlike the 1916 Rising, failed to produce an appetite for souvenir photograph albums amongst an Irish public who were by then increasingly war weary, and other publishers did not follow suit.

History does not repeat itself – but it does tend to rhyme a lot, and some of the photographs contained in this book are reminiscent of images from modern conflicts. For example, the photograph of IRA leaders Tom Hales and Pat Harte taken during the early part of their torture and interrogation by British army officers in July 1920 (*page 122*) is comparable to the now infamous photographs of the torture and interrogation of Iraqi prisoners by the US military at Abu Ghraib prison.

Similarly the photographs of the charred and horrifically disfigured corpses of Patrick and Henry Loughnane, who were brutally ill-treated before being killed

7 'Record of the Rebellion in Ireland 1920–1921', *The Irish Sword*, Vol. XXVII, No. 107, p. 56.

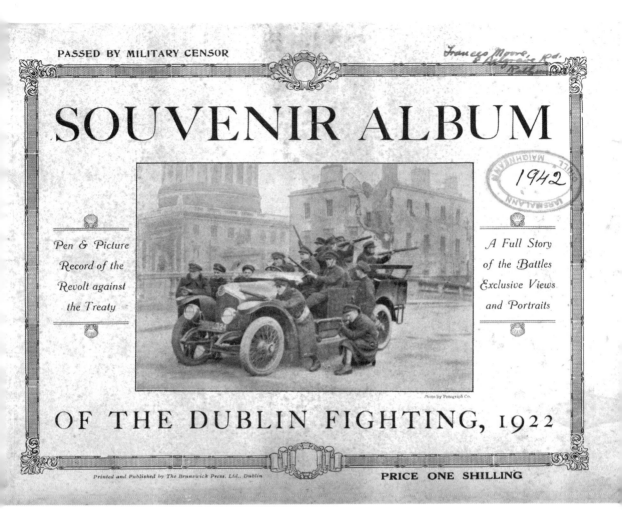

SOUVENIR ALBUM

Pen & Picture
Record of the
Revolt against
the Treaty

A Full Story
of the Battles
Exclusive Views
and Portraits

1942

Photo by Panograph Co.

OF THE DUBLIN FIGHTING, 1922

Printed and Published by The Brunswick Press, Ltd., Dublin

PRICE ONE SHILLING

by the RIC Auxiliaries (*page 133*), are chillingly reminiscent of the photographs of the bodies of the four Blackwater security contractors killed at Falluja whose charred bodies were photographed hanging upside down from a bridge. In both cases, the horrific nature of the deaths of those photographed would scarcely have been credible and would undoubtedly have been dismissed as unfounded propaganda if cameras had not been present to record the evidence.

The old adage that 'the camera doesn't lie' was essentially true in the early twentieth century. While a photograph taken in the War of Independence can be taken out of context or be subjected to a number of different interpretations, they essentially show what happened at that moment in time. However, that does not mean that the photograph was not staged for political effect. The photograph on

page 148 purporting to show RIC Auxiliaries searching a captured IRA Volunteer following an ambush in Kerry was exposed long ago as a fraud staged for propaganda purposes during the War of Independence by the film-makers Gennell and Starmer. Yet it continually gains acceptance as a genuine press photograph of the aftermath of an ambush and frequently appears as an illustration in modern history books.

Other photographs were deliberately altered afterwards to reflect the bitter political divisions following the Civil War. We would associate the 'airbrushed' photograph removing figures who had taken the 'wrong' side during the Civil War (*page 277*) more with Stalinist Russia than early twentieth-century Ireland, but clearly similar practices were not unknown here.

While I have made efforts to verify the authenticity of the photographs in this book and to identify those pictured in them, and the approximate date and place that they were taken, it is perhaps inevitable that all history books contain some unintentional mistakes. I have also made an effort to try to ensure that this book contains a wide spread of photographs from different parts of Ireland that narrate the key events of the Irish struggle for independence. However, since many of the key events in this period took place in Dublin, Belfast and the south and west, there is an unavoidable geographical bias towards these areas.

Opposite: Bullet holes in the face of the clock on the tower of Cork City Hall. The tower's interior and the workings of the clock collapsed into the ruins of City Hall during the fire started by British forces on 11 December 1920.

Mercier Archives

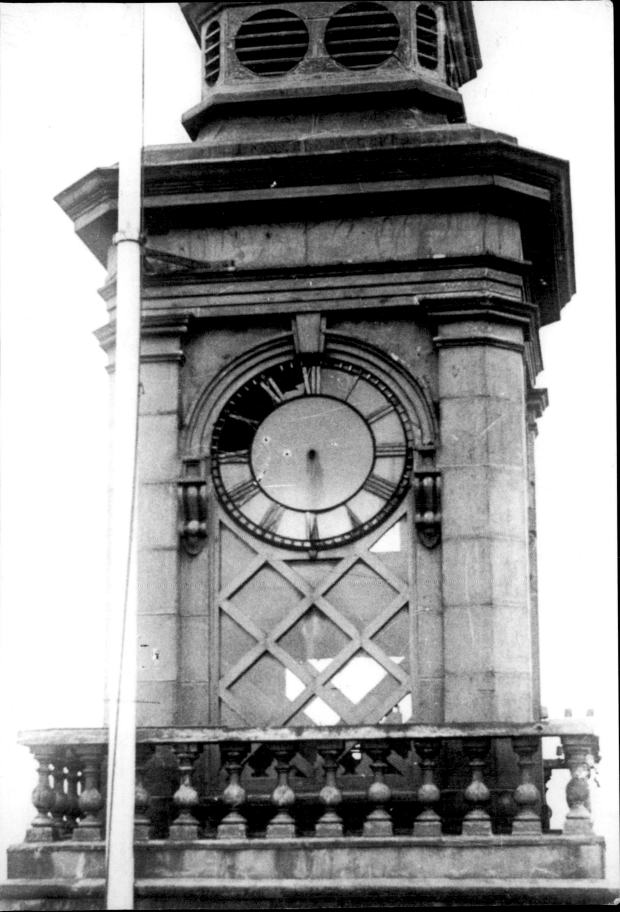

Chronology

1912 – The third Home Rule Bill is passed by the British House of Commons. The House of Lords vetoes the bill, delaying its implementation for at least two years.

13 January 1913 – The Ulster Volunteer Force (UVF) is founded to oppose Home Rule for Ireland.

August 1913 to January 1914 – A series of strikes organised by the Irish Transport and General Workers' Union leads to a lockout by the Employers' Federation led by William Martin Murphy. The Irish Citizen Army is founded during the strike as a workers' militia.

25 November 1913 – The Irish Volunteers are founded in response to the UVF, in support of Home Rule and 'To secure and maintain the rights and liberties common to the people of Ireland … [and] to unite, in the service of Ireland, Irishmen of every creed, of every party and class.'

March 1914 – The Curragh Mutiny. British army officers stationed in Ireland threaten to resign if they are ordered by the British government to take action against the UVF.

25 April 1914 – The UVF lands 24,600 rifles bought in Germany at Larne, Co. Antrim, and Bangor, Co. Down. The British army and RIC make no attempt to intervene.

26 July 1914 – A group of mainly Protestant Republicans and Nationalists led by Roger Casement finances and organises the importation of 900 rifles for the Irish Volunteers at Howth, Co. Dublin. The British army and RIC attempt to intervene. Later that day British soldiers open fire on an unarmed crowd at Bachelor's Walk, Dublin, killing three people.

4 August 1914 – Britain declares war on Germany.

20 September 1914 – John Redmond, leader of the Irish Parliamentary Party, makes a speech at Woodenbridge, Co. Wicklow, advocating that members of the Irish Volunteers should enlist in the British army.

24 September 1914 – Redmond's speech causes a split in the Irish Volunteer movement. The majority, over 100,000 members of the Volunteers, support Redmond's stance on the war and form the Irish National Volunteers. The minority, about 11,000 Nationalists and Republicans opposed to the war, led by Eoin MacNeill, the president of the movement, retains the title Irish Volunteers.

January 1916 – The Military Council of the secret Irish Republican Brotherhood (IRB) agrees that an insurrection against British rule in Ireland will take place at Easter.

21 April 1916 – The ship *Aud*, carrying 20,000 rifles destined for the Republican rebels, is intercepted by the British and scuttled by its German crew in Cork Harbour.

22 April 1916 – Having discovered the IRB's plans for an insurrection, Eoin MacNeill issues a general countermanding order for the Irish Volunteers in an attempt to stop the Rising.

24–29 April 1916 – The Easter Rising. Approximately 2,000 Republican rebels, members of the Irish Volunteers, Citizen Army, Cumann na mBan, Na Fianna Éireann and the Hibernian Rifles, take control of Dublin city but are defeated by the superior numbers of the British army. Fighting also takes places in Wexford, Galway and north Dublin.

3–12 May 1916 – Fifteen Republicans are executed by the British army.

3 August 1916 – Roger Casement is executed in Pentonville Prison.

December 1916 – Republicans interned in British prisons after the Easter Rising are released.

February 1917 – Republican candidate Count Plunkett wins the North Roscommon by-election. This is followed by two other Republican electoral victories when Joe McGuinness and Éamon de Valera are elected MPs for Longford and East Clare.

25 September 1917 – Republican Thomas Ashe dies on hunger strike.

October 1917 – Arthur Griffith's political party Sinn Féin adopts a new Republican constitution and de Valera is elected its president.

14 December 1918 – Sinn Féin gains a landslide electoral victory winning 73 of the 105 Irish seats in the 1918 general election. Sinn Féin candidates are elected unopposed in many constituencies.

21 January 1919 – Sinn Féin convenes a Republican parliament for Ireland called Dáil Éireann at the Mansion House in Dublin. On the same day the IRA kills two RIC constables during an ambush to capture explosives at Soloheadbeg, Co. Tipperary. The Irish War of Independence begins.

25 March 1920 – The first new recruits to the RIC (mostly British ex-soldiers) arrive in Ireland. They quickly become known as the 'Black and Tans'. Shortly afterwards the RIC Auxiliary Division is formed.

20 September 1920 – Members of the RIC and Black and Tans run amok in Balbriggan, Dublin, after the IRA kill a member of the RIC. They cause £16,000 worth of damage and kill two Republicans.

22 September 1920 – Following the Rineen ambush, during which six members of the RIC are killed, the RIC and British army carry out reprisals in West Clare which result in the damage or destruction of over seventy buildings and the deaths of six people.

25 October 1920 – Terence MacSwiney, mayor of Cork, dies in Brixton Prison after a seventy-four-day hunger strike.

1 November 1920 – IRA Volunteer Kevin Barry is executed by hanging at Mountjoy Jail, Dublin. He is the first Republican officially executed by the British authorities in Ireland since 1916.

21 November 1920 – Bloody Sunday. The IRA assassinate twelve suspected British intelligence officers in Dublin. In retaliation the British forces kill three suspected Republicans at Dublin Castle and open fire on crowds attending a football match at Croke Park, killing fourteen people.

28 November 1920 – The IRA kill sixteen members of the RIC Auxiliary Division in an ambush at Kilmichael, Co. Cork.

11 December 1920 – British forces carry out arson attacks causing over £3 million worth of damage in Cork city in reprisal for an IRA attack. The British authorities initially claim that the citizens of Cork set fire to their own homes and businesses.

19 March 1921 – The Crossbarry ambush. An IRA attack on a British army convoy results in the deaths of three IRA Volunteers and at least sixteen British casualties.

25 May 1921 – The IRA carries out a daylight raid on the Custom House in Dublin destroying the building. However, the operation comes at a high cost as three IRA Volunteers are killed and seventy captured during the operation.

11 July 1921 – The Truce comes into effect ending the Irish War of Independence.

6 December 1921 – The Anglo-Irish Treaty is signed. The question of whether to accept or reject the Treaty causes a split in Sinn Féin, the IRA and the other Republican organisations.

7 January 1922 – Dáil Éireann votes to accept the Treaty by 64 votes to 57. De Valera and the Republicans who oppose the Treaty walk out of the Dáil in protest.

14 January 1922 – The Provisional Government of the Irish Free State is established. Two days later it is given control of Dublin Castle, the former seat of British administration in Ireland.

31 January 1922 – Beggars Bush Barracks, the first army barracks evacuated by the British army, is taken over by the Dublin Guard, a pro-Treaty unit of the IRA. The Dublin Guard and other pro-Treaty units of the IRA form the nucleus of the new Free State army.

REVOLUTION

13 April 1922 – The IRA occupies the Four Courts, Dublin.

22 June 1922 – Sir Henry Wilson is assassinated by two members of the IRA in London.

28 June 1922 – The Free State army attacks the IRA garrison in the Four Courts. The Irish Civil War begins.

5 July 1922 – The fighting in Dublin city ends in a victory for the Free State army.

20 July 1922 – The Free State army captures Waterford.

21 July 1922 – The Free State army defeats the IRA in Limerick, driving them from the city.

24 July 1922 – In the first of a series of coastal landings, 400 Free State soldiers capture Westport, Co. Mayo, and force the IRA out of Castlebar.

2 August 1922 – The Dublin Guard unit of the Free State army land at Fenit, Co. Kerry, and shortly afterwards capture Tralee. The IRA abandon their stern defence of Kilmallock, Co. Limerick, shortly afterwards.

8–10 August 1922 – Free State troops land at Passage West and capture Cork city after a brief fight.

12 August 1922 – Arthur Griffith, president of the Provisional Government of the Irish Free State, dies of a brain haemorrhage.

22 August 1922 – Michael Collins is killed by the IRA in an ambush at Béal na mBláth, West Cork.

10 October 1922 – Irish Catholic bishops issue a joint pastoral condemning Republican opposition to the Provisional Government's authority.

17 November 1922 – The Free State army executes four members of the IRA – Peter Cassidy, James Fisher, John Gaffney and Richard Twohig – at Kilmainham Gaol in Dublin. They are the first of seventy-seven Republicans officially executed by the Free State army during the Civil War.

7 December 1922 – The IRA assassinates Seán Hales, a member of the Provisional Government, in retaliation for the Free State's policy of executing captured Republicans.

8 December 1922 – The Free State army executes four Republican leaders – Rory O'Connor, Liam Mellows, Joe McKelvey and Richard Barrett – in response to the IRA's assassination of Hales.

5 March 1923 – Lieutenant O'Connor and four other Free State soldiers are killed by an IRA booby-trap mine at Knocknagoshel, Co. Kerry.

6 March 1923 – Members of the Free State army in Kerry kill eight Republican prisoners at Ballyseedy by strapping them to a landmine and detonating it.

10 April 1923 – IRA Chief of Staff Liam Lynch is killed by Free State soldiers in the Knockmealdown Mountains.

24 May 1923 – Frank Aiken, Liam Lynch's replacement as IRA Chief of Staff, announces an IRA ceasefire.

15 August 1923 – The Free State army arrests de Valera at a political meeting in Ennis, Co. Clare.

13 October 1923 – Several hundred of the 15,000 Republicans interned by the Free State begin a hunger strike demanding unconditional release.

16 July 1924 – De Valera, the last Republican interned by the Free State, is released.

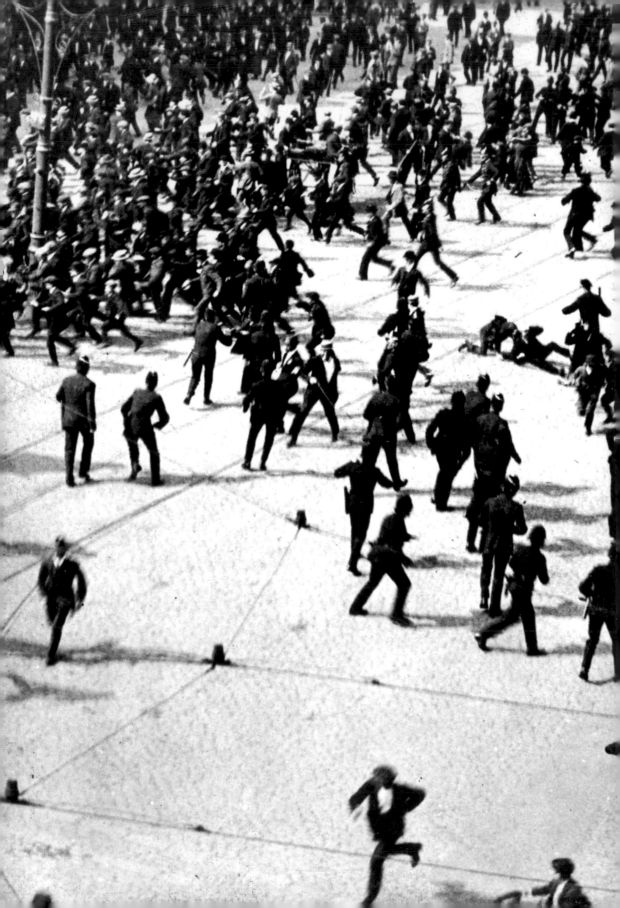

1913-1915

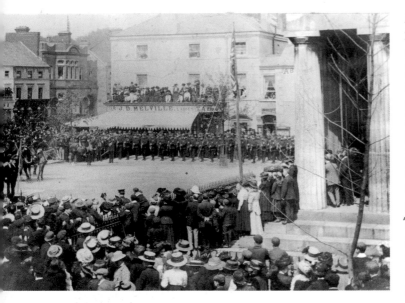

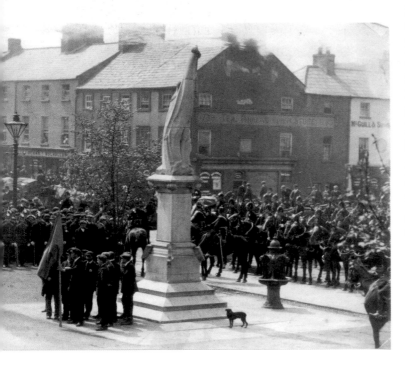

A Sinn Féin protest in the Market Square, Dundalk, 17 May 1910, on the occasion of George V being proclaimed King of Great Britain and Ireland. A handful of Sinn Féin protesters asserted their belief in Ireland's right to independence by counter-demonstrating and interrupting the ceremony. When the British flag was raised as part of the ceremony, the Sinn Féin group raised a green flag. When 'God save the King' was sung the protesters sang 'God Save Ireland' and shouted *'Go hifreann leis an Rí'*. The Royal Irish Constabulary (RIC) were apparently unable to interfere with the demonstrators because the 1798 memorial they were gathered at was considered private property. The protest was led by Patrick Hughes and the other protesters included Jason and Barney Kelly, Ned Ryan, Paddy Hughes, James Jennings, Ned Callaghan and Mr Fitzgerald. The photographs show the limited support Arthur Griffith's Sinn Féin party, the IRB and militant Irish Republicanism had before the Home Rule crisis and the 1916 Rising.

Courtesy of Kilmainham Gaol Museum 13PC IA21 22a & b

Members of the Royal Irish Constabulary. Also included in this photograph are four British soldiers and a member of the Royal Navy. The RIC, the mainstay of British rule in Ireland, was a paramilitary police force modelled on British army rifle brigades, and as such its rules, regulations and conditions differed significantly from those of other British police forces. The force had been granted the prefix 'Royal' for its role in suppressing the Fenian Rising of 1867. According to RIC veteran Thomas Fennell: 'Recruits generally were the sons of small farmers, with a sprinkling of policeman's sons ... They had no knowledge whatsoever of Irish history nor had their parents, and they were absolutely in the dark as to the purpose of this force, beyond the preservation of peace and order, like every other police force ... Young men went on thoughtlessly year after year, having a much improved position in life, carrying out what seemed to them the ordinary duties of a police force ... it was only after ten or twelve years that they began to see that this force was specially organised and equipped to sustain landlordism and keep the people in subjugation.'

Reference: Thomas Fennell, *The Royal Irish Constabulary: A History and Personal Memoir* (UCD Press, Dublin 2003), pp. 9–10.

Mercier Archives

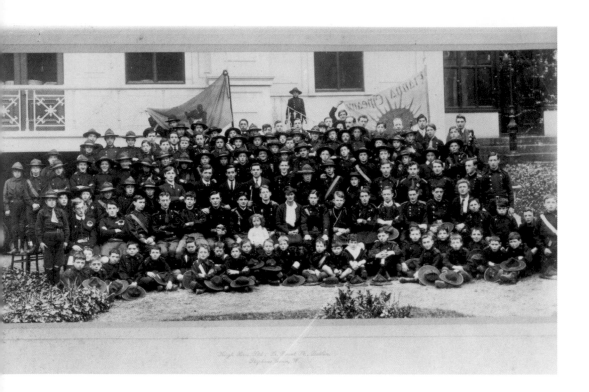

The Ard-Fheis of Na Fianna Éireann, the Irish national boy scouts. The photograph was taken at the Mansion House, Dublin, 13 July 1913. Countess Markievicz is seated in the centre of the group. Markievicz, a Protestant Republican, was one of the founding members of the organisation, which was established in 1909 to counteract the influence of the Boy's Brigade and Baden Powell's Boy Scouts in Ireland. Those youth movements emphasised loyalty to king and empire at the time, and were an important recruiting ground for the British army. By contrast, Na Fianna promoted the politics of Irish independence and stressed the 'Irish Ireland' ideals of the Gaelic Revival. When the Irish Volunteers were founded, many of their drill instructors were members of Na Fianna. Patrick Pearse stated in February 1914: 'We believe that Na Fianna Éireann has kept the military spirit alive in Ireland during the past four years, and that if the Fianna had not been founded in 1909, the Volunteers of 1913 would never have risen.'

Reference: P. H. Pearse quoted in Donnchadh O'Shea, *Na Fianna Éireann 1909–1975, with notes on Provisional Fianna Éireann and its offshoots*, unpublished manuscript in the author's collection.

Courtesy of Kilmainham Gaol Museum 16PC IA43 02

A Na Fianna Éireann physical education class at their Scout Hall, Barrington Street, Limerick 1913. Although often dismissed as a purely paramilitary body, Na Fianna were no more militant than their contemporaries in Baden Powell's Boy Scouts. Scouting was an educational youth movement and Na Fianna placed great emphasis on physical education, music, camping, sport, drama, first aid, history classes and the Irish language, as well as more military activities such as signalling, drill and shooting.

Mercier Archives

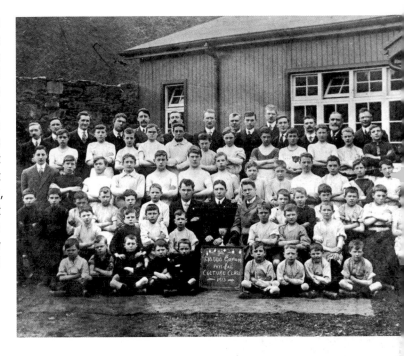

A group of Limerick Republicans taken at the rear of Na Fianna Scout Hall, Barrington Street, Limerick, c. 1913. *Standing L to R*: Joe Halpin, Joe Dalton, uni-dentified, unidentified (possib-ley Con Colbert), Seán Heuston, Jack Dalton and Ned Fitzgibbon. *Seated L to R*: Patrick Whelan, John Daly and James Leddin. John Daly had been imprisoned for twelve years in England for Fenian activities. He was later elected mayor of Limerick. Seán Heuston was executed for his part in the 1916 Rising.

Courtesy of Des Long, Limerick

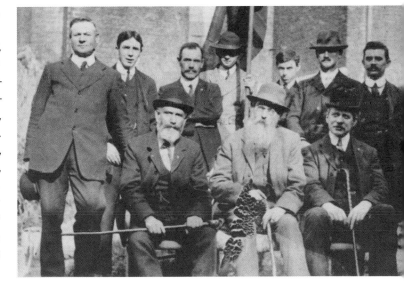

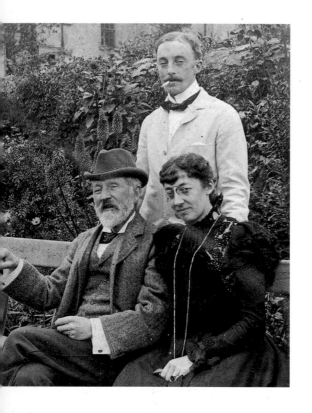

Press baron William Martin Murphy (1844–1919) (*seated on left*) with his wife and son. Murphy, a member of the Irish Parliamentary Party, was elected an MP for Dublin. He lost his seat, having opposed Charles Stewart Parnell when the controversy over Parnell's affair with Kitty O'Shea became public and spilt the party. In 1900 Murphy edited the *Irish Daily Independent* and in 1906 founded the *Sunday Independent* newspaper. Murphy led Dublin employers in opposing the activities of the Irish Transport and General Workers' Union, which was campaigning for improvements in working conditions and the right of workers to join a trade union. This struggle eventually culminated in the 1913 Dublin Lockout. Murphy's newspapers later pressed for the execution of James Connolly after the 1916 Rising.

Courtesy of Kilmainham Gaol Museum 15PO IA22 10

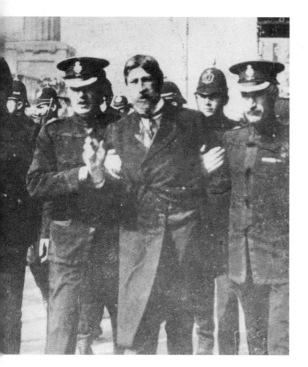

Members of the RIC and Dublin Metropolitan Police (DMP) arresting trade union organiser James 'Big Jim' Larkin during the 1913 Dublin Lockout. Having been prohibited from addressing a public meeting in Sackville Street, Larkin disguised himself with a beard and appeared at a hotel window to address the crowd gathered in the street below. He was arrested before he was able to finish his speech.

Courtesy of Mercier Archives

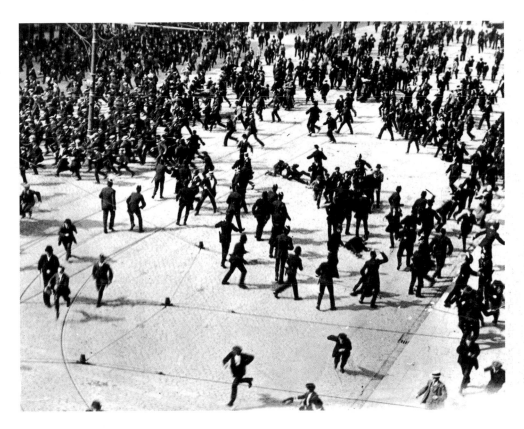

A riot in Sackville Street, Dublin, during the 1913 Lockout. Police violence against the strikers led to the formation of the Irish Citizen Army as a workers' defence force in 1913. The Citizen Army survived the collapse of the strike and became an armed Socialist-Republican militia led by James Connolly. Its members participated in the 1916 Rising but, lacking effective leadership after the death of Connolly, the organisation played a minor role during the War of Independence. Over 100 members of the Citizen Army took the Republican side during the Civil War. They fought in Dublin city in June and July 1922, and later formed a flying column which operated in the Wicklow mountains.

References: Brian Hanley, *The IRA – A Documentary History* (Gill and Macmillan, Dublin 2010), p. 45; R. M. Fox, *The History of the Irish Citizen Army* (James Duffy and Co. Ltd, Dublin 1944), p. 225.

Mercier Archives

Overleaf: Boys playing soldiers near Liberty Hall, Dublin 1914. All the boys are barefoot and dressed in ragged clothes. The diet, clothing and general living conditions of the urban poor in Irish cities at the time was horrific. Wages were low, especially for unskilled labour, and housing in Dublin and Belfast was amongst the worst in Europe. In 1911 the death rate in Dublin was 27.6 per 1,000, the highest in Europe (the next highest was Moscow).

Reference: Michael Kenny, *The Road to Freedom: Photographs and Memorabilia from the 1916 Rising and Afterwards* (Town House and Country House, Dublin 1993), pp. 14–15.

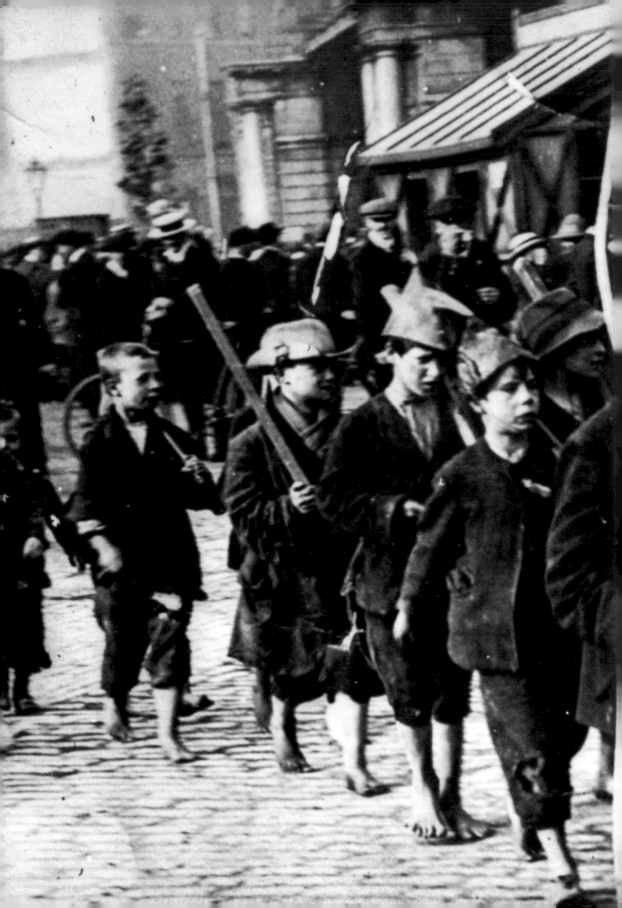

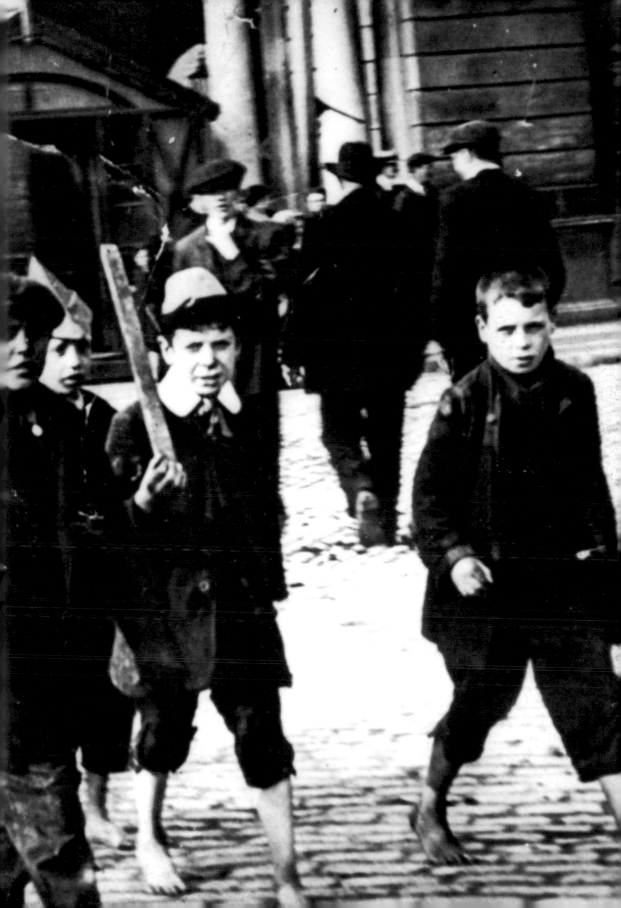

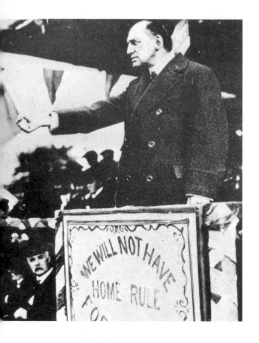

Edward Carson the political firebrand who led the Ulster Unionist Party and the anti-Home Rule movement. Carson, a Dublin-born solicitor, was elected MP for Trinity College. After the formation of the UVF he declared: '… drilling is illegal and the Volunteers are illegal and the government does not interfere with them – do not be afraid of illegalities'. This appeal to force and illegality by an armed Unionist minority in Ireland paved the way for the formation of the Irish Volunteers and their manipulation by the IRB for its own purposes.

Reference: Thomas Toomey, *The War of Independence in Limerick 1912–1921* (Limerick 2010), p. 87.

Courtesy of Kilmainham Gaol Museum 14PC IA54 22

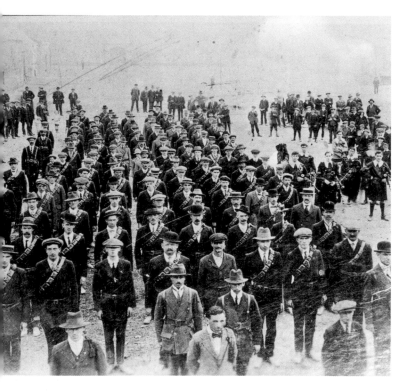

A group of Irish Volunteers, *c*. 1913. Irish Nationalists and Republicans were quick to note, and imitate, the actions of the UVF. In response to the article 'The North Began' by Eoin MacNeill, a respected Gaelic scholar, in the newspaper *An Claidheamh Soluis*, a public meeting was held at the Rotunda in Dublin on 25 November to establish the Irish Volunteers. Three thousand men enrolled in the new force that night and a number of women, who were refused admission to the meeting, later founded Cumann na mBan.

Courtesy of Kilmainham Gaol Museum 16PC IA43 07

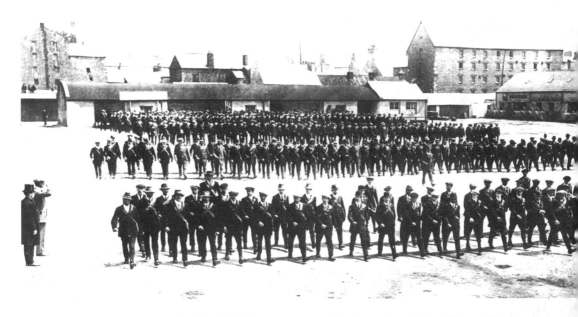

The Tralee Battalion, Kerry Brigade of the Irish Volunteers on parade in the market, Tralee, 14 June 1914. Although there are hundreds of men in attendance for the review, none appears to be armed with a rifle. Although 75,000 men had enlisted in the Irish Volunteers by May 1914, the force was critically short of arms – as long as they remained unarmed the Irish Volunteers were treated as little more than a farce by the British authorities.

Courtesy of Irish Military Archives, BMH P18 (Joseph McLinn Collection)

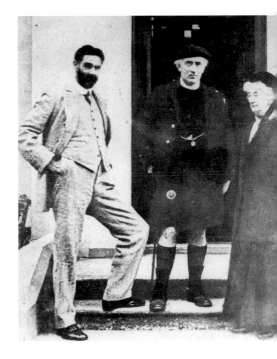

The architects of the Howth gunrunning: Roger Casement (*left*), Lord Ashbourne (*centre*) and Alice Stopford Greene (*right*). In 1914 Casement raised £1,500 amongst sympathisers in London for the purchase of arms for the Irish Volunteers. This money, used to finance the Howth gunrunning, was donated by Alice Stopford Greene, Erskine Childers, Mary Spring-Rice, Connor and Hugh O'Brien, Lord Ashbourne, Lady Young, Minnie Ryan and Captain Berkeley. All the subscribers to the fund, with the exception of Minnie Ryan, were Protestants of Anglo-Irish stock. Alice Stopford Greene subscribed £750 to the fund and although historians have largely overlooked her, she was extremely active and influential in the early Irish Volunteer movement.

Reference: Thomas Toomey, *The War of Independence in Limerick 1912–1921* (Limerick 2010), pp. 91–2.

Courtesy of Kilmainham Gaol Museum 16PC IA43 04

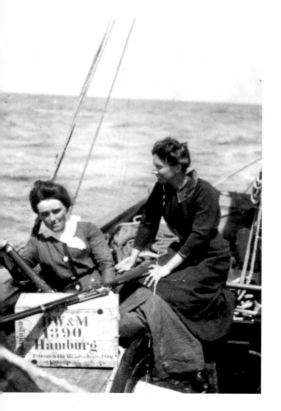

Molly Childers and Mary Spring-Rice on board the yacht *Asgard*, posing with Mauser rifles and ammunition boxes marked Hamburg. The *Asgard* was laden with approximately 900 Mauser rifles and 29,000 rounds of ammunition that had been purchased in Germany using the £1,500 raised by Roger Casement. With the assistance of the IRB, the Irish Volunteers and Na Fianna Éireann, the arms were landed at Howth in Dublin on 27 June 1914. The remaining 600 rifles of the shipment were landed from the *Kelpie* at Kilcoole, Co. Wicklow, a short time later.

Mercier Archives

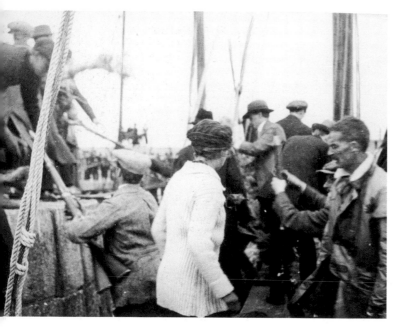

Unloading guns from the *Asgard* at Howth: Mary Spring-Rice (*centre foreground*) and Erskine Childers (*right foreground*). The guns were unloaded within an hour and were transported back to Dublin by taxi, bicycle and on the shoulders of the Volunteers who had marched from Dublin that morning. The rifles and ammunition landed at Howth formed a significant part of the rebel armament used in the 1916 Rising.

Mercier Archives

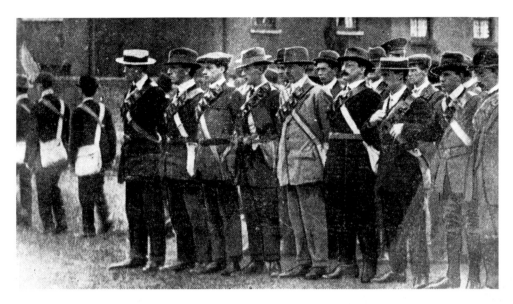

Irish Volunteers at Fr Mathew Park, Dublin, on the morning of the Howth gunrunning, 27 June 1914. Fourth from the right is Arthur Griffith, founder of Sinn Féin. The architects of the gunrunning had organised Irish Volunteer marches to Howth for several weeks beforehand so they would not arouse suspicion. The RIC and British army initially monitored these marches closely, but as each passed without incident their interest in these manoeuvres quickly evaporated. By the morning of the Howth gunrunning, the RIC and British army had grown complacent. They had no presence at Howth to prevent the unloading and distribution of arms.

Mercier Archives

A member of the Kings Own Scottish Borderers closing the gate of his barracks after the 'Bachelor's Walk Massacre'. Despite the fact that the importation of arms was not then illegal, the Irish Volunteers who returned to Dublin after the Howth gunrunning were confronted by British soldiers, who failed to disarm them. Later that evening, at Bachelor's Walk, soldiers from the Kings Own Scottish Borderers opened fire on a crowd of unarmed civilians who were jeering them, killing four people. The British army claimed that the shooting occurred when the order 'Prepare to Fire', supposedly given to scare off the crowd, was misinterpreted as the order 'Fire'. The contrast with the Larne gunrunning, when the UVF had imported thousands of rifles unhindered by the British army, was not lost on the Irish public.

© Topical Press Agency / Hulton Archive / Getty Images

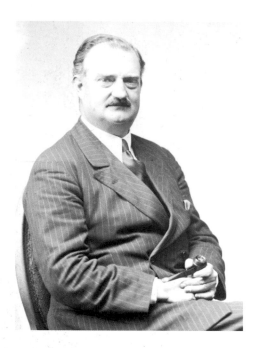

John Redmond leader of the Irish Parliamentary Party. On 20 September 1914 Redmond made a speech at Woodenbridge, Co. Wicklow, urging the Irish Volunteers to enlist in the British army and fight in the First World War. Redmond's comments caused an immediate split in the Irish Volunteers between those who supported the British war effort and the IRB faction, coupled with Nationalists like Eoin MacNeill, who were opposed to Irish involvement in the war. The vast majority of the Volunteer rank and file supported Redmond, with over 150,000 Volunteers forming the pro-war 'Irish National Volunteers'. About 10,000 Volunteers supported the hard-line Nationalist and Republican element that retained the title 'Irish Volunteers'.

Mercier Archives

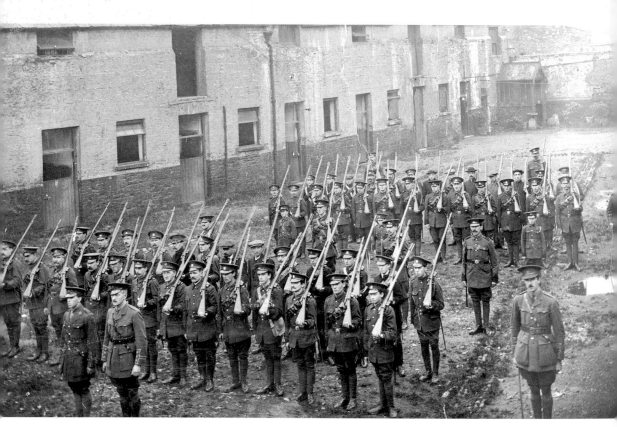

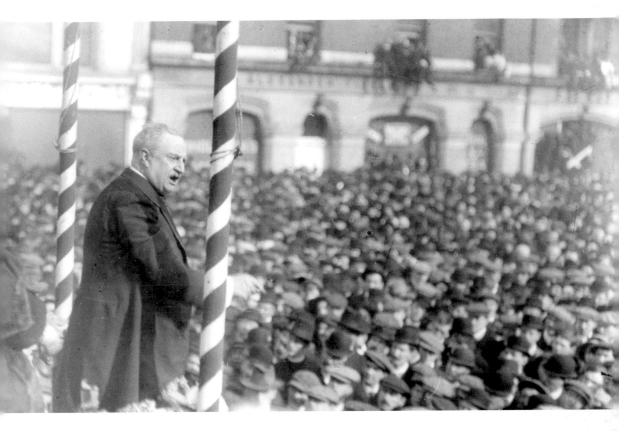

John Redmond addressing a British army recruiting meeting in 1914: 'Today, the whole of Ireland – with insignificant exceptions ... is united as Ireland was never united before, men of all political views and of all creeds and of all classes in support of the Empire ... She does not feel that she is fighting merely for England. She is fighting for the Empire, and in a special way for herself. In addition to that she is fighting for a great and holy cause – nothing less than the liberty and civilisation of the world, and the liberty, in a special way, of small nationalities.'

It is estimated that 10,000 of the Irishmen killed in the First World War enlisted because of Redmond's appeal to support Britain's war effort. Although Redmond's supporters are loath to admit it, his actions and those of other 'constitutional Nationalists' in 1914 resulted in the deaths of thousands more Irishmen than were killed in the 1916 Rising, War of Independence and Civil War combined.

Reference: *The War Illustrated, 8 January 1916* (Amalgamated Press Ltd, London 1916), pp. 483–4.

Courtesy of Kilmainham Gaol Museum 10PO 1A58 12

Opposite: A group of Irish National Volunteers on parade. Although they appear very well armed, the rifles appear to be mostly Italian Veterelli rifles, which were considered obsolete at the time as it was difficult to secure the proper ammunition for them.

Courtesy of Kilmainham Gaol Museum 16PO IA55 21

Royal Munster Fusiliers recruitment parade, Dublin 1915. Hundreds of thousands of Irishmen joined the British army during the First World War. Nationalists joined because they believed they were fighting for the rights of small nations and their politicians promised that their sacrifice would secure Home Rule. Unionists joined believing Unionist and Conservative politicians who promised that a Unionist contribution to the war effort would prevent Home Rule for Ulster. The British army recruitment figures for 1915 show that of the 51,141 British soldiers recruited in Ireland that year, 10,794 were members of the National Volunteers, 8,203 were members of the Ulster Volunteer Force and the remaining majority of 32,144 recruits were unconnected with either body. Many recruits enlisted to escape poverty and unemployment, out of a sense of adventure, because of social pressures or because they believed the British propaganda about supposed German war crimes in Belgium.

Reference: British Army recruitment figures 1915 in Major C. J. C. Street, *The Administration of Ireland, 1920* (Athol Books, Belfast 2001), p. 17.

Still from the film *Mise Éire,* courtesy of Gael Linn

Members of the Irish National Volunteers at rifle practice.

Courtesy of Kilmainham Gaol Museum 10PO IA58 23

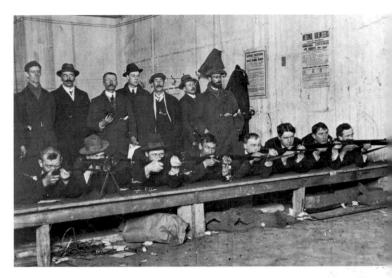

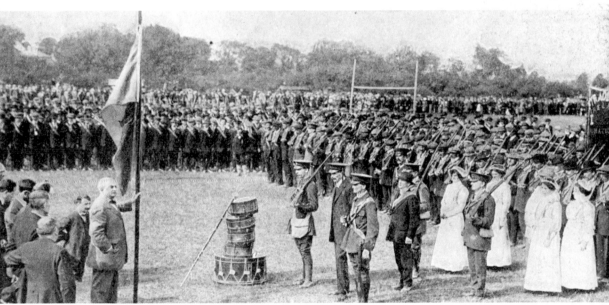

John Redmond, leader of the Irish Parliamentary Party, reviewing a parade of the Irish National Volunteers. A national review of the force was held in the Phoenix Park on Easter Sunday 1915. Special trains were arranged from different parts of the country and there was an attendance of several thousand. However, the Phoenix Park review was the 'swan song' of the National Volunteers. By 1915 their role appeared to have been overtaken by events in Europe and they seemed to have had no purpose except to fill the rapidly depleting ranks of Irish regiments on the Western Front. While a large part of the force did enlist in the British army, many others did not, and the movement had largely disappeared by the time of the 1916 Rising.

Author's Collection

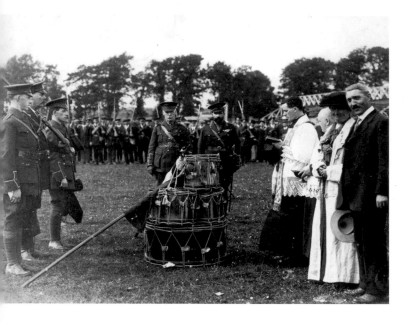

Blessing of the drums and colours at the Phoenix Park review, 1915.

Mercier Archives

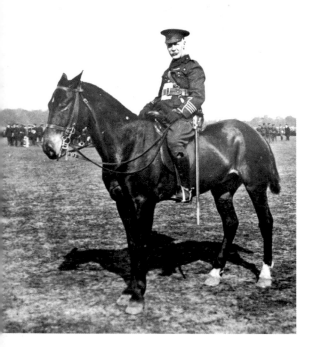

Colonel Maurice Moore at the Phoenix Park review. Moore had served in the British army during the Kafir, Zulu and Boer Wars. An enthusiastic member of the Gaelic League, he became a leading figure in the Irish Volunteers. He was present when Redmond made his famous speech at Woodenbridge and took Redmond's side when the movement split. However, he adopted a more hard-line position than Redmond and advised that no Irishman should join the British army until after Home Rule was granted. Following the 1916 Rising, Moore attempted to revive the National Volunteers as a pressure group campaigning for Home Rule. In November 1917 he held discussions with Sinn Féin's Joseph McGuinness and Michael Collins in an attempt to reunite the remainder of the National Volunteers with the Republican Irish Volunteers. A large proportion of the remaining members of the National Volunteers had already defected to the Irish Volunteers by this time. During the War of Independence, some defunct National Volunteer units gave their arms to the IRA.

Reference: Leon O'Broin, 'Maurice Moore and the National Volunteers', in *The Irish Sword*, Vol. XIII, No. 53, 1979.

Mercier Archives

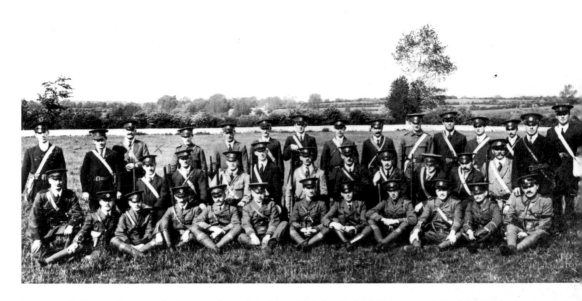

A group of officers photographed at a review of the Limerick Brigade, Irish Volunteers, held at Laffan's Field, Killonan, in the summer of 1915.

Mercier Archives

Irish Volunteer training camp at Coosan, Athlone, in the summer of 1915. Terence MacSwiney is standing third from the right (*marked with an X*); Richard Mulcahy is sitting cross-legged in the centre of the front row.

Courtesy of Kilmainham Gaol Museum 16PO IA23 19

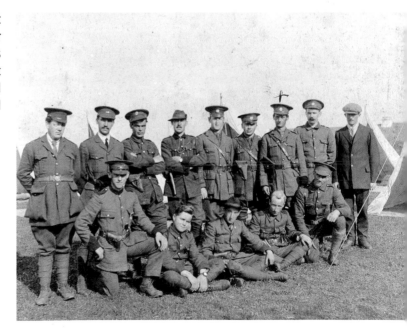

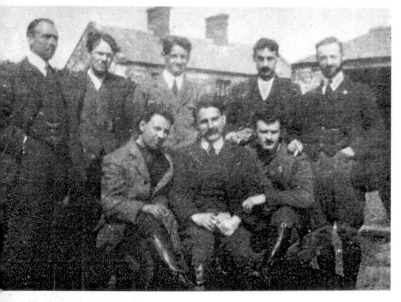

A group of leading members of the Irish Volunteers, photographed in Dundalk. Most of those pictured were members of the IRB and the photograph may have been taken at an IRB meeting. *Standing L to R*: Diarmuid Lynch, Ernest Blythe, Terence MacSwiney, Dick McKee and Michael Colivet. *Seated L to R*: Frank Thornton, Bertie Hunt and Michael Brennan. Lynch was the leader of the IRB in Munster at the time of the 1916 Rising. Blythe, a Protestant Republican from Antrim, was Minister for Finance for the Irish Free State from 1922–31. MacSwiney became mayor of Cork and died in Brixton Prison after seventy-four days on hunger strike in October 1920. McKee became leader of the IRA's Dublin Brigade and was killed by British forces in Dublin Castle in 1920. Thornton became a leading IRA intelligence officer, working closely with Michael Collins. Brennan was leader of the IRA's East Clare Brigade flying column during the War of Independence and later became leader of the Free State army.

Author's Collection

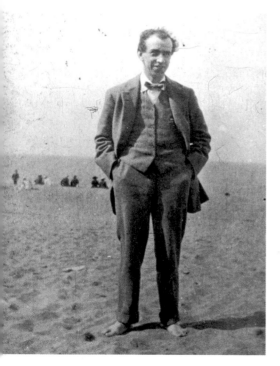

Thomas MacDonagh on Greystones beach, Co. Wicklow, around 1915. MacDonagh was a lecturer of English literature at University College Dublin. A leading member of the Gaelic League and the Irish Volunteers, MacDonagh was sworn into the IRB in 1915 and was swiftly appointed to the military council which planned the 1916 Rising.

Courtesy of Kilmainham Gaol Museum 16PC IA25 08

Patrick Pearse, director of operations for the Irish Volunteers. A fiery orator and skilled writer, Pearse was radicalised by the Home Rule crisis and eventually joined the IRB's military council. He was also appointed president of the Provisional Government of the Irish Republic. Retrospectively Pearse has been criticised for some of his rhetoric being 'bloodthirsty', but similar attitudes were common in Europe at the time, for example the English war poet Rupert Brooke, or the war correspondent Philip Gibbs. In writing about the deaths of 20,000 soldiers at the Battle of the Somme in 1916, Gibbs said: 'It is a good day for England and France. It is a day of promise in this war, in which the blood of brave men is poured out upon the sodden fields of Europe.'

Reference: Samuel Hynes, *A War Imagined: The First World War and English Culture* (Bodley Head, London 1992), p. 110.

Courtesy of Kilmainham Gaol Museum 17PO IB14 22

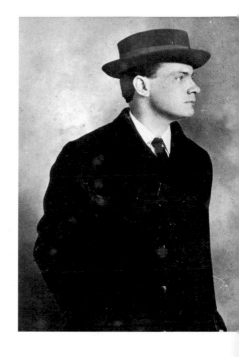

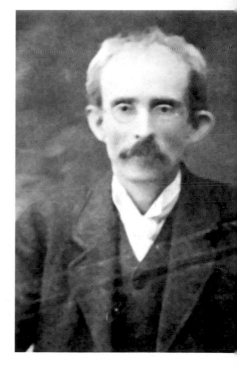

IRB leader Thomas Clarke. Clarke, a tobacconist who owned a shop on Sackville Street, was a veteran Republican who had served fifteen years' imprisonment for his part in the Fenian dynamite campaign of 1883. Clarke had overseen the revival of the IRB and the planning of the 1916 Rising after his return to Ireland.

Mercier Archives

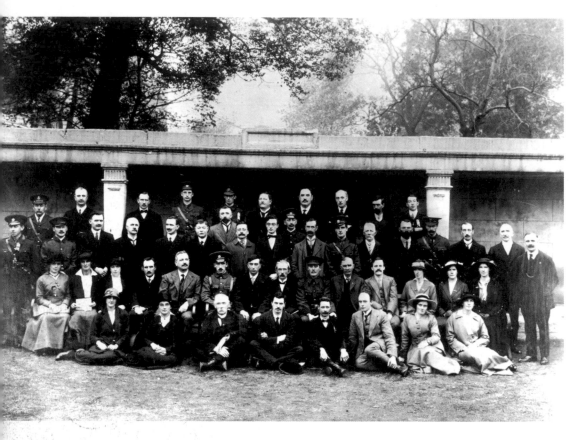

The O'Donovan Rossa Memorial Committee.

Back row, L to R: J. K. O'Reilly, P. J. Keohane, Diarmuid Lynch, Éamon de Valera, James Tobin, B. R. Parsons, John O'Mahony, W. O'Leary Curtis, John Larkin and Liam Cullen.

Third row: Thomas MacDonagh, Martin Conlon, J. J. O'Kelly, James Casey, Richard O'Correll, J. Farrenn, Seamus Baggy, Arthur Griffith, Seán Ó Gadhra, Joseph McGuinness, Joseph Murray, Henry Nicholls, J. Lawlor, William O'Brien, Cathal Brugha, James Wheelan, Major John MacBride and T. Farren.

Second row: Miss J. Walsh, Constance Markievicz, Mrs C. Holohan, B. Ó Foghludha, John R. Reynolds, Éamonn Daly, Seamus Ó Chonchubair, Thomas Clarke, Peadar McNally, James Stritch, Michael Slater, Mrs Thomas Clarke, Miss S. McMahon and Miss S. Cassidy.

Front row: Máire Ní Raghnaill, Mrs C. O'Moore, Michael McGinn, Thomas Meldon, Joseph Kelly, Brian O'Higgins, Mrs B. Walsh and Mrs Joseph McGuinness.

Courtesy of Kilmainham Gaol Museum 16PO IA23 01

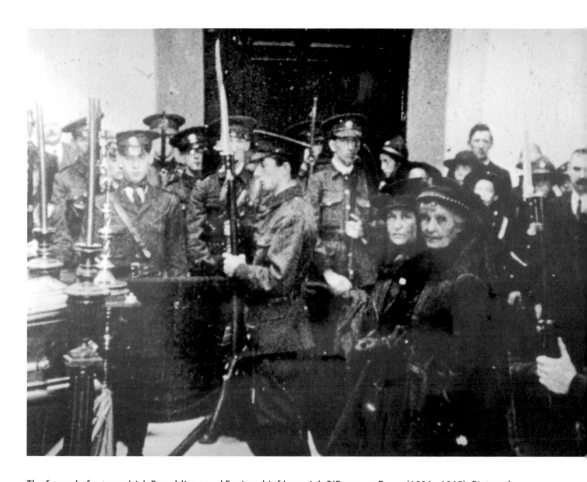

The funeral of veteran Irish Republican and Fenian chief Jeremiah O'Donovan Rossa (1831–1915). Pictured in the foreground are his wife and daughter. In the background on the extreme right of the picture is James Connolly, the leader of the Irish Citizen Army, executed for his part in the 1916 Rising. O'Donovan Rossa, a native of West Cork, had experienced the horrors of the Great Famine in his youth. He became a grocer in Skibbereen and founded the Phoenix Society in 1856, a political group which was absorbed into the fledgling IRB. He was imprisoned for his Fenian activities from 1865–1871 and after his release went to America where he started a 'skirmishing fund' to finance militant Republican activities. This led to his involvement in the 'Dynamite War', the first Irish Republican bombing campaign in Britain from 1881–1885. After his death in New York in 1915, his body was returned to Ireland for burial at Glasnevin Cemetery, Dublin. His funeral served as a rallying point for the IRB, Irish Volunteers, Citizen Army and other militant Republican groups. Some units of the Irish National Volunteers also attended the funeral, even though John Redmond had refused to sanction their attendance.

Reference: *The Oxford Companion to Irish History*, edited by S. J. Connolly (Oxford University Press, Oxford 2002), p. 425.

Still from the film *Mise Éire*, courtesy of Gael Linn

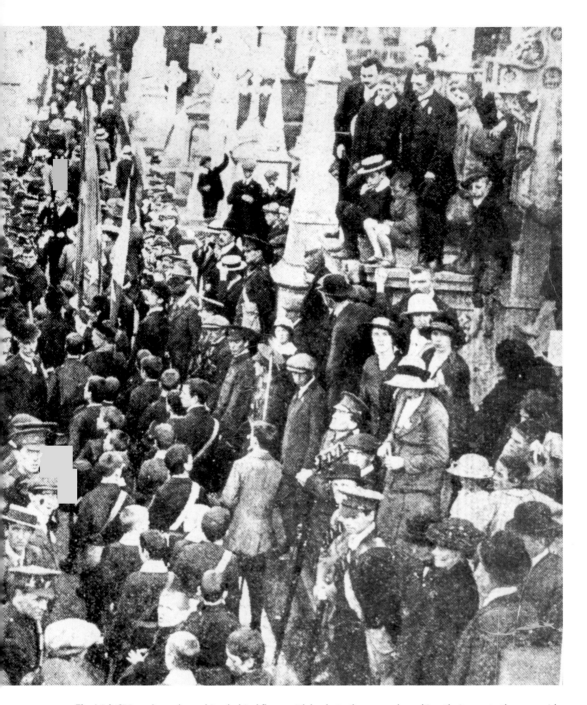

The Irish Citizen Army (*marching behind flags, with backs to the camera*), making their way to the graveside of O'Donovan Rossa, behind their banner 'the Starry Plough'.

Photograph courtesy of the *Irish Daily Mirror*

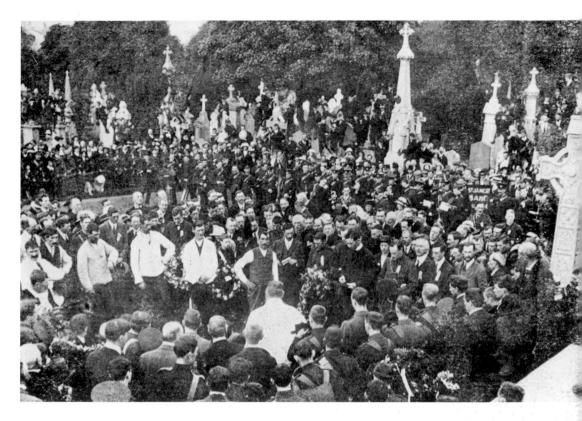

Patrick Pearse reading his oration at O'Donovan Rossa's funeral. *l to R*: Patrick Pearse (*to the right of the priest*), John MacBride, Seán McGarry, Liam Grogan (*in profile*), Darrell Figgis and Thomas Clarke (*in profile*). According to Republican folklore, Clarke had advised Pearse to make his graveside speech 'hot as hell, and throw discretion to the winds'. Those present who heard the oration, like Elizabeth Bloxham, were spellbound by Pearse's words: 'As he spoke, a biblical phrase ran through my head, "and he lifted up his voice and said unto them". Such uplift of voice and spirit I never heard before or since. It swept through the listeners so that for the time we were with him, I am no sentimentalist but the tears stood in my eyes, I knew that we need no longer continue to look to the past for our great men for there was one in our midst who was aflame with the same passionate devotion as the heroes of old.'

Reference: Elizabeth Bloxham, Bureau of Military History WS 632, pp. 31–2.

Mercier Archives

Clock at the GPO, Dublin, showing the time it stopped during the 1916 Rising.

Mercier Archives

1916

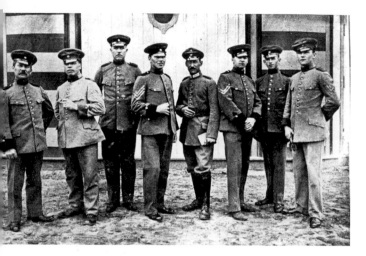

Non-commissioned officers of A Company of the Irish Brigade in Germany. Roger Casement recruited the brigade from members of Irish regiments of the British army held in German POW camps. Its purpose was to support a proposed German invasion of Ireland to coincide with the Rising. *L to R*: Peter Golden, Michael Kehoe (ex-Royal Irish Regiment), — O'Mahony, Daniel Julien Baily, — Zerhussen (German interpreter), — Kavanagh (ex-South Irish Horse), Corporal O'Callaghan and Timothy Quinlisk (ex-Royal Irish Regiment). Quinlisk later became a British spy and returned to Ireland in 1919 to try to have Michael Collins captured. The following year he went to Cork city and attempted to infiltrate local IRA units whilst posing as a gun smuggler. Quinlisk was captured by the IRA and executed at Tory Top Lane, Cork city, on 20 February 1920.

Reference: John Borgonovo, *Spies, Informers and the Anti-Sinn Féin Society – The Intelligence War in Cork City 1920–1921* (Irish Academic Press, Dublin 2007), pp. 76–7.

Mercier Archives

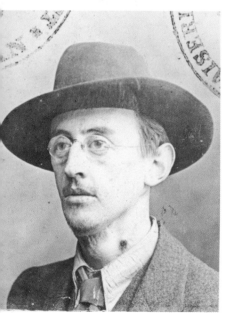

Joseph Mary Plunkett. Photograph taken for an identification card he used when travelling to Germany in 1915. Plunkett was in Germany seeking arms and military assistance from the German military for the planned rising. For most of his life, Plunkett was plagued by ill health and was recovering from an operation for glandular tuberculosis when he took part in the 1916 Rising. The scarring from a medical operation is visible on Plunkett's neck. He married his fiancée, Grace Gifford, while a prisoner in Kilmainham Gaol, shortly before his execution.

Reference: Ray Bateson, *They Died by Pearse's Side* (Irish Graves Publications, Dublin 2010), pp. 185–6.

Courtesy of Irish Military Archives, BMH P24 (copy courtesy of NLI. Copy made for Bureau of Military History by Dr Hayes McCoy)

U-boat 19, April 1916. Roger Casement is at the front of the turret in a dark civilian coat. Robert Monteith is on the extreme right, leaning on the railings. Monteith, a Protestant Republican from Wicklow, joined the British army at sixteen years of age and fought in the Boer War. The British conduct of that war led to his complete disillusionment and he eventually left the army. Having returned to Ireland, he secured employment with the Ordnance Survey. In 1913 Monteith joined the Irish Volunteers. As a result he was dismissed from his job and the British authorities issued an exclusion order barring him from Dublin. In September 1915 he travelled to Germany where he attempted to help Casement recruit an Irish Brigade. Failing in this they returned to Ireland on board U-Boat 19, a German submarine. They were put ashore in a collapsible boat and landed at Banna Strand, Kerry, on Good Friday 1916. Casement was arrested by the RIC shortly afterwards. Monteith made contact with the Irish Volunteers and remained in hiding until he escaped to America following the Rising. He later published his memoirs in a book entitled *Casement's Last Adventure*.

Mercier Archives

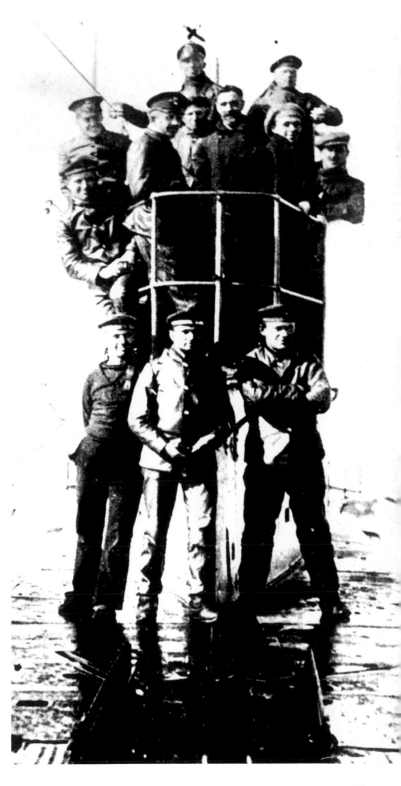

The crew of the German arms ship *Aud* (*centre in darker uniforms*) while in British captivity at Fort Westmoreland, Cork. Joseph Mary Plunkett had hoped for a large German invasion force of at least 12,000 soldiers to land at Limerick with 40,000 rifles to arm the Irish Volunteers. The German military authorities were unimpressed with the Irish Republican plans for a rebellion and refused to consider launching an invasion. In the end German military aid to the Irish rebels amounted to 20,000 Russian rifles, ten machine guns and millions of rounds of ammunition, which were to be smuggled to Ireland by a German naval crew posing as Norwegian sailors on board the *Aud*. The shipment was intercepted by two British warships and escorted to Cobh. Rather than surrender their cargo and their vessel to the British, the crew of the *Aud* scuttled their ship at the entrance to Cork Harbour. This photograph was taken by a British soldier at Spike Island.

Author's Collection

Eoin MacNeill, president of the Irish Volunteers. MacNeill discovered the IRB's plans for rebellion on Good Friday, and threatened to disrupt these plans until Seán Mac Diarmada pointed out that with German assistance due to arrive the rebellion was inevitable. On Saturday of Easter week, after hearing that the arms shipment on board the *Aud* had been captured, MacNeill went to the offices of the *Sunday Independent* newspaper and got the editor to publish a countermanding order cancelling all Irish Volunteer parades and manoeuvres planned for Easter Sunday. Reacting to this, the IRB postponed the rebellion until Easter Monday, hoping that if the Republican forces went into action in Dublin, Irish Volunteer companies around Ireland would follow suit.

Mercier Archives

The Irish Republic proclaimed. The flag of the Irish Republic flies over the Princes Street corner of the GPO. Gearóid O'Sullivan and Seán Hegarty raised the flag shortly after the rebels took over the GPO as their headquarters at noon on Easter Monday 1916. According to O'Sullivan 'the Flag was a Standard made of green poplin. On it was painted Irish Republic in white and orange letters.' A second flag, a Tricolour of green, white and orange, was also flown over the GPO during the Rising. Before 1916, Irish Republicans and Nationalists had used a green flag with a golden harp, but afterwards it was replaced with the Tricolour, which had first been used in the Young Irelanders' rebellion of 1848.

Reference: G. O'Sullivan, Bureau of Military History WS 218.

Courtesy of Kilmainham Gaol Museum KMGLM 2011.0191

Jack Doyle and Sergeant Tom McGrath, C Company, 2nd Battalion, Dublin Brigade, Irish Volunteers, photographed inside the GPO on Easter Tuesday 1916 by Joseph Cripps. Cripps, a photographic chemist, went to Sackville Street to take photographs as soon as he heard about the outbreak of the Rising. Cripps was also a member of the Red Cross and volunteered to stay with the Republican forces in the Sackville Street area. He spent the duration of the Rising acting as a medic. Later, during the War of Independence, he joined the IRA's Dublin Brigade and used his knowledge of chemistry to instruct others in the manufacture of explosives.

Reference: Éamonn O'Doherty, *An Illustrated History. The IRA at War 1916 to the Present* (Mercier Press, Cork 1985), p. 22.

Courtesy of Kilmainham Gaol Museum KMGLM 2011.0166

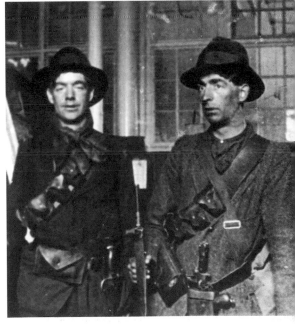

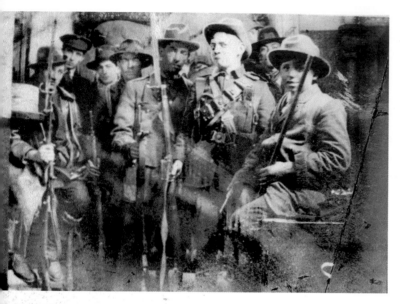

Photograph taken inside the GPO, Easter Week 1916. *L to R*: Desmond O'Reilly, B Company, 1st Battalion, James Mooney, E Company, 2nd Battalion, Paddy Byrne, 1st Battalion, and Jack Doyle and Sergeant Tom McGrath, C Company, 2nd Battalion, all of the Dublin Brigade, Irish Volunteers; Hugh Thornton and Paddy Twamly, Irish Citizen Army and Tony Swan. Joe Cripps took this photograph, like the previous photo, on Easter Tuesday. It is curious that Cripps chose to photograph ordinary members of the garrison rather than the Republican leaders.

Courtesy of Kilmainham Gaol Museum KMGLM 2011.0180

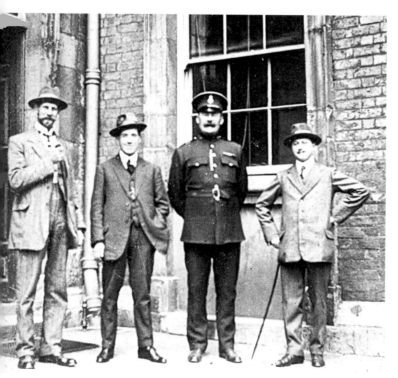

Constable James O'Brien, DMP (*in uniform*), was one of the first casualties of the 1916 Rising. O'Brien was on duty at the Cork Hill entrance to Dublin Castle when he was shot dead by the Republicans shortly before noon on 24 April. O'Brien was a native of Kilfergus, Co. Limerick.

Reference: Jim Herlihy, *The Dublin Metropolitan Police. A Short History and Genealogical Guide* (Four Courts Press, Dublin 2001), p. 177.

Courtesy of Kilmainham Gaol Museum 17PO IA24 11

James Joseph Coade (*right*) was shot in the head outside Rathmines church by Captain J. Bowen-Colthurst. Coade, nineteen years old at the time, was not involved in the Rising. Shortly afterwards Bowen-Colthurst shot Richard O'Carroll, a Dublin city councillor and member of the Irish Volunteers, having questioned him about his rebel sympathies. When a soldier told him that O'Carroll was not dead yet, Bowen-Colthurst replied, 'Never mind, he'll die later. Take him into the street.' During the Rising Bowen-Colthurst presided over the execution of three more men by firing squad at Portobello Barracks: Francis Sheehy Skeffington, a pacifist who sympathised with the Rising; Thomas Dickson and Patrick MacIntyre, two Loyalist newspaper editors who did not. After the Rising Bowen-Colthurst was tried for the killings of the five men, was found guilty but insane and imprisoned in Broadmoor Criminal Asylum. He served less than two years of his sentence.

Reference: Mick O'Farrell, *50 Things You Didn't Know about 1916* (Mercier Press, Cork 2009), pp. 96–7.

Courtesy of Kilmainham Gaol Museum 17PO IA24 09

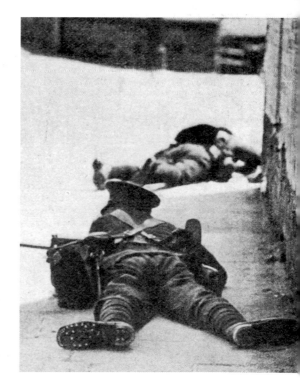

British soldiers taking cover from a Republican sniper.

Courtesy of Mick O'Farrell, *50 Things You Didn't Know about 1916* (Mercier Press, Cork 2009)

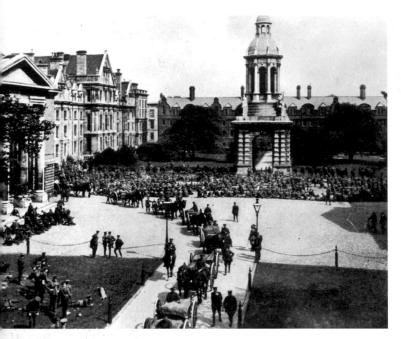

British troops in Trinity College Dublin during the Rising. British soldiers on leave in the city, including a handful from the Australia and New Zealand Corps, joined with members of the Trinity College Officer Training Corps to successfully defend the college and snipe Republican positions in Sackville Street.

Mercier Archives

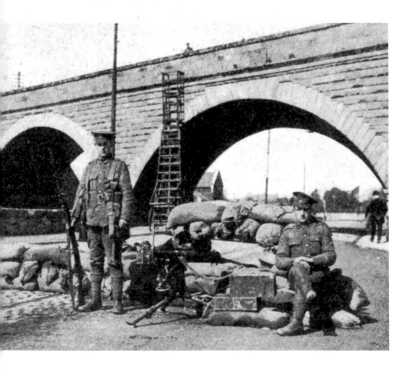

A machine-gun post and sandbag defences, built by the British, at Clontarf Railway Bridge.

Photo taken by T. W. Murphy, copyright the Murphy family

British soldiers from the Sherwood Foresters regiment resting after the Battle of Mount Street Bridge. The battle saw the heaviest casualties inflicted on the British during the Rising, when a handful of Republicans stationed at 25 Northumberland Road and Clanwilliam House killed four British officers, wounded fourteen others and killed or wounded 216 British soldiers before they were forced to retreat.

De Valera Papers, University College Dublin

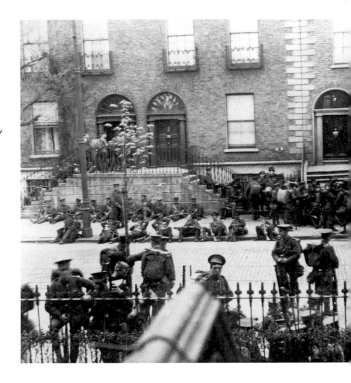

Lieutenant Michael Malone, who commanded the Republican garrison at 25 Northumberland Road during the Battle of Mount Street Bridge. Malone was killed in the fighting along with Patrick Doyle, Richard Murphy, George Reynolds and Patrick Whelan. Malone's brother, Sergeant Willie Malone, was killed in a German gas attack at 'Mouse Trap' farm during the Second Battle of Ypres while serving with the Royal Dublin Fusiliers.

References: Richard Holmes, *Shots From the Front. The British Soldier 1914–1918* (Harper Press, London 2008), p. 222; Paul O'Brien, *Blood on the Streets* (Mercier Press, Cork 2008).

Mercier Archives

Section Commander George Reynolds, who was killed while in command of Clanwilliam House during the fighting at Mount Street Bridge. Reynolds, a silversmith from Ringsend, joined the Irish Volunteers in 1915 and was appointed a section commander of C Company, 3rd Battalion, Dublin Brigade. His outpost at Clanwilliam House was set alight during the fighting and the flames consumed Reynolds' body. Only a few fragments of his skeleton were recovered afterwards and buried in Glasnevin Cemetery.

References: Ray Bateson, *They Died by Pearse's Side* (Irish Graves Publications, Dublin 2010), pp. 128–9; Paul O'Brien, *Blood on the Streets* (Mercier Press, Cork 2008).

Courtesy of Kilmainham Gaol Museum 17PC IA44 05

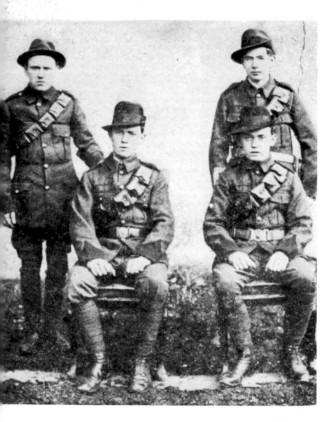

Veterans of the Battle of Mount Street Bridge. *Standing L to R*: Willie Ronan and Jimmy Doyle. *Seated L to R*: James Walsh and Thomas Walsh. All four were stationed at Clanwilliam House during the fighting.

Mercier Archives

British soldiers at a street barricade made from park benches. Though it purports to be a photograph taken during the fighting, the British soldier pictured top left standing 'at ease' indicates that the photograph was staged shortly after the Rising for use in British propaganda.

Author's Collection

Below: This photograph appeared in *The Illustrated War News* issue of 10 May 1916 with the caption 'Soldiers repelling a rebel attack (photographed under fire)'. The caption is probably accurate, as the photograph seems far more realistic and less staged than the previous one, and the photographer has maintained a safe distance from the fighting. It is probably one of the few actual photographs taken from behind the British lines during the fighting.

Author's Collection

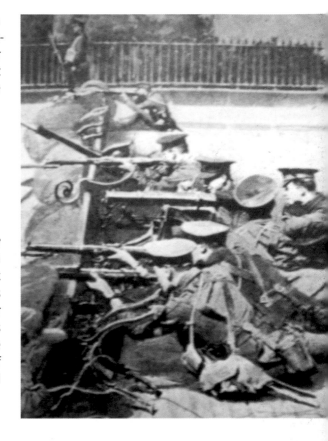

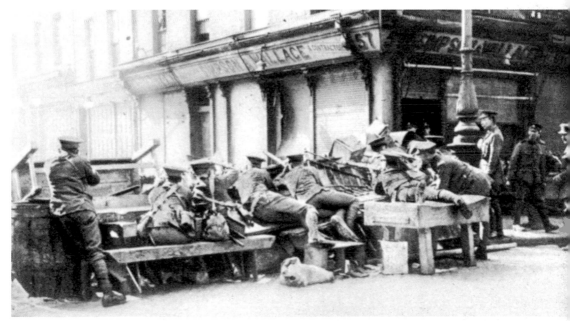

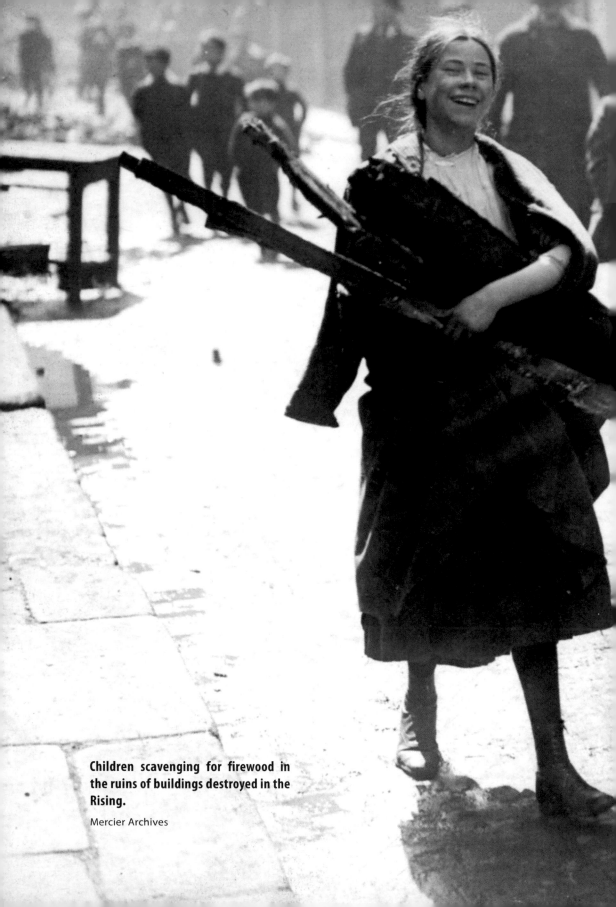

Children scavenging for firewood in the ruins of buildings destroyed in the Rising.

Mercier Archives

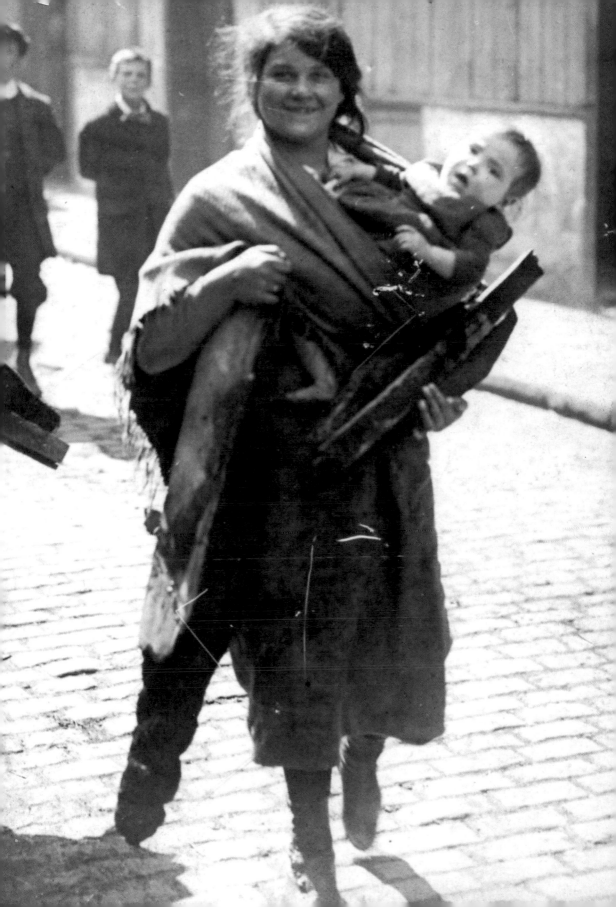

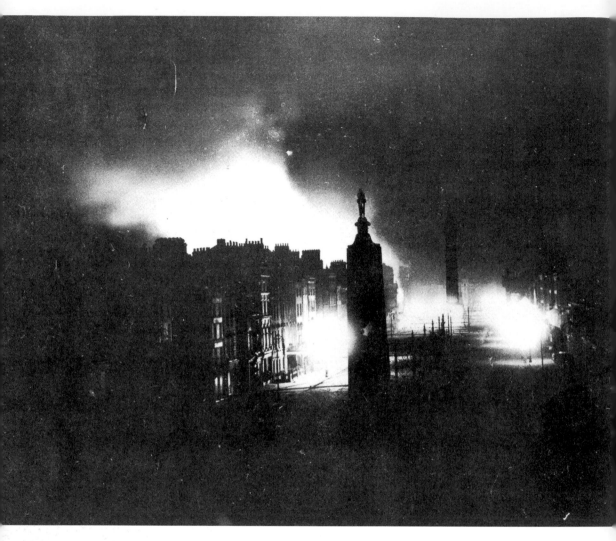

Fires blazing in Sackville Street during the final hours of the Rising. The Parnell monument, Nelson's pillar and the portico of the GPO (*on the right*) are all visible.

Courtesy of Mick O'Farrell, *A Walk through Rebel Dublin, 1916* (Mercier Press, Cork 1999)

Opposite: Bags of unsorted and undelivered post accumulating at Kingstown (Dun Laoghaire) Railway Station because of the disruption caused by the Rising.

Mercier Archives

Michael O'Callaghan, a leading member of the IRB and the Irish Volunteers in Tipperary town. O'Callaghan presided over two meetings during Easter week, where the local company of the Irish Volunteers debated whether or not to take military action in support of the Dublin rebels. On 26 April two members of the RIC, Sergeant O'Rourke and Constable Hurley, attempted to arrest O'Callaghan at Moanour Cross, Kilross. O'Callaghan shot and fatally wounded both men before escaping. O'Callaghan evaded capture and went to New York. In 1917 he was arrested as part of a failed British attempt to have him extradited and was imprisoned at Tombs Prison until January 1918.

Reference: Martin 'Bob' O'Dwyer, *Tipperary's Sons & Daughters 1916–1923* (Cashel Folk Village, Tipperary 2001), pp. 155–6.

Courtesy of Martin 'Bob' O'Dwyer

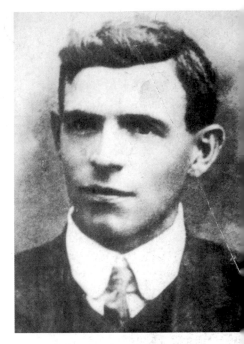

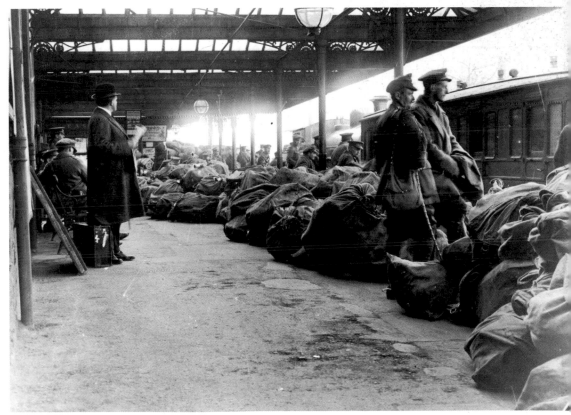

Michael 'The' O'Rahilly, director of armament for the Irish Volunteers. O'Rahilly opposed the Rising and spent Easter Sunday travelling through Munster spreading MacNeill's countermanding order. However, when the Rising began he threw his full weight behind it. On Friday 28 April, when the British artillery bombardment forced the evacuation of the GPO, O'Rahilly volunteered to lead a group to try to fight their way up Moore Street and break through the British army lines. O'Rahilly was mortally wounded leading his men in a charge against a British barricade at the end of Moore Street. He crawled into the doorway at the corner of Moore Street and Sackville Lane and in his dying hours he wrote the following note to his wife:

> Written after I was shot. Darling Nancy I was shot leading a rush up Moore Street and took refuge in a doorway. While I was there I heard the men pointing out where I was and made a bolt for the laneway where I am now. I got more [than] one bullet I think. Tons and tons of love dearie to you and the boys and to Nell and Anna. It was a good Fight anyhow. Please deliver this to Nannie O'Rahilly, 40 Herbert Park, Dublin. Goodbye Darling.'

Reference: Ray Bateson, *They Died by Pearse's Side* (Irish Graves Publications, Dublin 2010), pp. 209–19.

Courtesy of Kilmainham Gaol Museum 17PO IA24 22

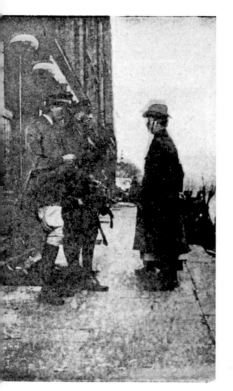

The surrender of the Irish Republican forces – 29 April 1916. Patrick Pearse (*right*) surrendering to Brigadier General William Lowe (*left*). Pictured on Pearse's right is Elizabeth O'Farrell, a member of Cumann na mBan, who acted as courier during the surrender process. Only the hem of O'Farrell's dress and her feet are visible. This photograph has often been cited as an example of how women were airbrushed out of the history of the period. However, those airbrushing photographs usually remove the whole person! According to an account of the incident she gave to the Cistercian monks of Roscrea in May 1956, O'Farrell stated that she deliberately hid from the camera. When O'Farrell saw a British soldier getting ready to take the photograph, she took a step backwards behind Pearse so as not to give the enemy press any satisfaction. In later years she regretted not being pictured. General Lowe's son, Major John Lowe (*far left*), later became a successful actor in both the German and American film industries under the stage name 'John Loder'.

References: Gerry Lyne, 'An Irishman's Diary', *The Irish Times,* April 2010; Mick O'Farrell, *50 Things You Didn't Know About 1916* (Mercier Press, Cork 2009), p. 133.

Mercier Archives

The leaders of the College of Surgeons/St Stephen's Green garrison under guard by British soldiers. Michael Malin (*centre*) and Constance Markievicz (*right marked with an x*) were both members of the Irish Citizen Army. Malin was executed by a British firing squad on 8 May 1916. Markievicz was tried by a British military court martial and was sentenced to death. The sentence was commuted to penal servitude for life because of the British military's reluctance to execute a woman.

Mercier Archives

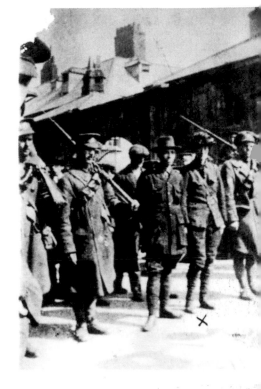

British army officers at the Parnell monument, Sackville Street, posing with the flag of the Irish Republic. The flag, which had flown over the GPO, survived the bombardment of the building and was taken as a trophy by British troops after the Republicans surrendered. The officers are holding the flag upside down in military tradition to show that the Republicans have been defeated. The flag was taken back to Britain and displayed upside down over the bar in a regimental mess. On the fiftieth anniversary of the Rising the flag was presented to the Irish government by the British government. It is currently held in the National Museum of Ireland, Collins Barracks, Dublin. (Interestingly many of the British army officers in this photograph were Irishmen.)

Still from the film *Mise Éire*, courtesy of Gael Linn

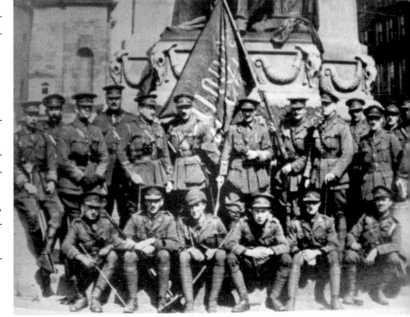

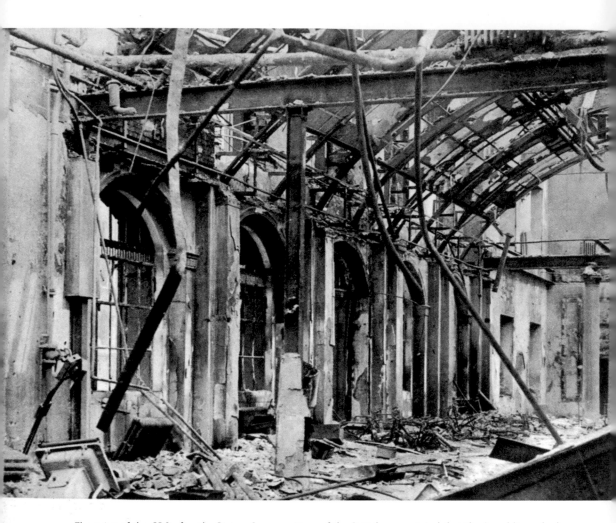

The ruins of the GPO after the Rising. Some sections of the British press stated that the Republicans had deliberately destroyed the building and were responsible for starting the fires which wreaked widespread destruction in the centre of Dublin. In fact the British shelling of Republican positions caused these fires. This photograph, which appeared in the British magazine *The Illustrated War News* on 10 May 1916, carried the caption: 'FIRED BY REBELS WHO COULD NO LONGER HOLD IT: THE BURNT-OUT INTERIOR OF THE POST OFFICE, DUBLIN … It is said that the Sinn Féiners who occupied the post office, finding themselves unable to defend it any longer, set fire to the interior with paraffin, and retreated to the Coliseum behind it, where they shortly afterwards raised the white flag.'

Author's Collection

One of the improvised armoured cars built by the British army during the Rising. This one was built by bolting together four boilers from the Guinness Brewery, which were mounted on a flatbed truck.

Mercier Archives

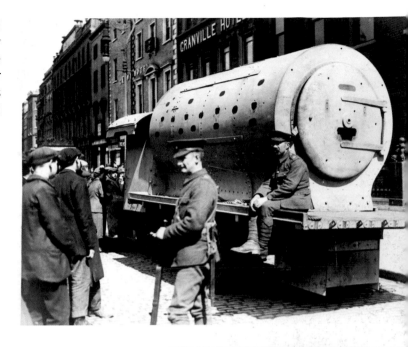

Photo and caption from *Dublin after the Six Days Insurrection*, published by Mecredy, Percy & Co. Ltd, Dublin 1916. It shows an armed member of the 'Loyal Dublin Volunteers', a 400-strong, Dublin-based Unionist paramilitary force which had links to the UVF, on guard duty outside the GPO. As well as the Loyal Dublin Volunteers, the British forces also received assistance from John Redmond's Irish National Volunteers. The National Volunteers also assisted the British forces in suppressing the Rising in Dublin. In a number of large towns and cities, including Castlebar, Drogheda, Dundalk, Galway, New Ross and Wexford, the National Volunteers joined with local Unionists and formed local defence corps to protect their areas from Republican attack.

References: Padraig Yeates, *A City in Wartime, Dublin 1914–18* (Gill & MacMillan, Dublin 2011) p. 17; Fearghal McGarry, *The Rising. Ireland: Easter 1916* (Oxford University Press, Oxford 2010), pp. 230, 242–3.

Photo taken by T. W. Murphy, copyright the Murphy family

LOYAL VOLUNTEER ON DUTY AT GENERAL POST OFFICE.

LOYAL VOLUNTEERS ON DUTY AT G.P.O.—MILITARY PASSING

Photo and caption from *Dublin after the Six Days Insurrection*, published by Mecredy, Percy & Co. Ltd, Dublin 1916. A British military patrol passing two armed members of the Loyal Dublin Volunteers (*uniformed figures extreme left and right*) on duty outside the ruins of the GPO. The Volunteers are both wearing police 'on duty' armbands issued by the British authorities on their left arms. Note the caption: 'Loyal Volunteers on duty at G.P.O. – Military Passing'.

Reference: Fearghal McGarry, *The Rising. Ireland: Easter 1916* (Oxford University Press, Oxford 2010), pp. 230, 242–3.

Photo taken by T. W. Murphy, copyright the Murphy family

British cavalry from the 6th Reserve Cavalry regiment patrol the Dublin Quays in the aftermath of the Rising.

Mercier Archives

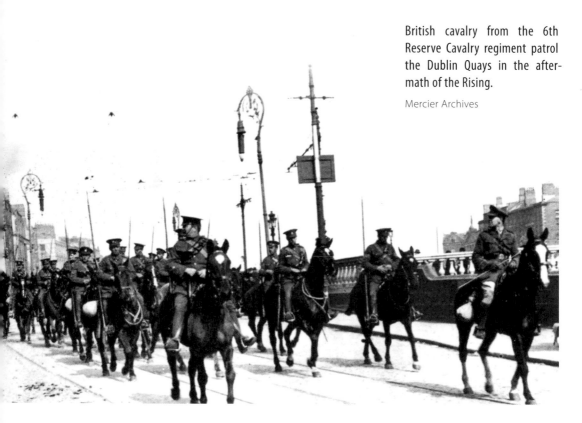

British soldiers on guard duty at Liberty Hall, headquarters of the ^lIrish Transport and General Workers' Union and the Irish Citizen Army. The British shelled the building during the fighting in the belief that the Republicans occupied it. In fact no one was in the building at the time except its caretaker, who fled when the bombardment began.

Mercier Archives

Fermoy, Co. Cork, 2 May 1916. Thomas Kent (*centre*) and his brother William Kent (*right*) being taken into custody by members of the British army. On 1 May the RIC surrounded the Kent family home in Fermoy to arrest the family's sons, but they resisted arrest. A prolonged firefight ensued during which RIC Head Constable Rowe and Richard Kent were killed. After the family surrendered, Thomas and William were arrested. They were being marched across Fermoy Bridge when this photograph was taken. Thomas is still in his bare feet as his captors refused him permission to get his boots. He was executed by a British firing squad at Victoria (now Collins) Barracks, Cork, two days later.

Mercier Archives

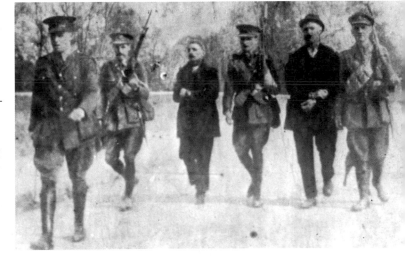

REVOLUTION

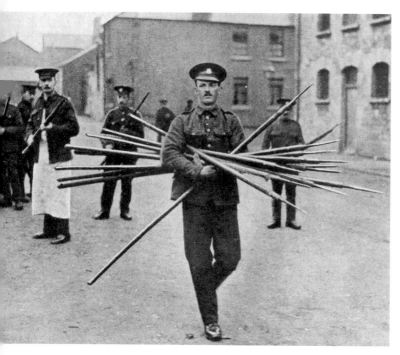

A British soldier disposing of a bundle of pikes, which were used by the Republicans during the Rising. The rebels had fought armed with a vast array of weaponry, including British army issue Lee Enfield .303 rifles, Mauser Model 71 rifles, shotguns, percussion cap, pin-fire and flint-lock muskets, home-made hand grenades, swords and pikes. While not very practical, pikes had a symbolic significance for the rebels since they had been used in the Republican rebellions of 1798, 1803, 1848 and 1867.

Reference: Mick O'Farrell, *50 Things You Didn't Know About 1916* (Mercier Press, Cork 2009).

Courtesy of Mick O'Farrell

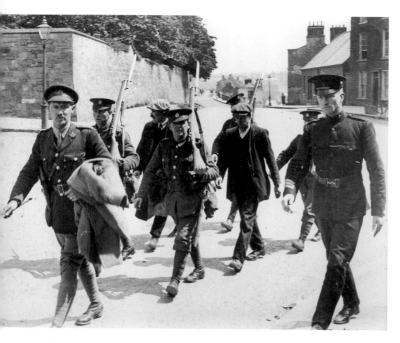

Rebel prisoners Dick Donoghue and Tom Doyle from Enniscorthy, Co. Wexford, being marched to Kilmainham Gaol by British soldiers and an RIC sergeant. The soldiers are members of the Connaught Rangers so are presumably Irishmen. A number of Irish regiments in the British army, including the Connaught Rangers, the Leinster Regiment and the Royal Inniskilling Fusiliers, were involved in suppressing the Rising.

Reference: Éamonn O'Doherty, *An Illustrated History. The IRA at War 1916 to the Present* (Mercier Press, Cork 1985), p. 28.

Courtesy of Kilmainham Gaol Museum 17PC IB14 20

Éamon de Valera in British custody at Richmond Barracks, 8 May 1916. Afterwards de Valera shot to prominence for his role in the Rising. He was hailed as 'The Hero of Boland's Mills' who 'made the Notts and Derbys [Sherwood Foresters] bite the dust during Easter Week'. In fact, de Valera's leadership of the Boland's Mills garrison during the Rising had been less than spectacular. The fact that the Battle of Mount Street Bridge, in which the British army suffered its heaviest casualties, happened under his command, earned de Valera his status as a Republican hero. He was sentenced to death for his part in the Rising but this was commuted to life imprisonment.

Courtesy of Kilmainham Gaol Museum 17PC IA44 01

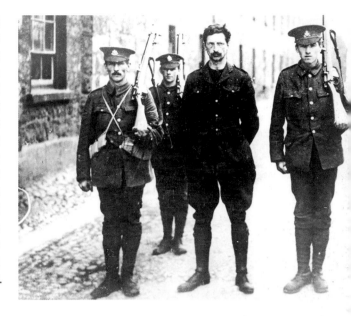

Mugshot of Peadar Clancy taken after the Rising. Clancy, a native of Cranny in Clare, had burned out a British army sniper's post and led a group of rebels in success-fully repelling a British attack near Church Street Bridge. He was sentenced to death for his part in the rebellion, but this was commuted to ten years' imprisonment. In April 1920 Clancy led a successful hunger strike of about 100 Republican prisoners in Mountjoy Jail and they were all released after just eight days. Clancy was appointed to the joint posts of vice-commandant of the Dublin Brigade and IRA director of munitions. He was captured by F Company of the Auxil-iaries on 20 November 1921 and was killed at Dublin Castle the following evening, 'Bloody Sunday', in revenge for the IRA's killing of thirteen British intelligence agents.

Reference: Pádraig Óg Ó Ruairc, *Blood on the Banner: The Republican Struggle in Clare* (Mercier Press, Cork 2009), pp. 53, 130–1, 198–9.

Courtesy of Kilmainham Gaol Museum 17PO IA22 20

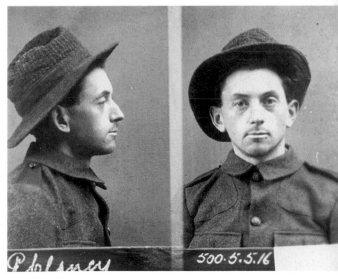

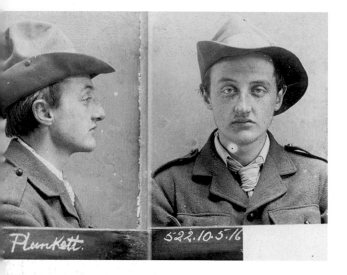

Mugshot of John Plunkett. Plunkett, an engineering student at UCD, fought in the GPO garrison during the Rising. He was a younger brother of Joseph Mary Plunkett, one of the leaders of the rebellion executed on 4 May 1916. John took the Republican side during the Civil War and fought in the Four Courts at the beginning of that conflict. He remained a member of the IRA until the Second World War. Plunkett was arrested in a raid on an IRA wireless broadcasting station in 1939 and interned in the Curragh, where he survived a forty-day hunger strike. He later worked as an engineer for the ESB and died in 1960.

Reference: Royal Irish Academy, *Dictionary of Irish Biography*, Vol. 8 (Cambridge University Press, Cambridge 2009), p. 186.

Courtesy of Kilmainham Gaol Museum 17PO IA22 18

Mugshot of Liam Tobin. Tobin, originally from Cork, worked as a clerk for Brooks Thomas Ltd in Dublin, and served in the Four Courts garrison during the Rising. He became the IRA's deputy director of intelligence and worked with Michael Collins directing and instructing 'The Squad'. Tobin took the pro-Treaty side during the Civil War and became an acting major general in the Free State army. He was one of the leaders of the failed 1924 army mutiny by former Collins associates who felt that the Cumann na nGaedheal government had betrayed Collins' commitment to lead the state towards an all-Ireland Republic. In 1929 he formed a short-lived political party named Clann na nGaedheal which attempted to heal the divisions of the Civil War. He died in 1963 and is buried in Glasnevin Cemetery.

Reference: Royal Irish Academy, *Dictionary of Irish Biography*, Vol. 9 (Cambridge University Press, Cambridge 2009), pp. 386–7.

Courtesy of Kilmainham Gaol Museum 17PO IA22 19

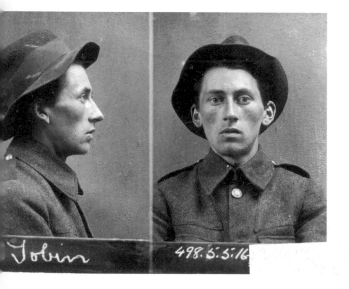

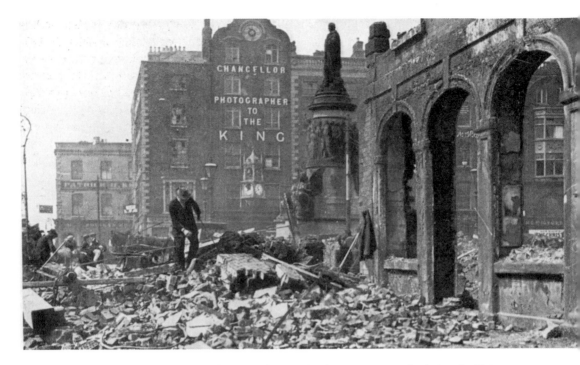

The corner of Bachelor's Walk and Sackville Street showing the destruction wrought during the Rising. The statue of Daniel O'Connell in the centre of the street still bears the bullet holes from the 1916 Rising and fighting during the Civil War in 1922. Note the sign on the building: 'Chancellor – Photographer to the King'.

Reference: Kilmainham Gaol Museum 17PC IB14 10 Booklet, *Sinn Féin Revolt 1916. Twelve Interesting Views* (T. J. Coleman & Co. Publishers, Dublin).

Courtesy of Kilmainham Gaol Museum 17PC IB14 10

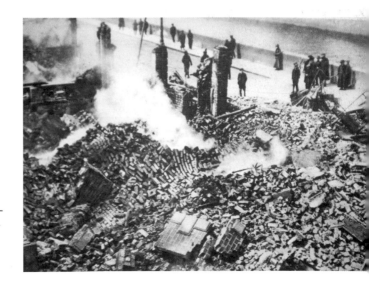

The ruins of a block of buildings on Merchants Quay still smouldering days after the Rising had ended.

Author's Collection

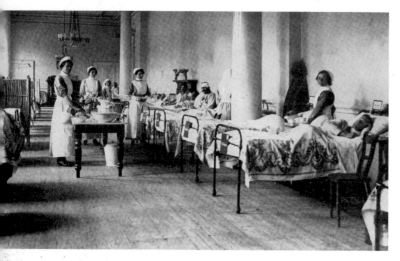

British soldiers wounded during the Rising recuperating in a makeshift hospital ward at Dublin Castle.

Author's Collection

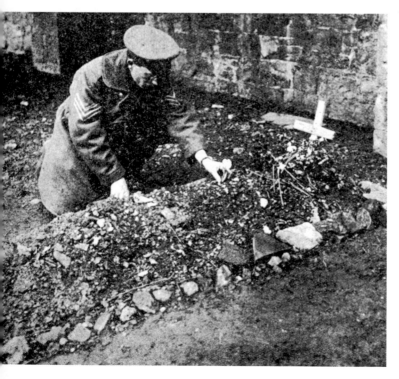

A British soldier tending the grave of Private Arthur Charles Smith who was killed during the Rising. Smith was buried in the grounds of Trinity College. The site of his burial is still marked by a plaque on the Nassau Street side of Trinity College.

Reference: Mick O'Farrell, *50 Things You Didn't Know about 1916* (Mercier Press, Cork 2009).

Courtesy of Mick O'Farrell

General Sir John Grenfell Maxwell (*centre right with papers*). Maxwell oversaw the executions of the leaders of the Rising which made them martyrs and created a groundswell of sympathy for them amongst the Irish people. Maxwell had commanded a British army brigade during the Boer War and was appointed military governor of Pretoria. He was in charge of the British concentration camps established by Lord Kitchener in which thousands of Boer civilians died of disease and starvation. He was knighted for his military services in 1900. Maxwell had previously ordered the execution of several Egyptian rebel leaders at Khartoum in 1898 declaring, 'a dead fanatic is the only one to extend any sympathy to'.

Reference: Lawrence James, *The Rise & Fall of the British Empire* (Abacus, London 1995), p. 283.

Courtesy of Kilmainham Gaol Museum 17PC 1A53 29

Thomas MacDonagh, his wife Muriel (née Gifford) and their son Donagh. Thomas MacDonagh was executed by a British firing squad at Kilmainham Gaol on the same day as Patrick Pearse and Thomas Clarke, 3 May 1916. His wife Muriel died accidentally, just over a year after her husband's death, whilst swimming at Skerries beach.

Courtesy of Kilmainham Gaol Museum 16PO IA25 09

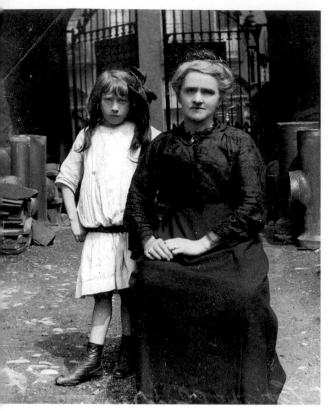

Mrs James Connolly and her daughter, Fiona, *c*. 1916. This photograph was presumably taken after Connolly's execution on 12 May 1916.

Courtesy of Kilmainham Gaol Museum 15PO IA22 11

Below: British Prime Minister Herbert H. Asquith leaves Richmond Barracks, Dublin, with a group of British officers, in late May 1916. Asquith had warned General Maxwell that 'anything like a large number of executions would … sow the seeds of lasting trouble in Ireland.'

Reference: Shane Hegarty and Fintan O'Toole, *The Irish Times Book of the 1916 Rising* (Gill and Macmillan, Dublin 2006), p. 175.

Author's Collection

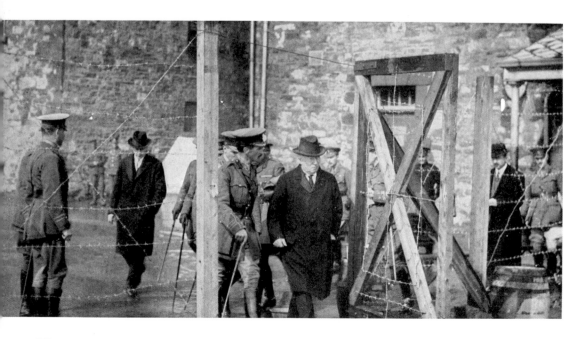

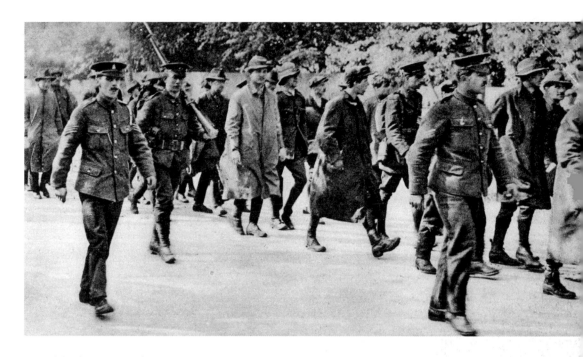

One of the first groups of Republicans being transferred to prisons in Britain. The British, who had been taken completely by surprise by the Rising, acted swiftly, arresting 3,149 men and 77 women throughout Ireland in the aftermath of the rebellion. The majority were interned at Frongoch Prison Camp in Wales or imprisoned in Lewes Prison and Wormwood Scrubs Prison in England.

Author's Collection

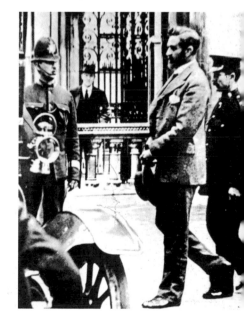

Roger Casement at his trial in London. Casement was tried for treason and sentenced to death. His trial attracted enormous public and media attention, resulting in campaigns for a reprieve. To stifle these and to discredit Casement, the British circulated extracts from diaries detailing homosexual activities which were apparently written by Casement. The authenticity of these diaries has been questioned, but they are widely accepted as being at least partially genuine. Casement was hanged at Pentonville Prison on 3 August 1916. He was the last of the leaders of the 1916 Rising to be executed.

Mercier Archives

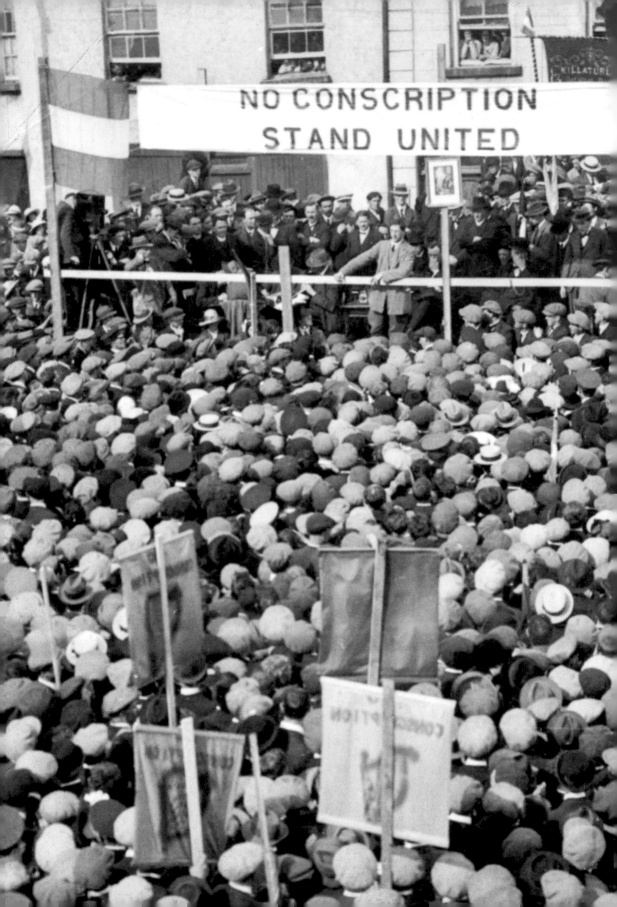

1917-1918

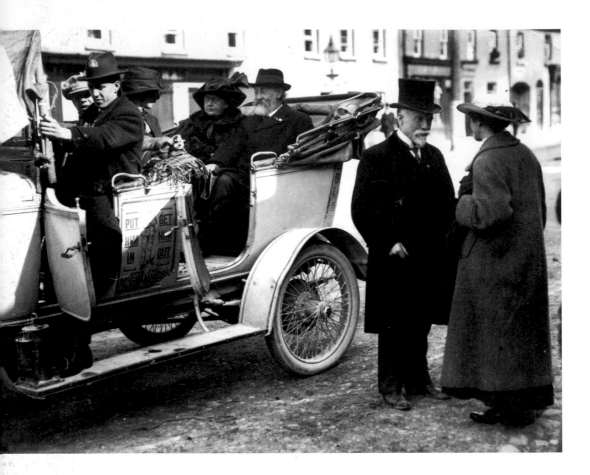

The Longford by-election May 1917. Larry Ginnell, MP (*in top hat*), speaking to Kathleen McGuinness the Republican candidate's wife. Count George Noble Plunkett (*seated in back of car*) was the father of the executed 1916 leader Joseph Plunkett. Count Plunkett was elected MP for North Roscommon in February 1917, defeating the Irish Parliamentary Party's candidate by 3,022 votes to 1,708. Plunkett was the first Republican elected an MP. He followed the Sinn Féin party's abstentionist policy declaring: 'It is in Ireland that the battle for Irish liberty must be fought ... The fight will be made in Ireland and won in Ireland. It will never be won in Westminster.' The Republican candidate for Longford, Joe McGuinness, a veteran of the 1916 Rising, was in prison at the time. Note his election poster on the door of the car showing the image of a convict with the slogan: 'Put him in to get him out'. Interestingly McGuinness was returned as an MP in 1918 and 1921, and was a prisoner on both occasions. The long periods of imprisonment broke McGuinness' health and he died in May 1922.

Reference: Kathleen Hegarty Thorne, *They Put the Flag a-Flyin. The Roscommon Volunteers 1916–1923* (Generation Organization, Oregon 2005), p. 14.

Supporters of Paddy McKenna, the Irish Parliamentary Party's candidate in the South Longford by-election. In an extremely close result McGuinness, the Republican candidate, was victorious, polling 1,498 votes to McKenna's 1,461. Frank Thornton, who was in Lewes Prison with McGuinness when the result was announced, recalled: 'Joe was seized and carried shoulder high around the grounds to the amazement of warders and governor. We retired to one end of the grounds which was near the gardens and held a sing-song there for hours.'

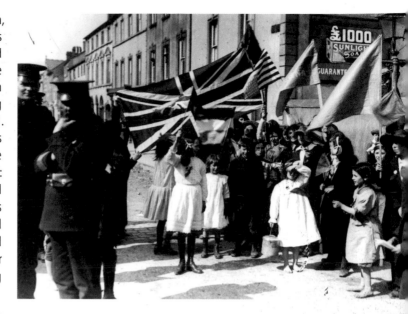

Reference: Frank Thornton, Bureau of Military History WS 510 and 615.

Mercier Archives

Bishop O'Dwyer of Limerick. With the exception of O'Dwyer, the hierarchy of the Catholic Church universally condemned the Rising. General Maxwell wrote to O'Dwyer demanding that he reprimand two of his curates who had been supportive of the Irish Volunteers. O'Dwyer wrote a stinging response to Maxwell which was widely published in the international press. In it O'Dwyer criticised the execution of the Republican leaders on Maxwell's orders. He highlighted the fact that British political pressure had saved Maxwell from imprisonment (and possible execution) for his involvement in the illegal South African 'Jameson Raid' in 1895.

Mercier Archives

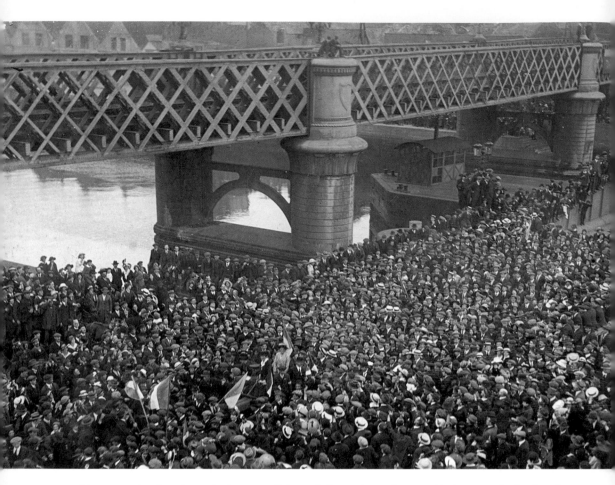

A huge crowd gathered outside the ruins of Liberty Hall to welcome Countess Markievicz and other Republican prisoners on their return to Dublin after their release from British jails, 17 June 1917.

Courtesy of Kilmainham Gaol Museum 18PC IA22 14

Opposite: Republicans who had been tried by British military courts martial in 1916, photographed at the Mansion House, Dublin, in 1917. The men pictured were mostly veterans of the Dublin fighting; the remainder were Republican prisoners from Dundalk, Galway, Waterford and Wexford. Many of those pictured are still sporting their short-cropped prison haircuts. This photograph marks the beginning of the political rise of de Valera who is seated in a central position beside Thomas Ashe (president of the IRB) and Eoin MacNeill (former president of the Irish Volunteers). Suffixes indicate the sentences handed out where recorded: D = Death (commuted), L = life in prison, 10 yrs, etc. = jail term.

1st row (*sitting on ground L to R*): Fionán Lynch, D; John J. Byrne, D; Seamus Doyle, D; John Carrick, 5 yrs; Conor McGinley, 8 yrs; John Tompkins, D; J. J. Walsh, D; Tommy Walsh, D; Seán McDuffy, D; Con Donovan, D; J. F. Cullen, D; Seamus MacLynn, D; Fergus O'Connor, relative of Ashe, not a convict.

2nd row (*kneeling L to R*): Tommy Bevin, D; Mick de Lacy, D; Peter Slattery, D; Con Collins, L; relative of Ashe, not a convict; J. F. Cullen, D; Peadar Clancy, D; Richard Donoghue, D; Thomas Doyle, D; Seán Etchingham, D; Dick Coleman, D; John J. Reid, D.

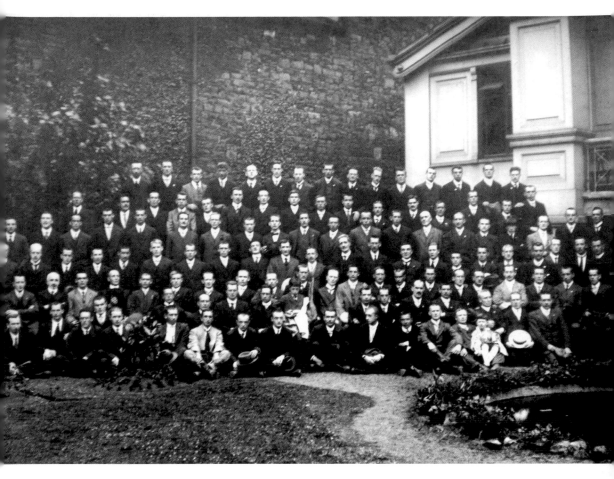

3rd row (*seated on bench L to R*): John Williams, D; P. B. Sweeney, D; J. J. Burke, D; John Quinn, 3 yrs; — Fury; Patrick Flanagan, 5 years; J. J. Brookes, D; — Corcoran; Frank Martin, D; Thomas Ashe, D; Eoin MacNeill, L; Éamon de Valera, D; Tom Hunter, D; Piaras Béaslaí, 5 yrs; — Corcoran; Michael Scully, 10 yrs; John McArdle, 8 yrs; Jack Shouldice, D; Austin Stack, D; John Lawless, D; Gallagher/Doherty, 10 yrs.

4th row (*L to R*): Dennis O'Callaghan, D; Phil Cosgrave, D; Seán MacEntee, D; Frank Thornton Brennan, 20 yrs; — Wilson; Mark O'Hehir, 5 yrs; Colm O'Geary, D; Pádraig Fahy, 10 yrs; — O'Toole; William O'Dea, D; Joe McGuinness, 3 yrs; David Kent, D; Liam Tobin, D; John Darrington, D; — Darrington, D; Charlie Bevin, D; Henry O'Hanrahan, D; James Kiely, D; Dick King, D; Desmond Fitzgerald, 20 yrs; Harry Boland, D; friend of Boland, not a convict.

5th row (*L to R*): Willie Corrigan, 5 yrs; Phil MacMahon, D; Bob Brennan, D; Dick Kiely, D; John Downey; Frank Fahy, 10 yrs; Seamus Hughes, 10 yrs; — Wilson; Maurice Brennan, D; Patrick Keily; Joseph Norton, D; John Clarke, D; Gerald Doyle; Michael Brady; Frank Lawless, D; George Irvine, D; Joseph Morrissey; J. O'Brien; Jack Plunkett, D; Mick Staines; — Kent.

6th row (*L to R*): D. Lynch, D; — Corcoran; Brian Molloy; John Fogarty, D; Christie Carrick, 5 yrs; Tadhg Brennan, 20 yrs; Patrick McNestrey, D; William Meehan, 5 yrs; — Peppard; Michael Mervine, D; George Levins, D; Seamus Rafter, D; James Joyce ICA, D; — Fury; John Falkner; James Loughlin, 5 yrs.

7th row (*L to R*): Richard Davis, 10 yrs; Jack Dempsy, D; Michael Higgins, 5 yrs; Mick Fleming, D; Peter Paul Gilligan, D; Michael Reynolds, 5 yrs; Joseph Burke, 5 yrs; Peadar Doyle, 10 yrs; William Cosgrave, D; William Hussey, 5 yrs; James Brennan, D; Dennis Leahy; James Sully, 10 yrs; — Wilson.

Courtesy of Kilmainham Gaol Museum 18PO IA51 17

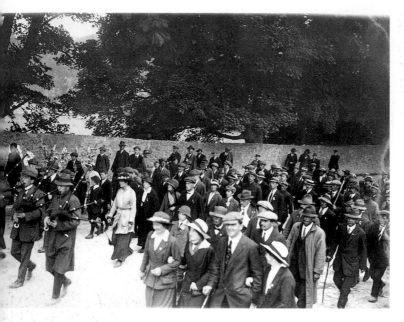

Countess Markievicz (*centre in light jacket*) marching with a Republican pipe band during the East Clare by-election. The Sinn Féin campaign in East Clare was built on de Valera's Republican credentials and his reputation as a 'hero' of the Rising. Leading figures who had taken part in the Dublin fighting came to Clare to support the campaign, including Markievicz, who had been a leader of the Citizen Army at St Stephen's Green, Thomas Ashe, who commanded the Irish Volunteers at the Battle of Ashbourne, and Peadar Clancy, who had been a member of the Four Courts garrison.

Courtesy of Kilmainham Gaol Museum 18PC IA45 02

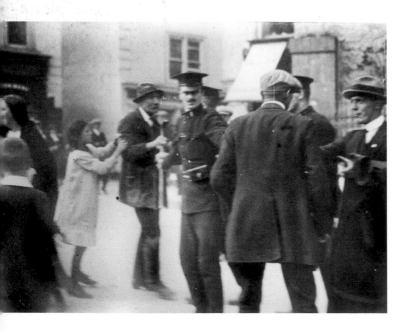

This photograph was apparently taken at Ennis shortly after an RIC baton charge during the East Clare by-election. During the election campaign supporters of the Irish Parliamentary Party, former British soldiers, their families and the RIC frequently attacked Sinn Féin meetings. In one incident de Valera and a group of his supporters came under rifle fire while travelling between Broadford and Tuamgreaney.

Mercier Archives

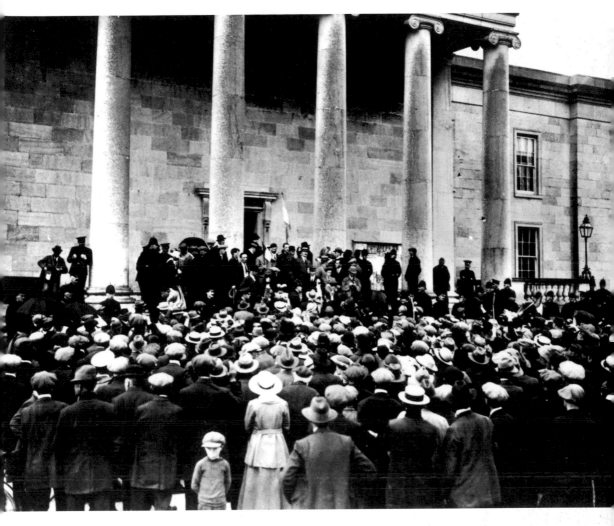

De Valera's election speech at Ennis courthouse, 11 July 1917. De Valera polled 5,010 votes against the Irish Parliamentary Party candidate Lynch's 2,035 votes. The *Daily Telegraph* described the by-election as 'the most important election that has ever taken place, or ever will take place in Irish history'. The fate of the Irish Parliamentary Party seemed sealed as Republican banners began appearing throughout Ireland with the words: 'Irish Party wounded in North Roscommon, killed in South Longford, buried in East Clare. R.I.P.'

References: *Daily Telegraph*, 10 July 1917; Marie Coleman, *County Longford and the Irish Revolution 1910–1923* (Irish Academic Press, Dublin 2006), pp. 66–7.

Mercier Archives

William Cosgrave making a speech after his election as MP in the Kilkenny by-election in August 1917. De Valera is also in the picture, standing two over from Cosgrave on the right.

Courtesy of Irish Military Archives, BMH P11

Thomas Ashe, president of the Irish Republican Brotherhood. Ashe, a native of Kerry, had commanded the Republican forces in north Dublin during the Rising and earned a reputation amongst militant Republicans for his capture of Ashbourne RIC Barracks during the Battle of Ashbourne. Ashe was sentenced to two years hard labour in August 1917 for making a seditious speech and was imprisoned at Mountjoy Jail in Dublin.

Courtesy of Kilmainham Gaol Museum 17PO IA24 04

Thomas Ashe's body lying in state at Dublin City Hall. On 20 September 1917 thirty-eight Republican prisoners at Mountjoy Jail, led by Ashe, began a hunger strike demanding to be treated as prisoners of war. Having been force-fed, Ashe died of heart failure and congestion of the lungs on the fifth day of the hunger strike. Tens of thousands of people queued to pay their respects as his body lay in state in Dublin's City Hall. Fearful of creating more Republican martyrs, the British authorities granted the Republican prisoners' demands.

Courtesy of Kilmainham Gaol Museum

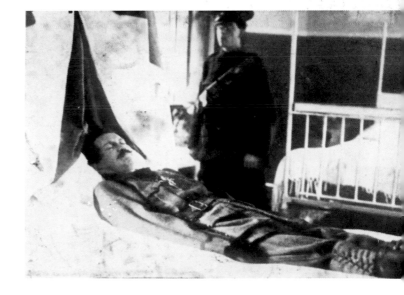

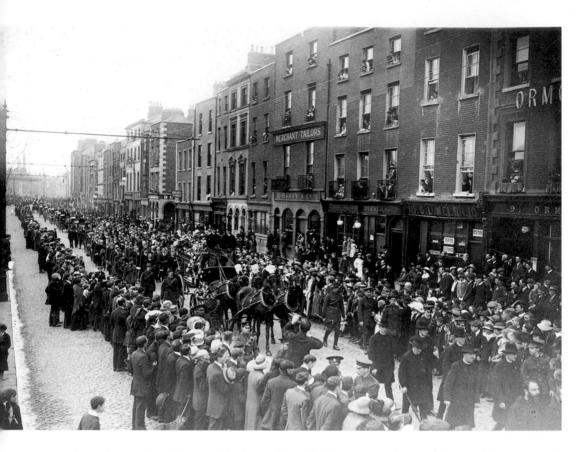

Funeral procession of Thomas Ashe, Ormond Quay, Dublin, 30 September 1917. The Republicans executed after the Rising had been buried secretly by the British in quicklime graves and as a result neither their families nor the Irish people were able to mark their deaths. By contrast, Ashe's funeral became a focus for Republican sentiment – a massive political demonstration. Over 20,000 people attended and a military guard of Irish Volunteers and members of the Irish Citizen Army marching in uniform, fully armed in public defiance of the law, led the cortège.

Courtesy of Kilmainham Gaol Museum 18PC IA45 04

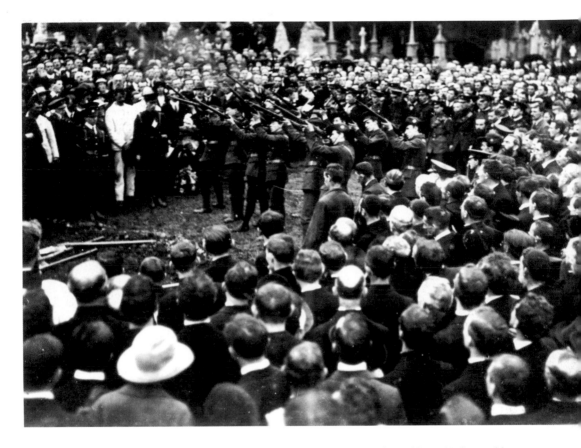

Michael Collins delivered Ashe's funeral oration. He spoke briefly in Irish before adding: 'Nothing additional remains to be said. That volley which we have just heard is the only speech which is proper to make over the grave of a dead Fenian.' The *Daily Mail* of 1 October 1917 stated that Ashe's funeral 'had set the eddy unrest of emotion spinning again in Ireland'.

Mercier Archives

REVOLUTION

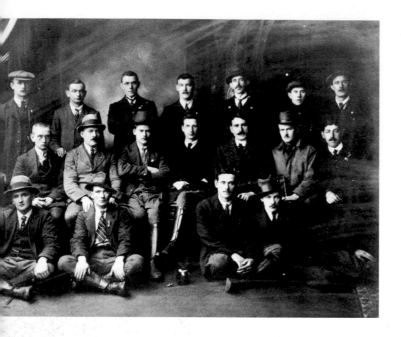

The Clare veterans of the 1917 Mountjoy hunger strike, with their newly elected MP, Éamon de Valera. Seventeen of the thirty-eight Republicans on the hunger strike were from Clare. After their release they marched, with the other released prisoners, to Glasnevin Cemetery, placed a wreath on Ashe's grave and returned to Ennis by train. The political effect of Ashe's death was immediately obvious to William McNamara: 'In Ennis to meet the train that night was a huge crowd to greet us and in that crowd I noticed several people who were our bitter opponents before we were arrested. In my opinion, Thomas Ashe's death on hunger strike did more to help the Sinn Féin cause than anything that had previously happened.'

Reference: William McNamara, Bureau of Military History WS 1135.

Mercier Archives

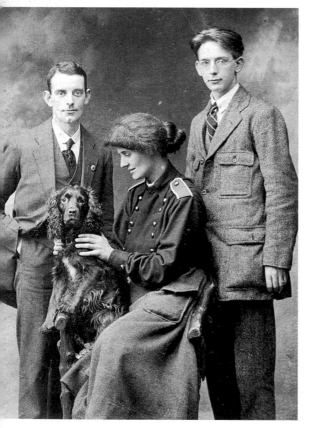

Countess Markievicz, her dog 'Poppett', Theo Fitzgerald and Thomas McDonald, members of Na Fianna Éireann, photographed at Waterford in 1917.

Courtesy of Kilmainham Gaol Museum 18PO IA21 18

De Valera addresses an anti-conscription meeting at Ballaghaderreen, Co. Roscommon, 1918. In April 1918 the British government's plans to enforce conscription in Ireland became a major boost for the Sinn Féin party. It effectively destroyed the Irish Parliamentary Party's stranglehold on Irish politics and the British abandoned their plan to extend conscription to Ireland when it became obvious that militant Republican opposition would have rendered the measure politically and militarily counter-productive.

Courtesy of Joan O'Brien Athlone, and Kathleen Hegarty Thorne, USA

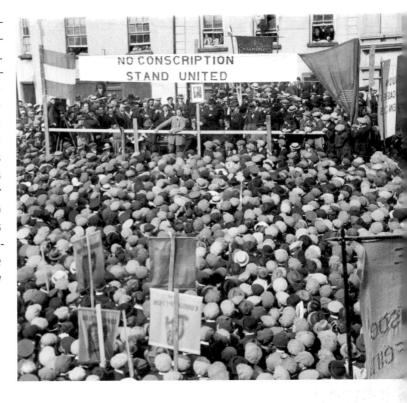

A British army officer searching a civilian who has adopted a defiant stance and expression. Scenes like this became more common throughout Ireland as tensions increased between the Republicans and the British forces.

Courtesy of Kilmainham Gaol Museum 19PC IA46 25

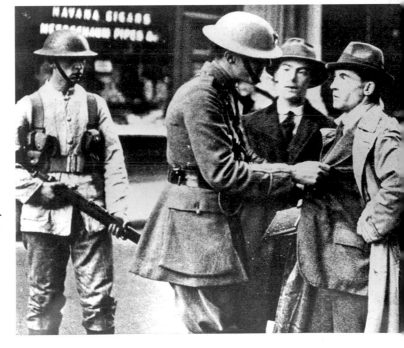

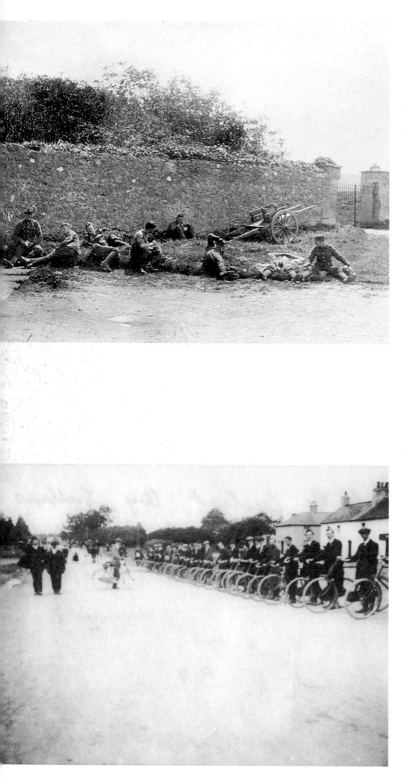

Soldiers from a Scottish regiment enjoying the fine weather at Doolin, Co. Clare, 1918. Despite the increasing unrest and political tensions, Ireland was still a relatively safe posting for British soldiers in 1918. Republican attacks on the British forces were still infrequent and mainly targeted the RIC rather than the British army.

Courtesy of Clare County Library

Irish Volunteers' parade, 23 June 1918, showing the 4th Battalion Cyclist Corps, Sallins Battalion, Kildare Brigade. Despite the political successes of Sinn Féin, the Irish Volunteers continued to prepare for war. Militant Republicans, such as Liam Deasy in Cork, refused to believe that political victories would force the British to grant the Irish people independence: 'From the first by-election in 1917 we were never unduly influenced by election results. Our mission was to continue the Fenian policy, to rouse the country and strive for its freedom. In our generation "the voice of the people" as expressed by the Irish Parliamentary Party at Westminster was a spent force and the people were gradually coming to realise that nationhood would never be won by talk only. It had to be fought for no matter what the cost.'

Reference: Liam Deasy, *Brother against Brother* (Mercier Press, Cork 1988), p. 43.

Courtesy of Irish Military Archives, BMH P9 (Garda Patrick Egan Collection)

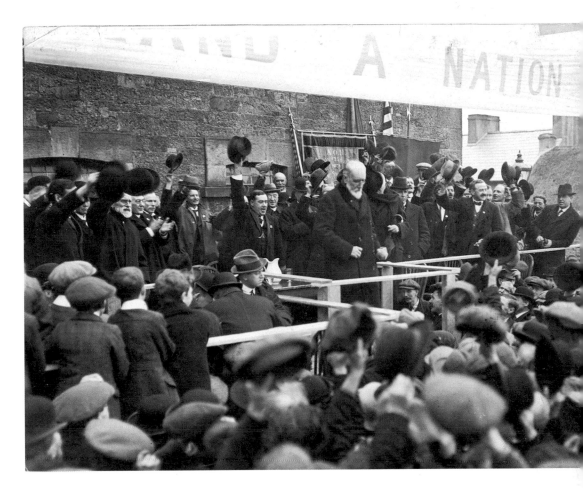

John Dillon (*centre*) presiding over his first public meeting as leader of the Irish Parliamentary Party at Enniskillen in March 1918. Dillon was nearly seventy years of age when he became leader of the ailing party after John Redmond's death. By this time the Irish Parliamentary Party had become increasingly politically impotent and irrelevant. The concept of Home Rule had been surpassed by a desire for a greater level of Irish independence from Britain. The party's tacit acceptance of partition and its support of the British war effort were also unpopular. Facing a possible political wipeout, the party agreed a pre-election pact with Sinn Féin in Ulster, where both parties faced strong Unionist opposition, which helped the Irish Parliamentary Party secure four seats. The Irish Parliamentary Party won just six seats nationwide in the 1918 general election.

Courtesy of Kilmainham Gaol Museum 18PO IA31 02

Thomas Johnson, the leader of the Irish Labour movement, in 1918. The Labour movement reached an agreement with Sinn Féin not to contest the 1918 general election because they had no other realistic option available. Many prominent figures in the Labour and trade union movement in the south, such as Constance Markievicz and Joseph McGrath, were also members of Sinn Féin and had decided to stand for that party, causing a shortage of potential Labour candidates. In the north the Labour movement was worried that too close an association with republicanism would cost them the small foothold they had gained among workers from a Unionist background. Labour's absence meant that Sinn Féin could maximise their gains and present the election as a plebiscite on the question of Irish independence. In return for Labour's compliance, Johnson demanded that Sinn Féin introduce sweeping social and economic reforms to improve the lives of urban workers, 'small farmers' and the poor. These reforms were encapsulated in the Democratic Programme of 1919. However, many of its measures were considered too socialist and radical by the more conservative elements within Sinn Féin and it was never fully implemented.

Courtesy of Kilmainham Gaol Museum 19PC IB51 04

SOLDIERS ARE WE
VES ARE PLEDGE TO

Éamon de Valera addressing a political rally in Ennis. The 1918 general election saw a landslide win for the newly reformed Sinn Féin party, which won 73 of the 105 available seats. Note the militant imagery in the photograph. De Valera is dressed in the Irish Volunteer uniform he had worn during the 1916 Rising and a placard to de Valera's left has the slogan 'Remember Thomas Ashe' and bears a photograph of the dead Republican hunger striker. The banner on the platform is emblazoned with lines from 'The Soldier's Song', the Republican anthem popularised after the Rising, which eventually became the Irish national anthem.

Author's Collection

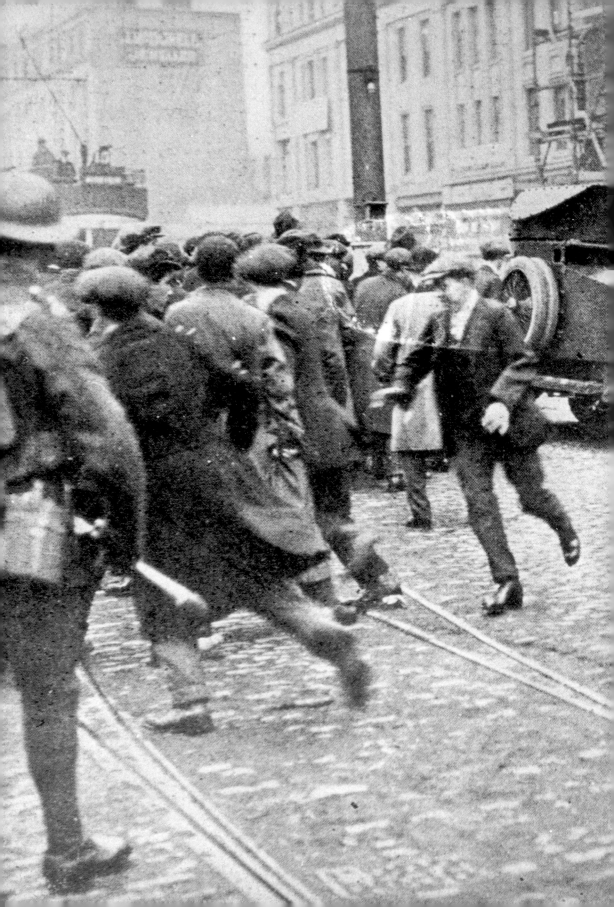

1919-1921

Dáil Éireann in session. During the 1918 election Sinn Féin candidates had promised that, if elected, they would not take their seats in the British parliament and would instead constitute themselves as Dáil Éireann, the parliament of an independent Irish Republic. The first meeting of Dáil Éireann took place at the Mansion House, Dublin, on 21 January 1919. Only twenty-seven of the Sinn Féin MPs were able to attend since the British had imprisoned the others. The first meeting of the Dáil lasted two hours and dealt with three items of business: a declaration of Irish independence was read aloud in Irish, English and French and unanimously adopted; a 'Message to the Free Nations of the World' was issued which appealed for international support for Irish representation to the Paris Peace Conference due to meet a few days later – Seán T. O'Kelly was appointed leader of the Irish delegation to the conference; and finally, the 'Democratic Programme of the Irish Republic', which outlined the rights and freedoms of the Irish people, was ratified and the proceedings ended.

The British authorities had decided not to declare Dáil Éireann an illegal assembly and prevent it meeting by force. The meeting attracted significant interest from the public and the international press. A queue of spectators, journalists and newspaper correspondents attempting to gain admission to the meeting stretched from the Mansion House to Kildare Street.

Mercier Archives

Twenty-seven of the Sinn Féin TDs who attended the first meeting of Dáil Éireann, photographed on the steps of the Mansion House, flanked by two members of Cumann na mBan wearing military uniform.

Courtesy of Irish Military Archives
A/0862 Collins Papers

Michael Collins signing Dáil Éireann-issued Republican Bonds. In April 1920 de Valera announced a scheme to raise £500,000 in funds for Dáil Éireann through the sale of bonds to Republican sympathisers in Ireland and abroad. The scheme was a huge success and eventually raised over £1 million. This photograph is a still from a cinema newsreel made to publicise the bond drive. In a carefully choreographed scene designed to express ideological continuity with previous Republican rebellions, Collins is shown at the steps of Saint Enda's school, established by Patrick Pearse, signing Republican Bonds on the block upon which Robert Emmet, leader of the 1803 rebellion, had been beheaded.

Mercier Archives

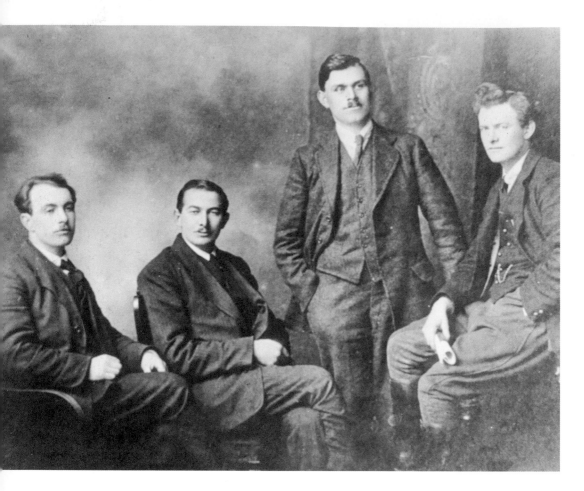

Seamus Robinson, Seán Treacy, Dan Breen and Michael Brennan. Robinson, Treacy, Breen and six other members of the 3rd Tipperary Brigade set up an ambush to capture a consignment of explosives being transported to a quarry at Soloheadbeg. The Republicans waited in ambush positions for five days until the consignment of explosives, escorted by two armed RIC men, arrived at the quarry on 21 January 1919 – the same day that Dáil Éireann held its first meeting. When they reached the gates of the quarry the two RIC constables, James McDonnell and Patrick O'Connell, were called upon to surrender. They reacted by reaching for their rifles and were shot dead by the Republicans. The Soloheadbeg ambush is seen today as the first action of the Irish War of Independence.

The killing of the two RIC constables shocked the public and was widely condemned in the press and by the Catholic Church. Following the attack Monsignor Ryan of St Michael's Church in Tipperary declared: 'God help poor Ireland if she follows this deed of blood. But let us give her the lead in our indignant denunciation of this crime against our Catholic civilisation, against Ireland against Tipperary.' The action also caused division within the independence movement: it was condemned by some of the more moderate elements of Sinn Féin, but defended by hardliners like Michael Collins and Cathal Brugha.

Mercier Archives

Seán T. O'Kelly finds his way barred by a French soldier, having been refused entry to the Paris Peace Conference in 1919. Many members of Sinn Féin had hoped that the conference would examine the Irish people's claim to full independence from Britain. However, Irish participation in the talks was vetoed by the British representatives and was also opposed by Woodrow Wilson, the American president. Wilson was a noted Anglophile, unsympathetic to the idea of Irish independence. He was unwilling to do anything to upset his wartime British allies, despite the domestic political pressure mounting on him from Irish-American organisations in the United States.

Courtesy of Kilmainham Gaol Museum 19PC IA46 10

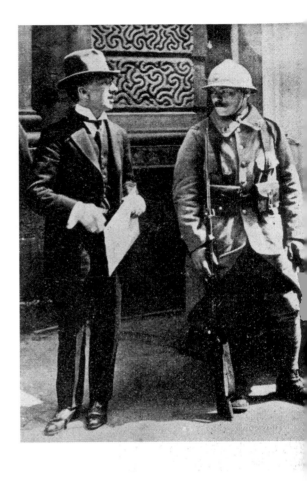

Seán Hogan, who was rescued from RIC custody at Knocklong Railway Station on 13 May 1919. Hogan had been in hiding with Dan Breen, Seamus Robinson and Seán Treacy since they killed the two RIC constables at Soloheadbeg. Hogan was arrested by an RIC search party at Annfield, near Thurles, on 12 May. The following day he was being taken to Cork for trial when an IRA rescue party boarded the train at Knocklong. A bloody, close-quarters battle ensued within the confines of the railway carriage when the IRA confronted the RIC party escorting Hogan. Two members of the RIC, Sergeant Peter Wallace and Constable Michael Enright, were killed and Dan Breen was seriously wounded. During the fighting Hogan escaped. After Hogan's rescue 'the Big Four', as Robinson, Treacy, Breen and Hogan subsequently became known, were constantly on the move through Limerick, Kerry and Clare in an effort to keep one step ahead of their RIC pursuers.

Mercier Archives

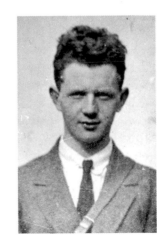

The following four photographs and descriptions are from the notebook of Lieutenant J. B. Jarvis, intelligence officer of the Oxford and Buckinghamshire Light Infantry, who was stationed in Limerick city during the War of Independence.

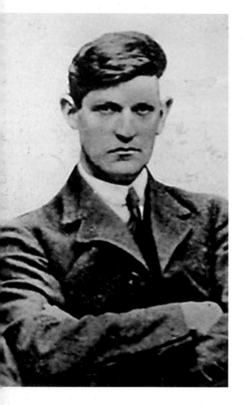

The Neil Jordan film *Michael Collins* has created the false impression that Collins evaded capture because the British had no photographs of him. However, copies of this photograph of Collins were widely circulated amongst British officers and it was published in the RIC magazine *The Police Gazette*. The following is an extract from Jarvis' information about Collins: 'Woodfield, Rosscarbery, Co. Cork W.R. [West Riding] COLLINS Michael, M.P. for Co. Cork. Age in 1920 30 [years]. Commander-in-chief IRA Adjutant General and Chief of IRA is a member of Dáil Éireann having been elected for South Cork, and is responsible for the administration of its finances under the title of Rionn Airgead, or Minister of Finance he shows a definite link between An Dáil and the Murder Gang.'

Reference: J. B. Jarvis Papers, Oxford & Buckinghamshire Light Infantry.

Courtesy of Oxford & Buckinghamshire Light Infantry – Soldiers of Oxfordshire Trust

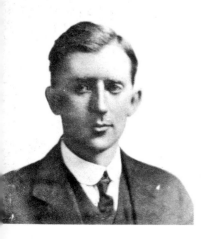

'MULCAHY Richard. Chief of Staff IRA MP for Dublin City. Age 33. Walks with a stooping gait. Participated in 1916 rebellion: volunteer chief of staff 21st Jan 1920.'

Reference: J. B. Jarvis Papers, Oxford & Buckinghamshire Light Infantry.

Courtesy of Oxford & Buckinghamshire Light Infantry – Soldiers of Oxfordshire Trust

'BREEN Daniel, Tipperary. S.F. Stormtrooper. Attacked our men at Oola, killing L/Cpl. Parker and Pte. Bayliss. Commandant, South Tipperary 3rd Brigade. Manufacture of bombs. Shot two constables conveying gelignite first police murder. – Constables Mac Donnell & O Connell murders Seamus Robinson, John Treacy & John Hogan – Shot Major Smith at Drumcondra. Led the Glencurran Wood ambush successfully. Description: Native of Soloheadbeg. Mothers name Moore. Height 5' 8", thick set, bull neck, sulky appearance. Looks like a blacksmith coming from a forge. Employed as a linesman on G.S. & W. railway. At Knocklong 13 May 1919.'

Reference: J. B. Jarvis Papers, Oxford & Buckinghamshire Light Infantry.

Courtesy of Oxford & Buckinghamshire Light Infantry – Soldiers of Oxfordshire Trust

'BRENNAN Michael Commandant East Clare Brigade. Meelick farm (destroyed). Stops in different friends houses, but local young men are commandeered to go on guard while he is sleeping. Supposed to have been wounded at SCARIFF.
'Description: well made, muscular, brown hair, brown eyes, good looking, full face, height 5' 8½". Present at the Broadford, O'Briensbridge and Feackle ambushes. Sometimes lodges at Hogan's house in Bodyke on Tuamgreany Road. Believed to have gone to Dublin after Feackle murder.'

Reference: J. B. Jarvis Papers, Oxford & Buckinghamshire Light Infantry.

Courtesy of Oxford & Buckinghamshire Light Infantry – Soldiers of Oxfordshire Trust

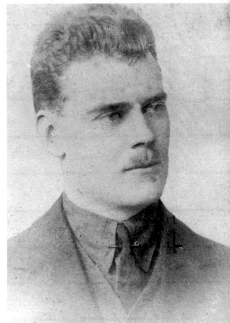

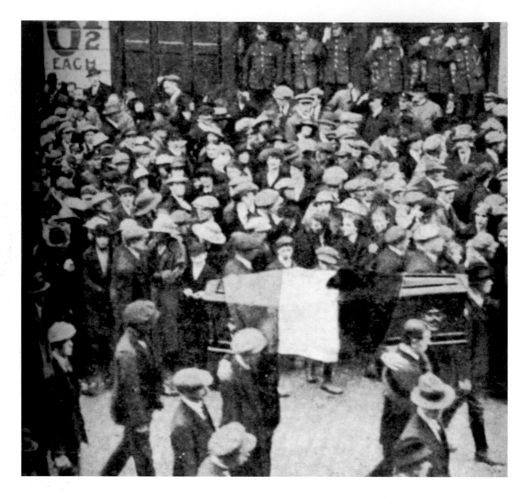

Funeral of Robert Byrnes, adjutant of the 2nd Battalion, Mid Limerick Brigade, IRA, 10 April 1921. Note the British soldiers in the background saluting as Byrnes' coffin passes them.

Byrnes had been serving a one-year sentence in Limerick Prison for possession of a revolver when he began a hunger strike. Having refused food for three weeks, he was removed to a hospital and kept under constant police guard. One RIC man was killed and Byrnes was fatally wounded during an IRA attempt to rescue him. The day after Byrnes' funeral, the British declared martial law in Limerick and decreed that anyone entering the city would need a special permit authorised by the RIC. The ^llrish Transport and General Workers' Union and Sinn Féin immediately called a strike in protest. The strike lasted two weeks, involved over 15,000 workers and was dubbed the 'Limerick Soviet'. Harsh working conditions, the encouragement of Socialists and sympathetic Republicans, and the example provided by Bolshevik Russia influenced dozens of other experimental soviets in Irish towns over the next few years including Bruree, Broadford, Cork and Waterford.

Mercier Archives

Detectives of G Division of the DMP, July 1919, in conversation with a British officer. None of those pictured appears to be aware they were being photographed. 'The Squad', an elite IRA unit directed by Michael Collins, Liam Tobin and Frank Thornton, used photographs such as this to assassinate leading members of the British forces. Detective Dan Hoey (*tallest man at back*) was shot outside police headquarters in Brunswick Street, Dublin, on 13 September 1919. Detective Sergeant Smith (*centre, facing camera*) was shot outside his house in Drumcondra on 30 July 1919.

Mercier Archives

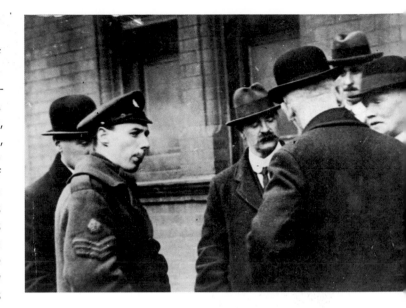

Right: Members of 'The Squad'. *L to R*: Michael McDonnell, Tom Keogh, Vincent Byrne, Paddy O'Daly and James Slattery.

Mercier Archives

Overleaf: Armistice Day parade, Dublin, November 1919, passing the Bank of Ireland, College Green.

Mercier Archives

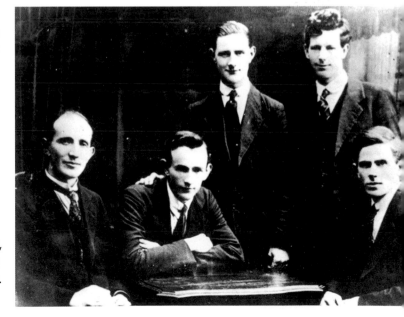

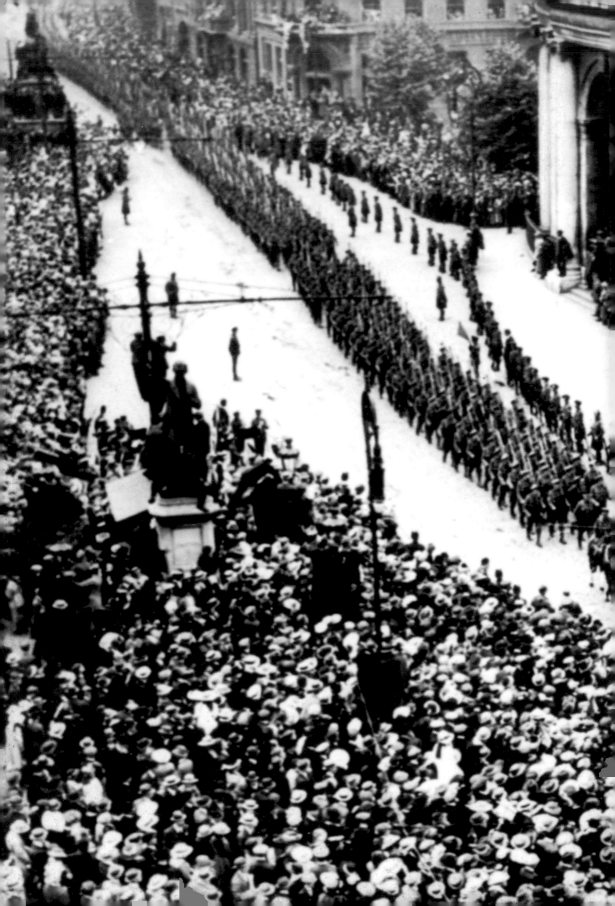

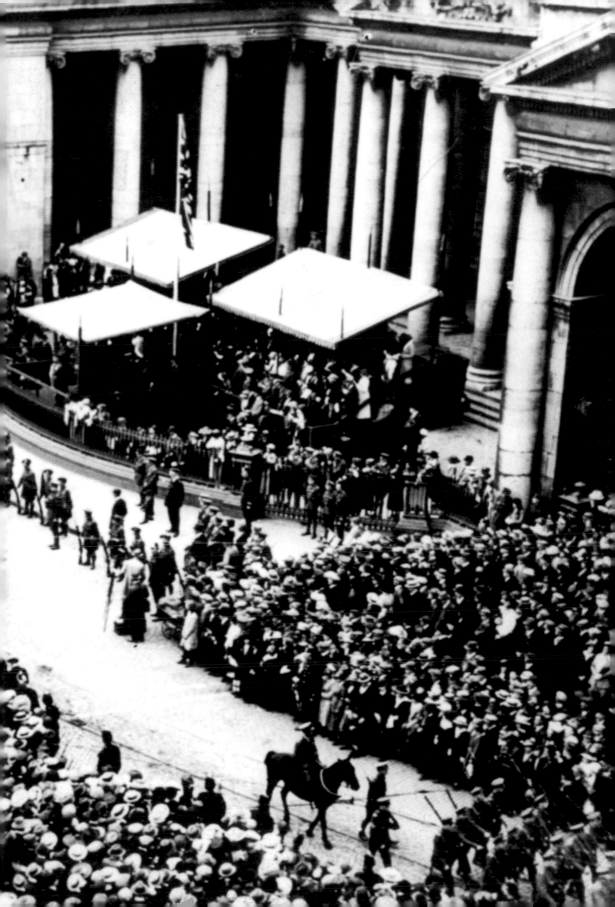

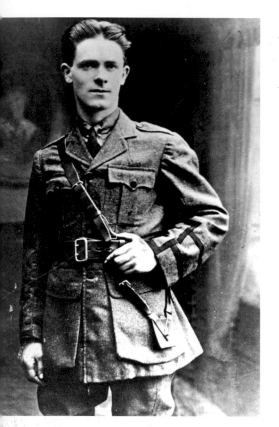

Lieutenant Martin Savage from Ballisodare, Co. Sligo. On 19 December 1919 the IRA attempted to assassinate Field Marshal Sir John French, Lord Lieutenant of Ireland. Eight members of 'The Squad', accompanied by Dan Breen, Seán Treacy, Seamus Robinson and Seán Hogan, attacked French's motorcade at Ashtown Cross, Dublin, as he returned to his residence in the Phoenix Park. One member of French's escort and Martin Savage were killed during the attack. French, who was travelling in the first car, had a narrow escape – the IRA had concentrated their fire on the second vehicle in the motorcade in the mistaken belief that French was travelling inside it.

Mercier Archives

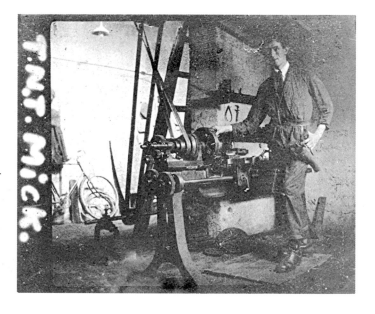

'TNT Mick' – an IRA engineer making grenade components on a lathe during the War of Independence period, photographed by Joseph Cripps.

Courtesy of Kilmainham Gaol Museum KMGLM 2011.0205

The MacCurtain family home, taken shortly after the killing of Mayor of Cork, Tomás MacCurtain, on 20 March 1920. MacCurtain was shot dead in the last room on the left of the top floor. Although MacCurtain's assassination is often attributed to English members of the Black and Tans, it was actually carried out by Irish members of the RIC. The British authorities attempted to point the finger of blame at the IRA, claiming that MacCurtain's death was the result of a Republican feud.

Courtesy of Kilmainham Gaol Museum 19PC IK43 23

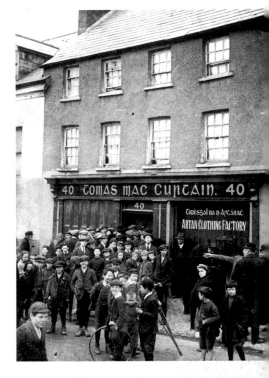

Below: A scene from the funeral of Tomás MacCurtain.

Mercier Archives

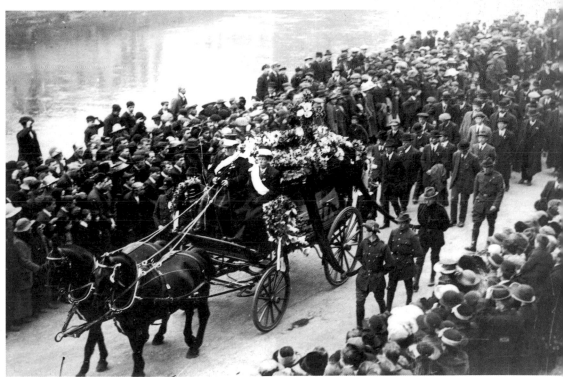

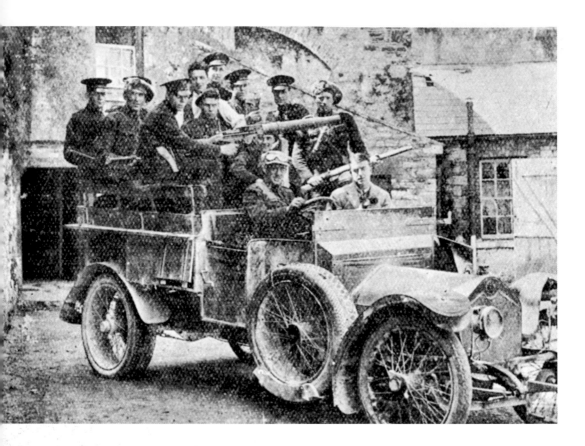

Black and Tans and RIC Auxiliaries photographed at Dungarvan RIC Barracks, Co. Waterford. The British government faced a crisis in Ireland as the RIC experienced a flood of resignations from constables suffering from social boycott and Republican intimidation, or who had Republican sympathies. Between January 1920 and the force's disbandment in 1922, 3,700 men were recruited to the RIC. The majority of these were unemployed ex-soldiers from Britain and the British colonies, although a minority of Irishmen also joined. The recruits were not subject to the RIC's physical regulations and many were too short to fit the existing stock of uniforms, so the RIC was unable to equip these new recruits with dark green RIC uniforms. The boycott of the RIC meant that many tailors refused to make new uniforms so the new members supplemented their dress with khaki or tan-coloured British army uniforms. This peculiar costume earned them the nickname 'Black and Tans' after a famous pack of hunting dogs from Limerick. In May 1920 the British government began recruiting ex-British army officers for the Auxiliary Division of the RIC, better known as 'the Auxiliaries' or 'the Auxies', who were attired similarly to the Black and Tans.

Courtesy of Waterford County Museum, Dungarvan

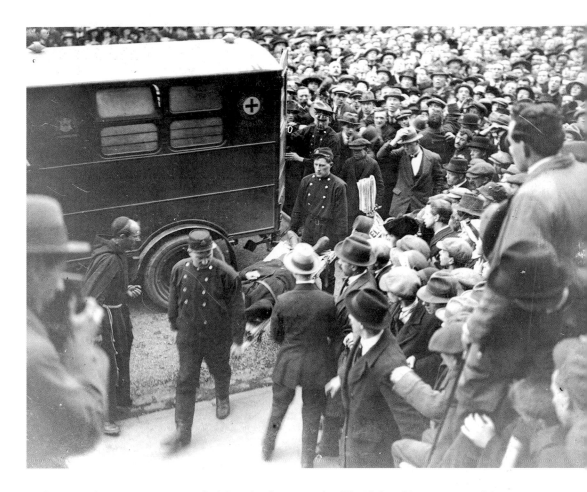

As the IRA's military campaign intensified, British jails continued to fill with Republican prisoners. Prison protests and hunger strikes became commonplace as Republican prisoners demanded to be treated as prisoners of war rather than common criminals. On 7 April 1920 one hundred Republican prisoners in Mountjoy Jail, led by Peadar Clancy, a veteran of the 1916 Rising, went on hunger strike. Sir Hamar Greenwood, the British chief secretary in Ireland, said the hunger strikers would be allowed to starve and their demands would not be met under any circumstances. Just hours after the deputy prime minister had told the House of Commons and the world's media that the British government would never yield to the hunger strikers, their demands were granted. However, Clancy raised the stakes by demanding that the hunger strikers be released from prison immediately. Fearful of creating another martyr like Thomas Ashe, the British government released the prisoners at Mountjoy on the eighth day of their hunger strike.

Courtesy of Kilmainham Gaol Museum 19PC IB51 03

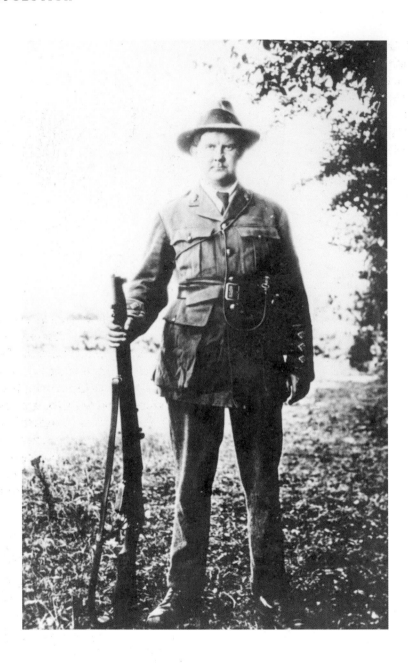

Lieutenant Seán Cooney, Clonmel, engineering officer with the 5th Battalion, 3rd Tipperary Brigade, IRA, photographed during the War of Independence. Interestingly, Cooney is wearing a British army officer's tunic which has regimental insignia on the collar. The IRA were hampered by the shortage of uniforms and equipment during the war and often used captured British uniforms and equipment which they altered to suit their own needs.

Mercier Archives

The ruins of an RIC barracks destroyed by the IRA and daubed with Republican slogans. As IRA attacks on rural RIC barracks became more frequent, the British decided to abandon the majority of these outposts in an attempt to consolidate the RIC's strength in larger, more modern barracks located in cities and towns, as they were easier to defend. This decision was very costly for the British as it in effect surrendered large sections of the Irish countryside to the IRA. In April 1920 IRA headquarters issued orders that all abandoned RIC barracks were to be burned as a Republican show of strength to commemorate the fourth anniversary of the 1916 Rising. Almost 300 former RIC barracks and fifty courthouses were burned by the IRA in the spring of 1920.

Mercier Archives

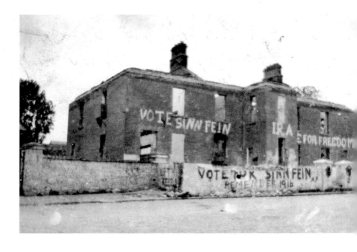

A Dáil Éireann court in session in Westport Town Hall, Co. Mayo, 1920. The Republican-imposed boycott of the British court system caused a legal vacuum in areas under Republican control. Republican sympathisers in the west of Ireland agreed to have legal disputes settled by respected local figures, including teachers, doctors, priests and elderly community leaders. This practice soon spread and in June 1920 Dáil Éireann issued a decree establishing the 'Dáil courts'. These gradually came to replace the crown courts and became popular with the Irish populace, regardless of their political sympathies. By July 1921 there were over 900 parish courts and seventy district courts in operation throughout Ireland.

Courtesy of Kilmainham Gaol Museum 19PC IA46 05

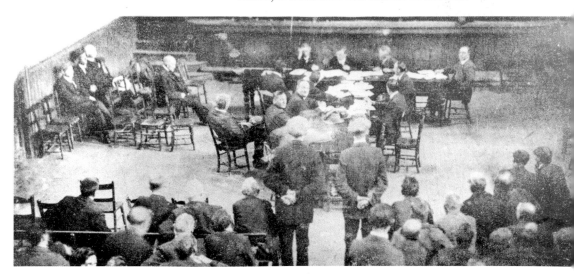

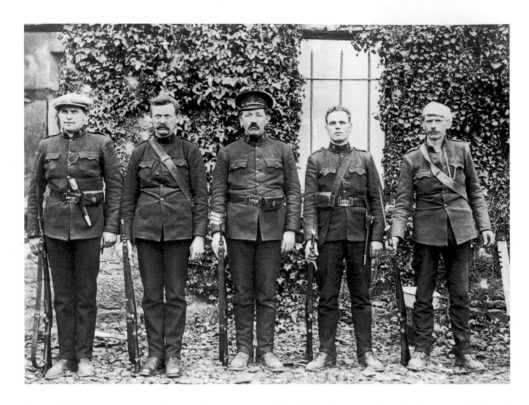

Some of the surviving members of the garrison at Kilmallock RIC Barracks, which was attacked and destroyed by the IRA on 28 May 1920. *L to R*: Constable Hall, Constable Holmes, Sergeant Tobias O'Sullivan, Constable Bailey and Constable Barry. The RIC garrison inside the barracks maintained a dogged resistance during the attack, which lasted for several hours, and refused to surrender even after the barracks was being consumed by fire. Two members of the RIC, Sergeant Thomas Keane and Constable Joseph Morton, and one member of the IRA, Liam Scully, were killed during the attack. Sergeant O'Sullivan was later shot dead by Captain Con Brosnan of the IRA at Church Street, Listowel, in January 1921.

Reference: Thomas Toomey, *The War of Independence in Limerick 1912–1921* (Limerick 2010), pp. 339–42.

The evacuation of Fenit RIC Barracks, which was destroyed in an IRA attack in June 1920. Imitating the tactics employed by the IRA at Kilmallock, the IRA's North Kerry Brigade climbed on top of the building during the attack and smashed their way through its slate roof. The barracks was then set on fire by pouring petrol and paraffin through the holes in the roof. Whilst the attack was in progress, a Royal Navy gunship stationed in Fenit Bay fired a shell in an attempt to frighten off the IRA, but it exploded harmlessly on Ballyheigue Strand. When it failed, the Royal Navy sent reinforcements ashore and forced the IRA to retreat. Whilst the IRA failed to compel the RIC garrison to surrender, which would have resulted in the capture of valuable weaponry and ammunition, their success in destroying the building was an important victory for IRA morale and propaganda.

Mercier Archives

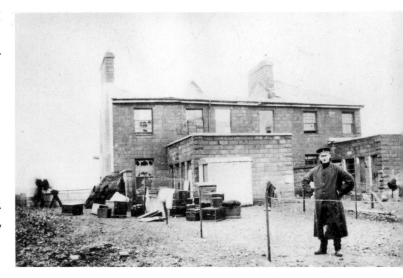

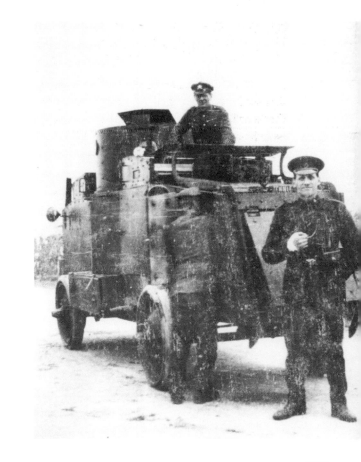

Constable Sullivan (*right*) posing in front of a Peerless armoured car, June 1920. Constable Sullivan was wounded in the hand during the attack on Fenit RIC Barracks.

Mercier Archives

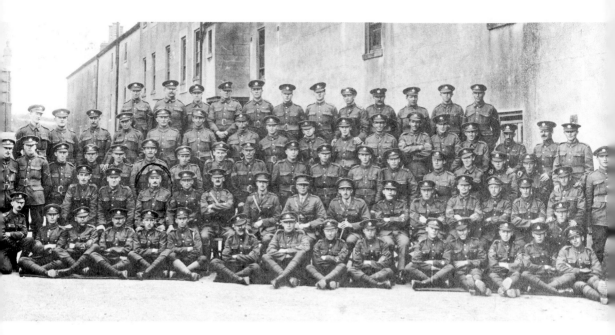

Members of the Essex Regiment photographed at Kinsale Barracks. The Essex Regiment were posted to Cork in August 1919 and were stationed there until their transfer to Belfast in February 1922. At least thirteen members of the regiment were killed in Cork during the War of Independence – one of the highest casualty rates for any British regiment in Ireland during the conflict.

Courtesy of Essex Regiment Museum, Chelmsford

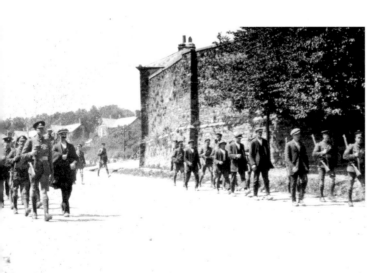

British soldiers from the Essex Regiment marching suspected Republicans to Bandon military barracks for interrogation following the killing of Sergeant William Mulherin. Mulherin, an RIC detective sergeant from Mayo, had been very successful in gathering intelligence about the activities of the IRA in West Cork and was a prime target for assassination. He had survived an attempt on his life in March 1920, but was shot dead by two members of the IRA when he arrived at St Patrick's Church, Bandon, for 8 a.m. Mass on 25 July 1920.

Mercier Archives

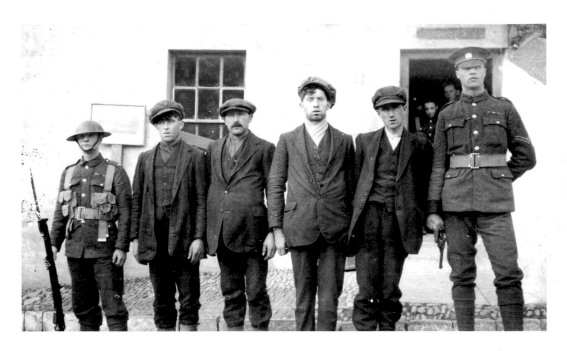

Suspected members of the IRA inside Bandon military barracks, photographed for identification purposes by British army intelligence officers. The suspects in the photograph above have been positioned between the shortest and tallest British soldiers present so that their height can be gauged from the photograph.

Mercier Archives

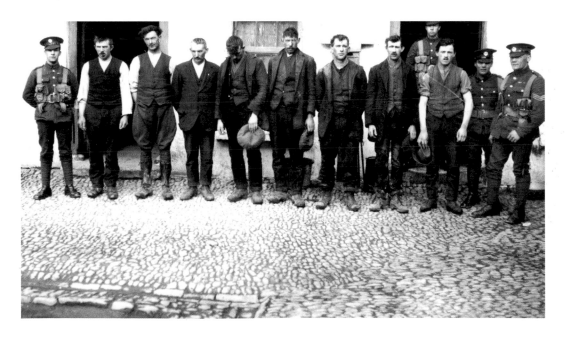

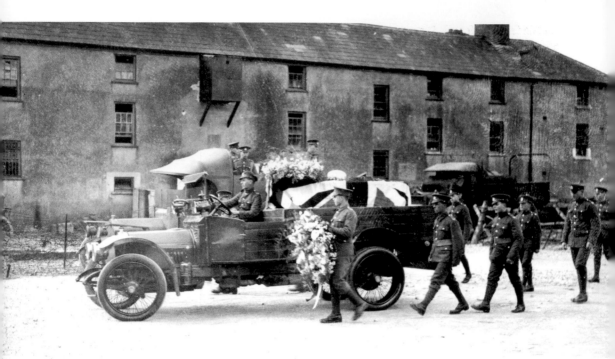

The funeral cortège of Lance Corporal Maddox leaving Bandon Barracks in July 1920. Major Percival, the Essex Regiment's intelligence officer, led a raid on the home of a suspected member of the IRA on 27 July 1920 following the shooting of Sergeant Mulherin, and Maddox was killed: 'I took a picked man and proceeded to the house of a local IRA leader, which was situated only about 500 yards from our barracks, with a view to watching it; on entering the garden a shot rang out and the man with me fell dead. Shot through the head by a fellow armed with a shotgun loaded with slugs; we had walked on to the top of an IRA piquet which was protecting the house.'

When the Essex Regiment heard of Lance Corporal Maddox's death, members of the regiment ran amok in Bandon attacking commercial properties and attempting to set fire to two businesses in Watergate Street. They used trench tools to attack passing civilians, including a number of former British soldiers who lived in the town and a local Justice of the Peace, Mr Burke.

Reference: Arthur E. Percival in William Sheehan's, *British Voices from the Irish War of Independence 1918–1921* (Collins Press, Cork 2005), pp. 113–14.

Mercier Archives

Captain Campbell Joseph O'Connor Kelly, intelligence officer for the British 6th Division in Ireland. Although the torture of Hales and Harte (*see next page*) is often attributed to the English officers from the Essex Regiment who were involved (namely Major Percival and Lieutenant Hotblack), it was in fact led by Captain Kelly, an Irish Catholic. Kelly, an officer with the Royal Garrison Artillery, was born in Ballyhaunis, Co. Mayo and later lived in Kildysart, Co. Clare. During the War of Independence he was stationed in Victoria Barracks in Cork and directed intelligence operations in that county. The IRA made several unsuccessful attempts to assassinate him during the War of Independence. He was promoted to the rank of major and awarded an OBE for his intelligence work in Ireland. This photograph was taken from Frank Thornton's intelligence dossier and was used by the IRA for identification purposes in their attempts to assassinate Kelly.

Courtesy of Irish Military Archives CD 227/35

CAPT. KELLY

IRA Volunteers Jack O'Connell from Derrygallon, Kanturk, Cork, and Patrick Clancy (*seated*) from Limerick, both of whom were captured and killed at O'Connell's house by members of the Machine Gun Corps on 17 August 1920. Medical evidence given at their inquest suggested that O'Connell died having been shot in the head with a 'dum-dum' or expanding bullet (illegal under the Hague Convention which governed the rules of war). Clancy died from a bayonet wound to his back.

Reference: Thomas Toomey, *The War of Independence in Limerick 1912–1921* (Limerick 2010), p. 418.

Courtesy of Kilmainham Gaol Museum 19PC IB51 03

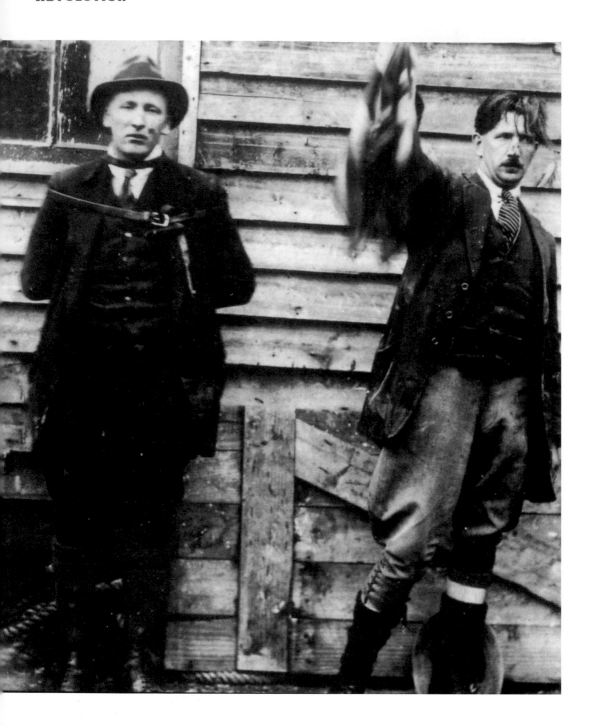

Commandant Tom Hales (*left*) and Brigade Quartermaster Pat Harte (*right*) of the IRA's 3rd West Cork Brigade photographed during their interrogation by members of the Essex Regiment and British army intelligence officers at Bandon Barracks. They were captured by the British near Bandon on 27 July 1920, stripped naked, placed on an improvised explosive mine and threatened with being blown up. Following this they were taken to Bandon Barracks where they were beaten, caned, whipped and threatened with summary execution before having their fingernails crushed with pliers. Both men refused to give their interrogators any information. During the interrogation, Harte was tortured so badly that he lost his sanity and spent the rest of his life in a lunatic asylum. Hales made an affidavit to the American Commission on Conditions in Ireland describing what was happening when this photograph was taken:

> We were still tied with our hands behind our backs, and the soldiers hit us with their fists. My sight was getting very dim owing to the blood I was losing, and I felt very weak. [Captain] Kelly paced out twelve to fifteen paces from us, and then put five or six men with rifles at the end of the fifteen paces. Harte was then very weak and could hardly see. He stuck a flag into Harte's hand, and made him hold his hand up. I recognised that the flag Harte was holding up was the Union Jack, but Harte himself was too far gone to recognise it. A man came up with a camera and then took a snapshot. Kelly then said we must get some information first before we shoot them. We were then taken across the Barracks' yard into a room in the Barracks. The soldiers were furious at not being allowed to shoot us, and they punched and pummelled us the whole way across the yard.

When Hales' sister Madge visited him in Dartmoor Prison six months later she found he was still suffering from the physical effects of his interrogation: 'his mouth is destroyed ... He cannot speak as his tongue catches in the broken teeth.'

References: Affidavit of Thomas Hales to the American Commission on Conditions in Ireland 1920; Madge Hales to Donal Hales 25 Feb. 1921 (Hales Papers) quoted in Peter Hart, *The IRA & Its Enemies: Violence and Community in Cork 1916–1923* (Oxford University Press, Oxford 1998), p. 196.

Imperial War Museum

Overleaf: Church Street, Dublin, photographed at noon on 20 September 1920 shortly after the arrest of Kevin Barry. A short time earlier, the IRA surprised a group of British soldiers who were collecting a consignment of bread from Monks Bakery. The Republicans had hoped to disarm the British soldiers without a fight, but one of them resisted. A firefight ensued which resulted in the deaths of three British soldiers. Barry's gun had jammed during the shoot-out and he hid under the British army lorry when his comrades retreated. He was arrested, court-martialled and sentenced to death. Despite a public campaign and several high-profile pleas for leniency, Barry was executed at Mountjoy Jail on 1 November 1920, the first of twenty-four members of the IRA to be officially executed by the British during the War of Independence. Barry was eighteen years old when he was executed. His youth ensured his posthumous fame as a Republican martyr, still celebrated in Republican ballads.

© RTÉ Stills Library

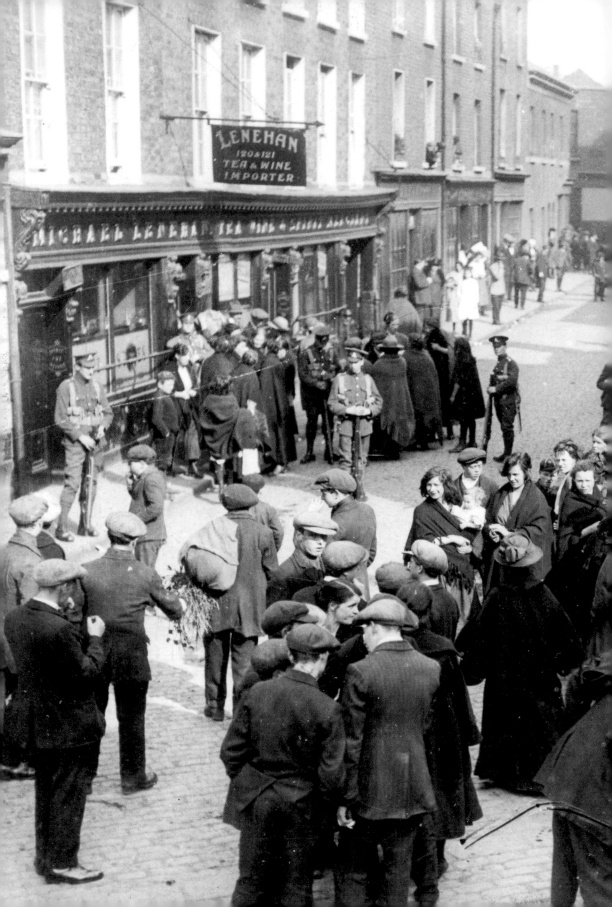

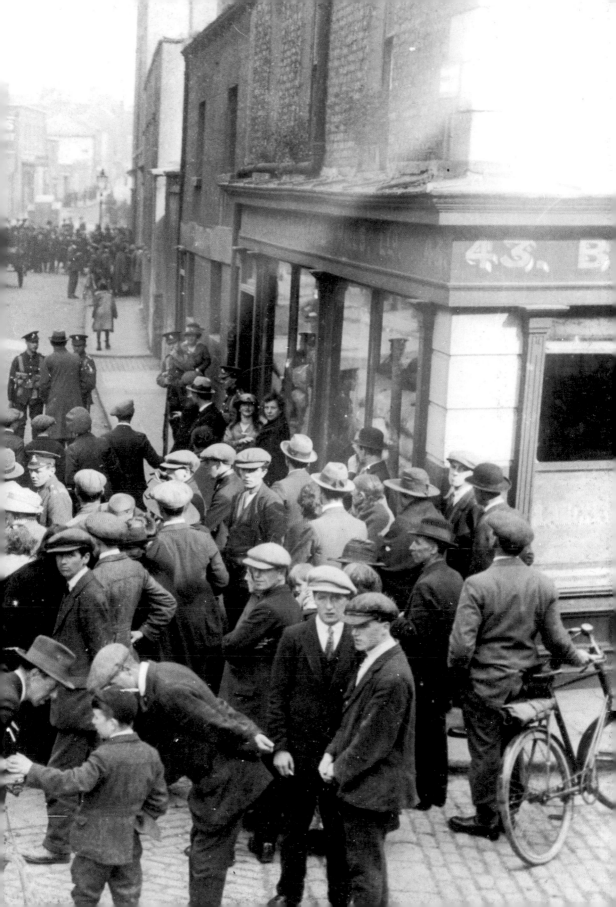

HIS EXCELLENCY THE VICEROYS INSPECTION OCT 7 1920

'Depot Company' of the RIC Auxiliary Division at their headquarters in Beggars Bush Barracks after inspection by the viceroy on 7 October 1920.

Courtesy of Kilmainham Gaol Museum 19PO IA32 14, restored by Robert McDonough, Alexandria, Virginia, USA

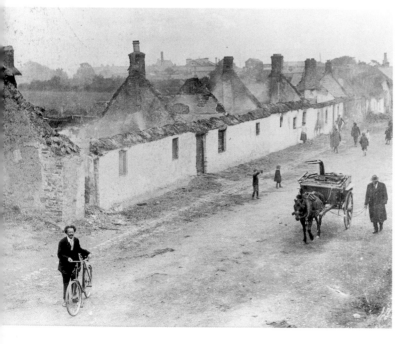

'The sack of Balbriggan'. On 20 September 1920 RIC Auxiliaries and Black and Tans went on a rampage in the town of Balbriggan following the shooting of RIC Head Constable Peter Burke. They burned down four pubs, a factory and nineteen houses, causing £160,000 worth of damage. The same night the RIC arrested two members of the IRA, James Lawless and Jim Gibbons, who were taken from Balbriggan RIC Barracks, bayoneted and shot dead.

Courtesy of Kilmainham Gaol Museum 19PC IA46 25

British soldiers removing the body of Seán Treacy after he was killed in Talbot Street, Dublin, on 14 October 1920. Treacy had taken part in the Soloheadbeg ambush, the rescue of Seán Hogan and the attempt to assassinate Lord French. During his time in Dublin he had several narrow escapes, including one famous incident at 'Fernside', Drumcondra, a short time earlier, when he and Dan Breen had fought their way out of a house they had been tracked to by British forces. Treacy was killed during a shoot-out with two British intelligence officers during a raid on Peadar Clancy's shop, where a meeting of the IRA's Dublin Brigade was taking place.

Mercier Archives

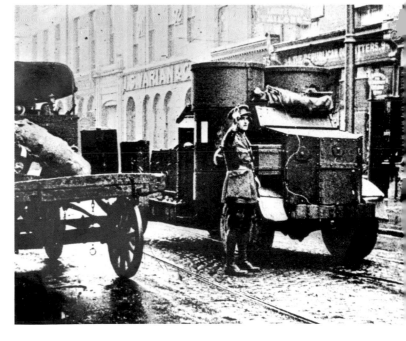

A British army officer directing his troops in the wake of the Talbot Street raid. In addition to Treacy, two British intelligence officers, Lieutenant Price and Lieutenant Christian, and two civilians, Joseph Corringham and Patrick Carroll, were killed during the shoot-out.

Mercier Archives

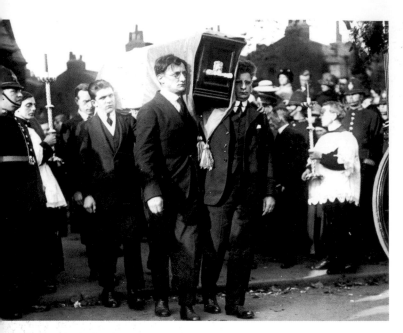

Terence MacSwiney's brothers, Peter and John, carrying his coffin from Southwark Cathedral, London, to a waiting hearse, October 1920. Terence MacSwiney, the lord mayor of Cork, died in Brixton Prison, London, on 25 October 1920 after seventy-four days on hunger strike.

Mercier Archives

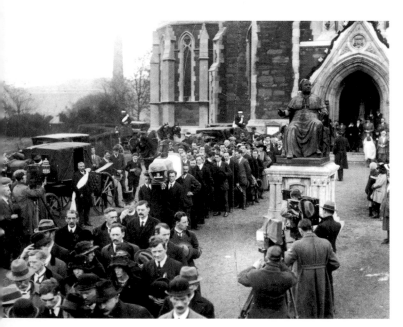

Terence MacSwiney's funeral leaving the Cathedral of St Mary & St Anne, Cork. MacSwiney's death made newspaper head-lines around the world and brought increasing international political pressure on the British government to reach a political settlement with the Irish Repub-licans. Note the press photo-graphers and cameramen on the right.

Mercier Archives

Tom Barry, commander of the 3rd West Cork Brigade flying column. On 28 November 1920 Barry led an IRA flying column that ambushed a patrol of eighteen RIC Auxiliaries at Kilmichael, Co. Cork. Sixteen of the Auxiliaries and three IRA Volunteers were killed in the ambush. One of the Auxiliaries escaped, but was captured and killed by the IRA shortly afterwards. Only one Auxiliary, Cadet H. F. Forde, survived the ambush. The IRA's success at Kilmichael was a serious blow to the British. David Lloyd George, the British prime minister observed: 'The last attack of the rebels seemed ... to partake of a different character from the proceeding operations. The others were assassinations. This last was a military operation.'

Reference: Tom Jones, *Whitehall Diary: Ireland, 1918–25* (Oxford University Press, Oxford 1969), p. 41.

Mercier Archives

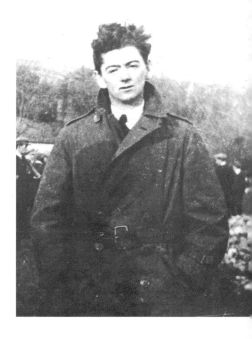

This photograph was apparently taken from a British officer during the War of Independence and shows the bodies of three IRA Volunteers killed by the British army in West Cork. It has been speculated that the photograph may show the bodies of IRA officers Captain John Galvin, Lieutenant Jim Begley and Section-Commander Joe Begley, who were killed by the Essex Regiment on 3 December 1920. However, since their faces are not visible this cannot be confirmed.

Mercier Archives

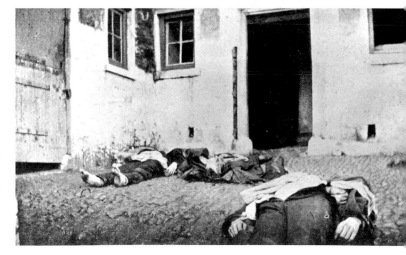

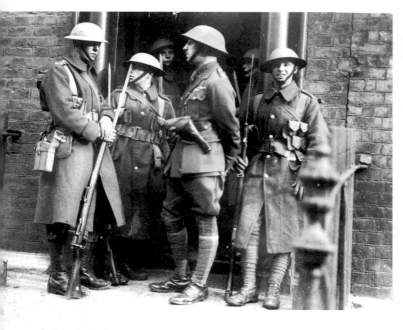

Two pictures of a British army raid on the Sinn Féin bank at 76 Harcourt Street on 29 November 1920. The building was raided by the Auxiliaries, who discovered a hidden safe in the floor. They opened the safe, using explosives, and discovered £500 in cash and papers belonging to Michael Collins.

Reference: Ernest McCall, *The Auxiliaries – Tudor's Toughs* (Red Coat Publishing, Newtownards 2010), p. 135.

Courtesy of Irish Military Archives, BMH CD 6 (Erskine Childers Collection)

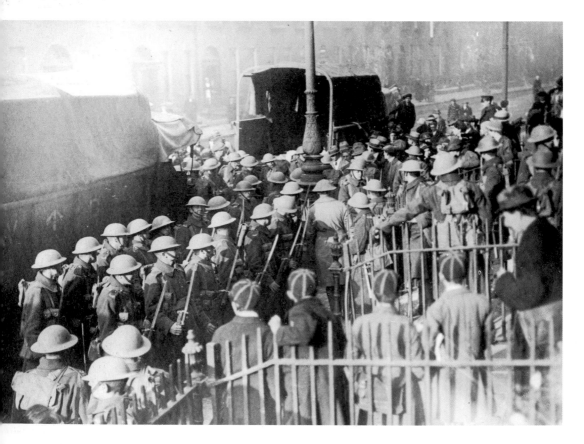

In November 1920 the British created a special detective unit based in Dublin Castle led by Head Constable Eugene Igoe (*pictured*) an RIC man from Mayo. This unit was tasked with identifying and killing members of the IRA from the provinces who had come to the capital, such as Dan Breen. The group, known as the 'Igoe Gang', was mainly composed of Irish members of the RIC who could identify leading IRA figures by sight. They patrolled the streets heavily armed, wearing plain clothes, and frequented railway stations on the lookout for Republicans travelling to Dublin. Thomas Newell, an IRA Volunteer from Galway, was brought to Dublin to identify Igoe for assassination. Newell was one of the few members of the IRA captured by Igoe who lived to tell the tale. 'He gave me a hell of a punch which sent me several yards into the street and immediately opened fire on me … I had received four bullet wounds, one in the calf of the right leg, two in the right hip and one flesh wound in the stomach. I then saw Igoe blow a whistle. Within a minute a police van arrived, I was put roughly into it and taken to the bridewell. I was questioned as to where I lived in Dublin. I refused to tell them. I was beaten on the head with the butt end of a revolver; four of my teeth were knocked out and three or four others broken. I was left lying on the floor for some hours and was then taken in an ambulance to King George V hospital.'

Reference: Thomas Newell quoted in T. Ryle Dwyer, *The Squad and the Intelligence Operations of Michael Collins* (Mercier Press, Cork 2005), p. 205.

Courtesy of Kilmainham Gaol Museum 19PO IA32 03

Funeral of a member of G Company of the RIC Auxiliary Division, November 1920. The coffin is most likely that of Michael Fleming, a Catholic Auxiliary cadet from Laois, or else Edward Roper, a Protestant Auxiliary cadet from Hants in England. Both men were with RIC Constable Driscoll from Cork when the lorry they were travelling in crashed into the gateway at Dromoland Castle, Co. Clare, on 22 November 1920. The background of the photograph and some of its details have been retouched by painting, most likely for reproduction in a newspaper.

Author's Collection

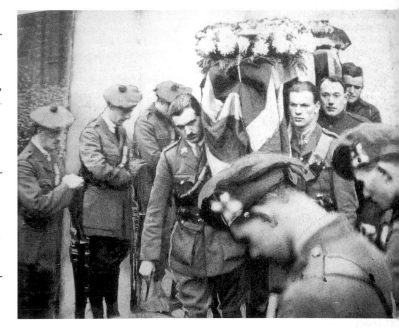

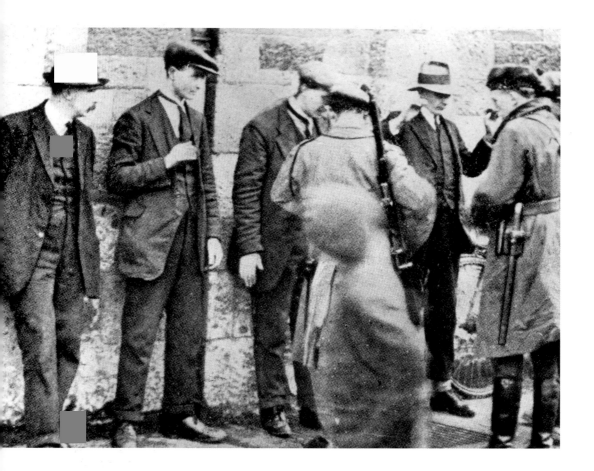

Above: Civilians being searched for weapons by RIC Auxiliaries.

Mercier Archives

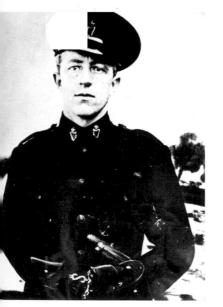

RIC Constable George Emerson, a former soldier and bootmaker from Chester, who joined the RIC in November 1920. He was stationed at Kilmallock, Co. Limerick, and remained in the RIC until the force's disbandment in February/March 1922. Although he was considered a Black and Tan, the uniform shortages which gave the new recruits to the RIC their nickname in the spring of 1920 had largely been solved by the time Emerson enlisted. By late 1920 most Black and Tans were dressed the same as their counterparts in the regular RIC, but were distinguishable by their behaviour and possibly by having foreign accents.

Mercier Archives

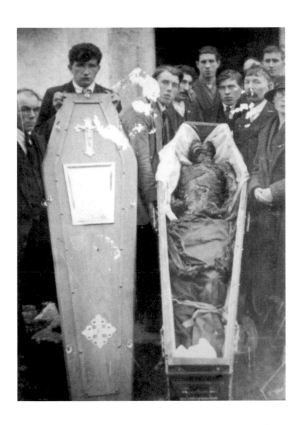
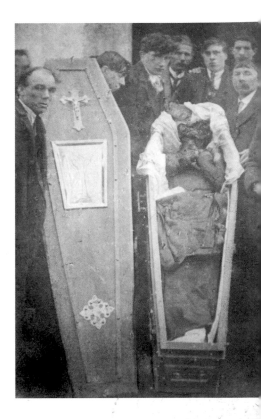

The bodies of IRA members Patrick and Harry Loughnane, who were killed by D Company of the RIC Auxiliary Division in November 1920. These photographs were taken at their wake at the Hynes farm, Dungora, near Kinvara, Co. Galway. The Loughnane brothers were arrested in daylight at their family home at Shanaglish on 26 November 1920. Their partially burned and mutilated bodies were discovered in a pond near Ardrahan on 5 December 1920. The two brothers were tied to the back of an RIC lorry and forced to run behind it until they collapsed from exhaustion and were dragged along the road. Both of Pat's wrists, legs and arms were broken. His skull was fractured and there were diamond-shaped wounds carved into his torso. Harry's body was missing two fingers, his right arm was broken and nearly severed from his body. Nothing was left of Harry's face except for his chin and lips. A doctor who examined the Loughnane's bodies stated that the cause of death was 'laceration of the skull and the brain'. The British authorities claimed that the Loughnane brothers had escaped from the RIC and that members of the RIC Auxiliary Division were not involved in their deaths. In the same month that the Loughnane brothers were killed, the British forces in Galway also killed a pregnant woman and a Catholic priest.

References: 'The murders of Pat and Harry Loughnane', Cormac Ó Comhraí, www.warofindependence.info; *Connaught Tribune*, 11 December 1920; UCD Archives O'Malley Notebooks P17b/136; NUI Galway Special Collections Pol 4/7 — papers relating to the deaths of H. and P. Loughnane, Memories of November 1920 by Norah Loughnane.

Courtesy of Irish Military Archives, BMH P39 (Miss Cait Ní Lochlain Collection)

The burning of Cork. On 11 December 1920 the IRA ambushed an RIC patrol at Dillon's Cross, Cork city, killing Spencer R. Chapman, an Auxiliary from London. In revenge for Chapman's death, members of the Auxiliaries, the Black and Tans, the RIC and British soldiers went on a rampage, attacking civilians, looting shops and setting fire to businesses in the city centre. The same night the British forces raided the family home of Con and Jeremiah Delaney, who were members of the IRA, and killed them as they lay in bed. The fires started by the British forces caused £3 million worth of damage, destroyed five acres of property and left at least 2,000 workers unemployed. Sir Hamar Greenwood denied that the British forces were responsible and suggested that the people of Cork had destroyed their own city.

Reference: Gerry White and Brendan O'Shea, *The Burning of Cork* (Mercier Press, Cork 2006).

Mercier Archives

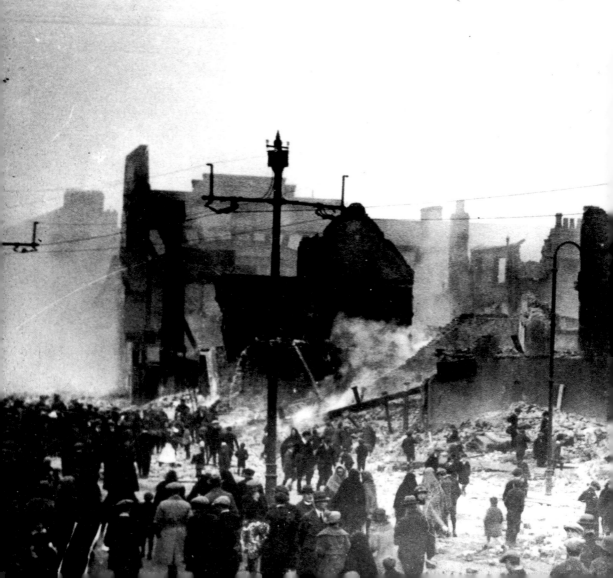

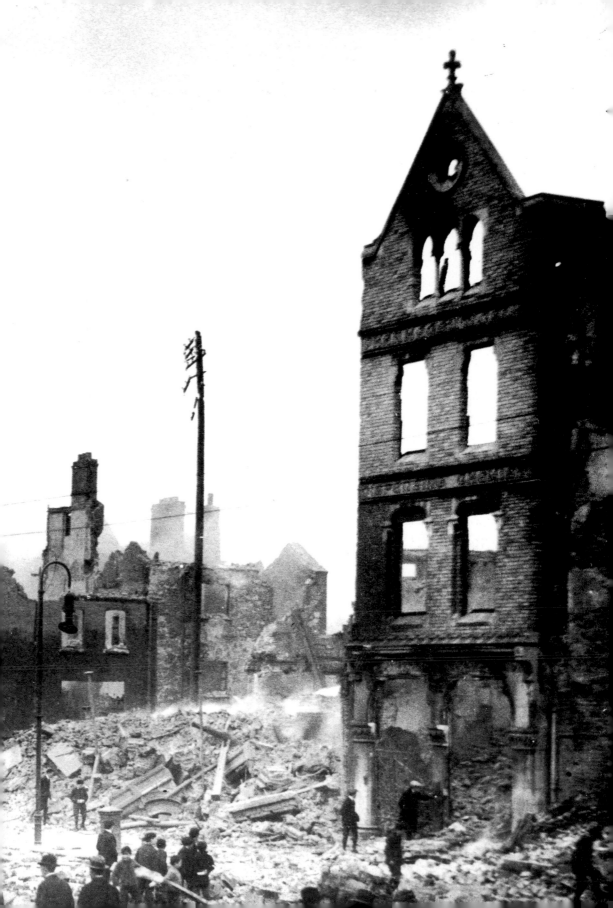

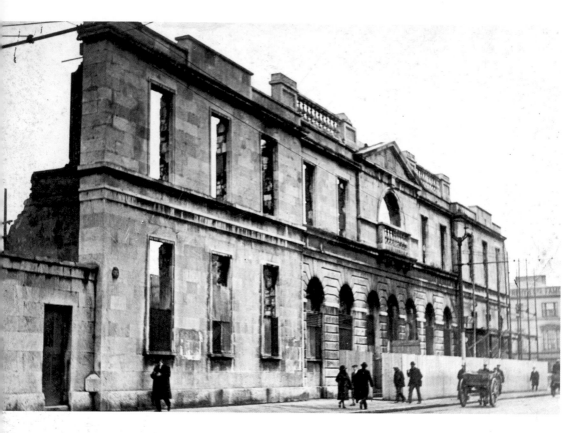

The ruins of Cork City Hall destroyed by the British forces during the burning of Cork. The Black and Tans had made an unsuccessful arson attack on the building two months earlier. Sir Hamar Greenwood told the British House of Commons that Cork City Hall had been destroyed when fires started by the citizens of Cork spread from Patrick Street. However, this was impossible since City Hall was over 500 yards from Patrick Street on the opposite side of the River Lee. To bolster Greenwood's ridiculous claim several British newspapers published a fraudulent map of Cork (*reproduced below*) which depicted City Hall at the northern end of Patrick Street.

Reference: Gerry White and Brendan O'Shea, *The Burning of Cork* (Mercier Press, Cork 2006).

Mercier Archives

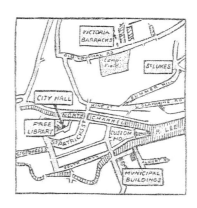

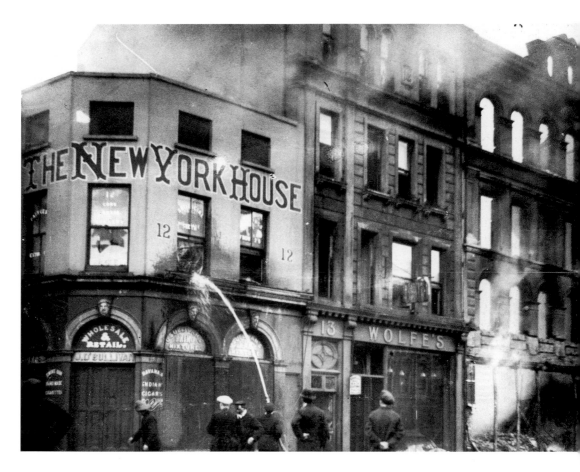

Attempts to put out the fires started by British forces in Cork were still ongoing the following morning.

Reference: Gerry White and Brendan O'Shea, *The Burning of Cork* (Mercier Press, Cork 2006).

Mercier Archives

A British army tank demolishing the ruins of Brian Dillon House, Cork.

Reference: Gerry White and Brendan O'Shea, *The Burning of Cork* (Mercier Press, Cork 2006).

Courtesy of Cork Public Museum

Dr Daniel Cohalan, Bishop of Cork, 1920. Following the burning of Cork, Bishop Cohalan issued a decree stating that anyone engaged in murders or ambushes incurred automatic excommunication from the Catholic Church. In theory the decree applied in equal measure to both the IRA and the British; in reality it was directed solely against the IRA. Councillor Ó Cuill of Sinn Féin was quick to show his contempt for the bishop's actions by stating: 'He stands now only where his people always stood – in the wrong.' This was a reference to the Catholic Church hierarchy's unfailing support for British rule and their condemnation of every Republican rebellion in Ireland since 1798.

Reference: Gerry White and Brendan O'Shea, *The Burning of Cork* (Mercier Press, Cork 2006), p. 146.

Courtesy of Cork Public Museum

Photograph of IRA leader Thomas Malone, alias 'Seán Forde', taken by British intelligence in December 1920 after he was captured in Cork. Malone does not appear in the least bit cowed and had the presence of mind to move his head as the photograph was taken. As a result the picture is blurred and not very useful as a means of identification.

Courtesy of Tom Malone (Junior)

Devastation at Meelin, Co. Cork, the result of an official reprisal carried out by the British army in January 1921. The British policy of destroying houses and other property in areas where Republican attacks had taken place was based on a similar campaign they had conducted during the Boer War. Sometimes the houses selected for destruction were the family homes of known IRA men or Republican supporters, and the aim was to deny IRA columns food and shelter. In other instances, houses were destroyed at random or because of their proximity to an ambush site. In these cases the destruction was intended as a collective punishment to make communities abandon their support for the IRA's campaign and compel them to give information and support to the British forces.

Mercier Archives

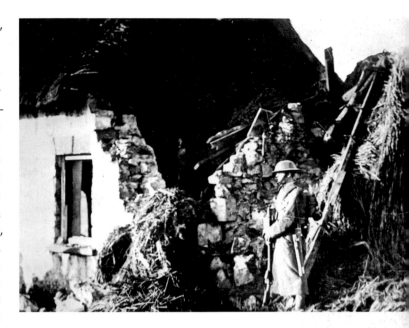

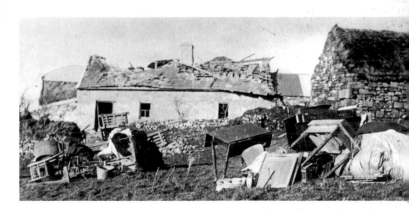

Mrs Brown's house at Meelin after its destruction by the British army. British soldiers allowed her to remove the furniture and some of her possessions from the house before it was destroyed by explosives. Although the British forces had engaged in reprisals and house burnings throughout the war, the policy of 'official reprisals' only began in January 1921. Before this the British authorities had frequently turned a blind eye to reprisals committed by their forces or else given them tacit support and encouragement. Official reprisals carried out by the British army usually involved the destruction of property with explosives. Unofficial reprisals committed by the Black and Tans and Auxiliaries usually consisted of arson attacks.

Mercier Archives

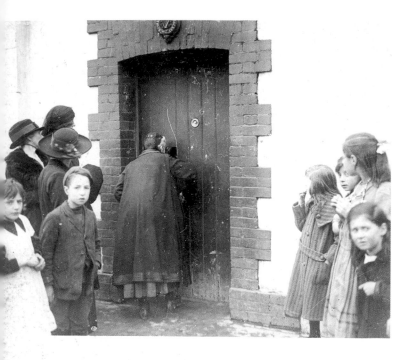

Charlotte Despard remonstrating with members of the RIC through a hatch in the door of their barracks at Meelin, Co. Cork, following reprisals in the area. Despard's activities exposing British reprisals in Ireland were a major source of embarrassment to her brother, Field Marshal Sir John French, who was lord lieutenant of Ireland at the time.

Courtesy of Kilmainham Gaol Museum 19PC IA35 27A

Below: Civilians run for cover during a British army raid in Sackville Street, Dublin.

Courtesy of Kilmainham Gaol Museum 19PC IA46 25

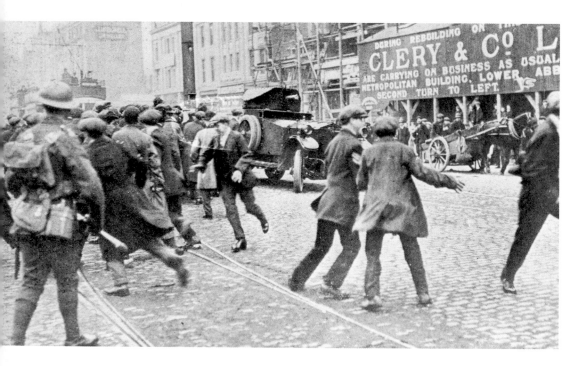

Wedding photograph of Captain William Lorraine King, commanding officer F Company, RIC Auxiliaries, and Helen Gilbert, daughter of a British army general, taken at Monkstown church, Dublin. King, nicknamed 'Tiny', was reputed to have stood over 6' 6" tall and was seconded to the Auxiliaries from a South African infantry regiment in October 1920. He had fought in the First World War and was awarded the Distinguished Conduct Medal and Military Cross. King was involved in the killing of two IRA leaders, Dick McKee and Peadar Clancy, and a civilian, Conor Clune, in revenge for the killing of British intelligence agents on 'Bloody Sunday' on 21 November 1921. He was tried for the murder of Patrick Kennedy and James Murphy at Drumcondra on 9 February 1921 and acquitted. King died during the Second World War and is buried in Palestine.

Reference: Ernest McCall, *The Auxiliaries – Tudor's Toughs* (Red Coat Publishing, Newtownards), pp. 66, 144–5.

Courtesy of Irish Military Archives, BMH CD 227/35 (Fintan Murphy Collection)

Brigadier General Frederick Crozier inspecting recruits for the RIC Auxiliary Division. Appalled by the lack of discipline in the force and its involvement in reprisal killings, Crozier resigned as head of the Auxiliaries on 19 February 1921. He later stated that he had resigned, 'because the combat was being carried out on foul lines, by selected and foul men, for a grossly foul purpose, based on the most satanic of all rules that "the end justifies the means".'

Reference: Brigadier General Crozier, 'Unpublished Memoirs', *The Kerryman*, March 1938.

Mercier Archives

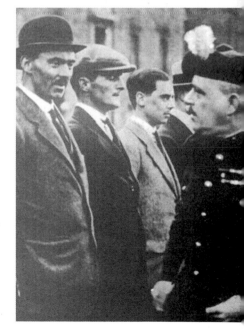

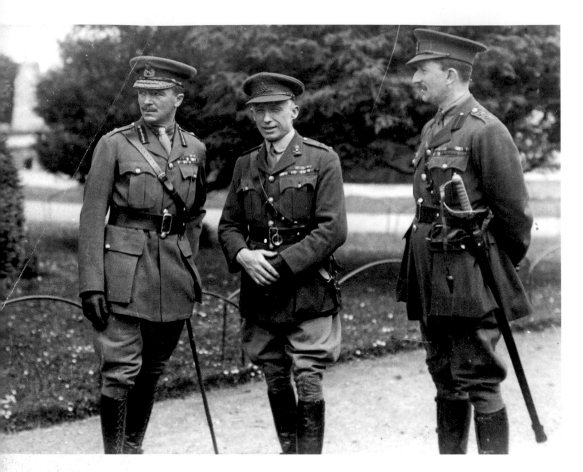

Major General Sir Henry Tudor (*left*) who was appointed inspector general of the RIC on 15 May 1920.

© RTÉ Stills Library

Frank Thornton, the IRA's deputy director of intelligence, photographed at IRA intelligence headquarters at the Antient Concert Rooms, Dublin, on 11 July 1921. Thornton worked closely with Michael Collins, directing and instructing 'The Squad'. The following six photographs come from Thornton's intelligence dossier and were used to identify members of the British forces.

Courtesy of Irish Military Archives, BMH CD 188/1/2 (Frank Thornton Collection)

Members of F Company of the Auxiliaries stationed at Dublin Castle. The Auxiliaries have been numbered by IRA intelligence for identification: 1. W. McConnell Carson; 2. Captain J. P. Stokes; 3. G. R. Thompson; 4. J. C. Reynolds; 5. Captain A. Bennett; 6. — Warrior.

Number 4 Section Leader J. C. Reynolds was selling intelligence information to the IRA in Dublin, which he passed to Thornton: 'I met Reynolds regularly in different public houses and gave him certain jobs to do, which he did successfully … as time went on, Reynolds became more useful and secured quite a lot of very valuable information in the form of photographs of the murder gang – F Company, Q Company and other companies of the Auxiliaries.'

Reference: T. Ryle Dwyer, *The Squad and the Intelligence Operations of Michael Collins* (Mercier Press, Cork 2005), p. 195.

Courtesy of Irish Military Archives, BMH CD 227/35 (Fintan Murphy Collection)

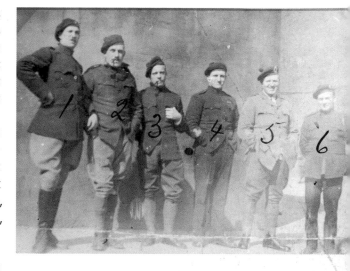

Members of the DMP receiving small arms training from Inspector Carey. The DMP had traditionally been an unarmed police force, but this changed in response to Republican violence. In the wake of the 1916 Rising the force had been armed with Lee Metford .303 rifles for a brief period. During the War of Independence the force was rearmed with Webley & Scott .32 automatic pistols which they are shown training with above.

Courtesy of Irish Military Archives, BMH CD 227/35 (Fintan Murphy Collection)

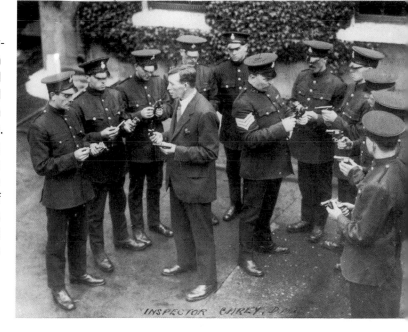

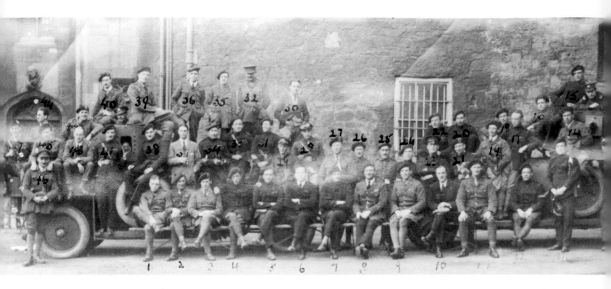

Group photograph of F Company of the Auxiliaries stationed at Dublin Castle. This photograph is taken from Frank Thornton's intelligence dossier and was used by the IRA in an attempt to identify and kill members of the British forces. Thornton had identified thirty of those pictured:

F Coy. Aux. 1. Dore 2. Halper 3. Palmer 4. Herrett (London) 5. Reynolds (L'pool) 6. — 7. Lewis (wounded at Custom Ho.) 8. Huntingtonford 3rd D.I. 15. Shelton 10. Cassmaker Sec Ldr 12. Thompson (Intelligence) 16. McClean 17. Axminster (bad pill). Fletcher (18). 19. Gorman 20. Hughes 21. Florry 3rd D.I. 22. Derrick (Tortures prisoners) 23. Igoe (Murder) 26. Webb 27. Bennett 29. Frail Lt. Tony 30. Coaker 31. Costigan 35. Beckett 36. Carew 39. Lamb 40. Sparron 41. Captain (O/C 'F') 42. Barrett 43. Downes 44. Cutting 46. Webber (It Tank Corps)

Courtesy of Irish Military Archives, BMH CD 227/35 (Fintan Murphy Collection)

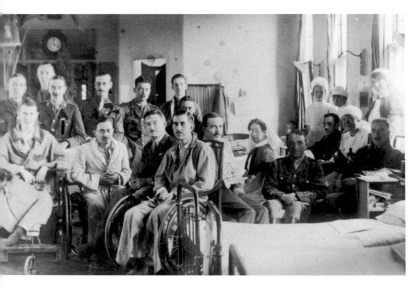

Wounded members of the British forces. The three men standing at the back numbered 1 to 3 and marked with arrows were members of the British secret service stationed at Dublin Castle. They have been identified by Thornton as: 1 — Rodgers. 2 — Jones. 3 — Hyde.

Courtesy of Irish Military Archives, BMH CD 227/35 (Fintan Murphy Collection)

Thomas Gore-Hickman, RIC District Inspector for Mohill, Co. Leitrim. Gore-Hickman came from a prominent Loyalist family in Clare. On 11 March 1921 he led a British patrol that surprised members of an IRA flying column at Selton Hill, Co. Leitrim. Five IRA members were killed in the incident; a sixth, Seán Connolly, O/C of the IRA's Longford Brigade, was mortally wounded and died in RIC custody the following day. Gore-Hickman left for England immediately after the Selton Hill ambush and did not return to Ireland until after the Truce. On 5 July 1921 the IRA burned Hazelwood House, one of his family's properties at Quin, Co. Clare. The house and its contents were valued at £100,000. After the disbandment of the RIC in 1922, he emigrated to Alberta, Canada.

Reference: Ernie O'Malley, *Rising Out. Seán Connolly of Longford* (UCD Press, Dublin 2007), pp. 157–63.

Courtesy of Irish Military Archives, BMH CD 227/35 (Fintan Murphy Collection)

Olive Cox (*right*) was a typist for the British at Dublin Castle. She was one of many women who played an important role in the intelligence war fought between the IRA and the British forces. The IRA hoped that they might get an opportunity to assassinate leading British officers by gathering intelligence information about their secretaries. Bridget Burke, the typist for Captain Kelly, the intelligence officer for the British 6th Division, was arrested and interrogated by the IRA in July 1921. She was held for almost two weeks before being released. Women like Lily Mernin, a shorthand typist in Dublin Castle who secretly passed intelligence information to IRA, were vital to the Republican war effort.

Courtesy of Irish Military Archives, BMH CD 227/35 (Fintan Murphy Collection)

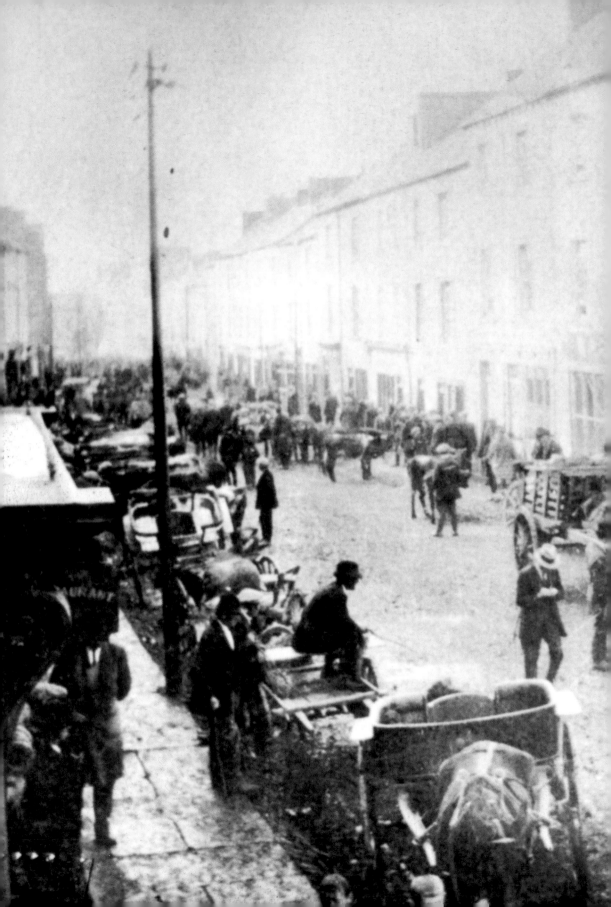

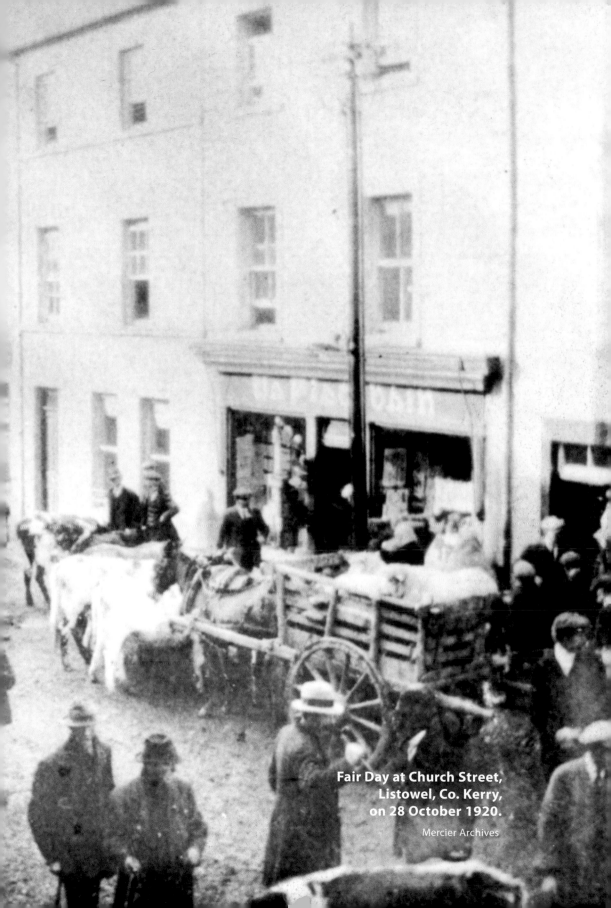

**Fair Day at Church Street,
Listowel, Co. Kerry,
on 28 October 1920.**

Mercier Archives

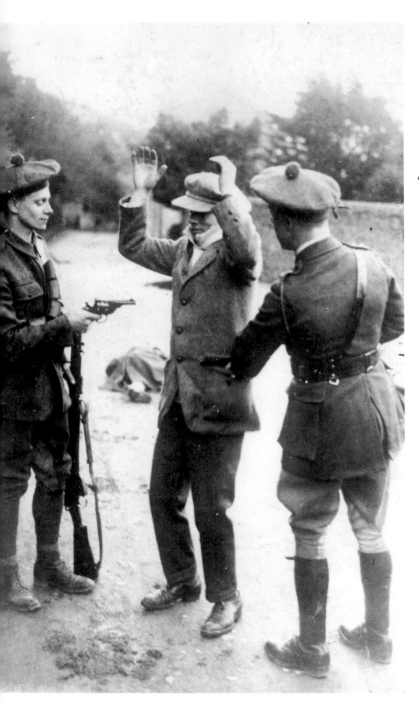

This photograph purporting to show two RIC Auxiliaries searching a captured IRA Volunteer following an IRA ambush in Kerry, is actually a staged propaganda photograph taken on the set of a propaganda film at Vico Road, Killiney, Co. Dublin. Note the 'dead' body in the background. In January 1921 a pair of film-makers named Gennell and Starmer filmed a series of fake newsreels in Wicklow and Dublin to give the impression that the British forces were gaining control of the military situation in Ireland. These newsreels were intended for cinema audiences in Britain in an effort to generate support for the British government's increasingly unpopular military and police policies in Ireland. Despite this photograph being exposed as a fraud in the late 1990s, it still makes regular appearances in modern history books.

© Topical Press Agency / Hulton Archive / Getty Images

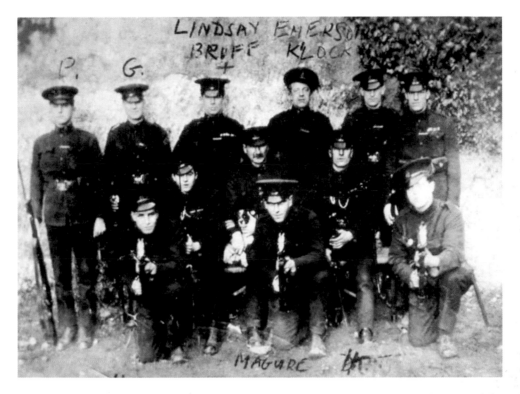

Members of the Kilmallock garrison of the RIC photographed around Christmas 1920. This copy of the photograph was used to identify members of the garrison for assassination.

Standing L to R: Constable Fred Palmer (Black and Tan), Constable C. Goulty (Black and Ian), Constable Andrew Lindsay (Black and Tan), Constable George Emerson (Black and Tan), unidentified, unidentified.

Middle Row L to R: unidentified, Sergeant James Maguire (with dog), Constable James Howes (Black and Tan)

Front Row L to R: unidentified, Constable Harry Beard (Black and Tan), Unidentified.

Sergeant Maguire, a native of Cavan, was an exceptionally shrewd intelligence officer who ran a network of local intelligence agents. He was shot dead by members of the IRA in Kilmallock on 6 March 1921. In retaliation for Maguire's death, the British army destroyed two nearby houses using explosives. That night members of the RIC killed three Republicans in Limerick city.

Mercier Archives

REVOLUTION

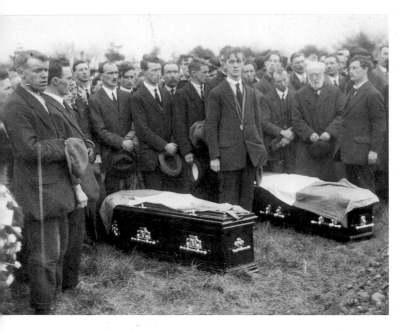

The funerals of the Mayor of Limerick, Seoirse (George) Clancy and his predecessor, ex-Mayor Michael O'Callaghan, in March 1921. On the night of Sunday 6 March 1921 Clancy and O'Callaghan were shot dead in their homes by a group of RIC Auxiliaries led by District Inspector George Montague Nathan. The same night they also killed James O'Donoghue, an IRA Volunteer from Co. Westmeath, who lived at Rathbane on the south side of the city. As with the assassination of the Lord Mayor of Cork, Tomás MacCurtain, the British forces claimed that Clancy and O'Callaghan had been murdered as part of an internal IRA feud.

Courtesy of Kilmainham Gaol Museum 19PO IB14 27

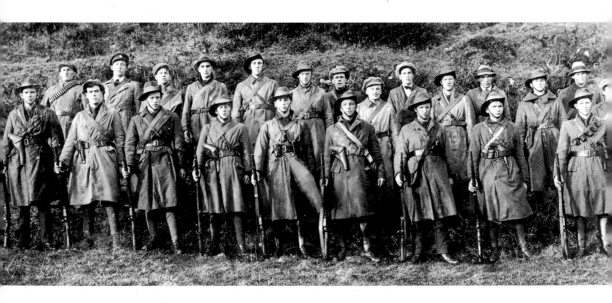

West Connemara Brigade flying column 1921. The IRA in West Galway were very active during the spring of 1921, but their level of activity and efficiency had waned by the time of the Truce a few months later. Although the unit pictured is very well armed, the IRA in the area were suffering from a critical shortage of ammunition.

Copyright J.J. Leonard, courtesy of Anthony Leonard

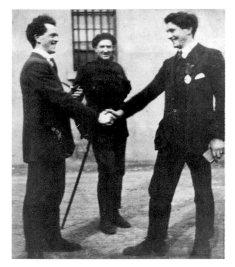
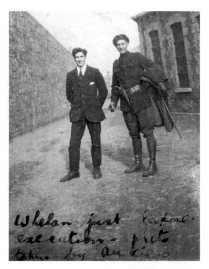
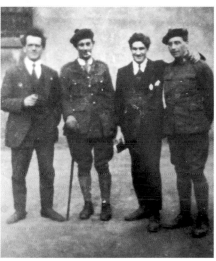
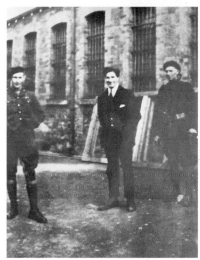

A remarkable series of photographs showing IRA Volunteers Paddy Moran and Thomas Whelan awaiting execution at Mountjoy Jail in 1921. Both men were hanged at Mountjoy on 14 March 1921 for involvement in the assassinations of British intelligence officers on 'Bloody Sunday'. The men show no ill-will towards their captors and appear to be quite happy to pose with them for photographs. Whelan even has his arm around an Auxiliary in one photograph. The photographs were secretly taken inside the prison and the negatives were smuggled to Arthur Griffith who was a prisoner in Mountjoy at the same time. Griffith preserved the negative until his release. Auxiliary Cadet Lester Collins from New Zealand is pictured in the first photograph where Whelan and Moran are shaking hands. The Auxiliary pictured with Whelan in the second photograph was known as 'Tiny' and was noted for being kind towards some Republican prisoners (not to be confused with Captain William Lorraine King who had the same nickname). The handwritten note on this photograph reads 'Whelan just [before] execution – pic taken by Auxie'.

Courtesy of Kilmainham Gaol Museum 19PO IA33 22 and 19PO IB14 13

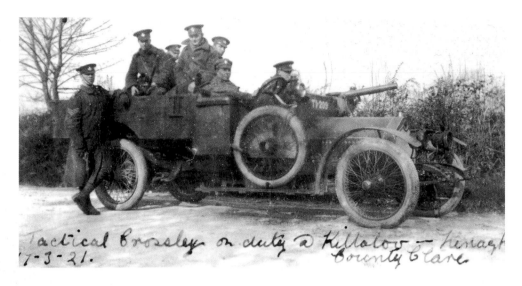

Tactical Crossley on duty @ Killaloe – Nenagh 17-3-21. County Clare

Members of the Oxford and Buckinghamshire Light Infantry on patrol between Killaloe and Nenagh on Saint Patrick's Day 1921. When compared to other British regiments stationed in Ireland during the War of Independence, the Oxford and Buckinghamshire Light Infantry were relatively well disciplined. They usually treated Republicans they had taken prisoner well and appear to have only been involved in reprisal killings on one or two occasions. Other British army regiments stationed in the Munster area at the same time, such as the Essex Regiment, the Royal Scots and the Royal Highland Light Infantry had a much worse reputation amongst Republicans for brutality, torturing prisoners and indiscriminately killing civilians.

Courtesy of Soldiers of Oxfordshire Trust

Tom Barry, commander of the 3rd West Cork Brigade flying column. This photograph was taken immediately after the attack on Rosscarbery RIC Barracks on 30 March 1921 and Barry's face shows the physical and emotional strain of the intense fighting. The IRA began their attack on the barracks by mining the building with an 80lb bomb. However, this failed to blow a large enough hole to allow an IRA storming party to fight their way in. Eventually the IRA captured the barracks after an attack lasting almost five hours. The surviving nineteen members of the RIC garrison had been forced to surrender after the building caught fire and two of their number were killed in the attack. Barry later praised the courage of his opponents: 'no members of this garrison had ever run amok … This garrison had fought exceptionally well and defended their barracks to the end. But good as those men were, they were far excelled by the men of the flying column.'

Reference: Tom Barry, *Guerrilla Days in Ireland* (Anvil Books, Dublin 1981), p. 151.

Author's Collection

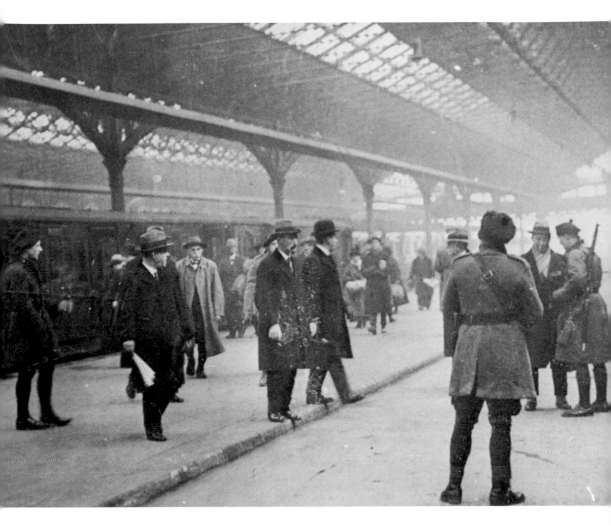

Members of the RIC Auxiliary Division searching civilians disembarking from a train at Kingstown Railway Station.

Mercier Archives

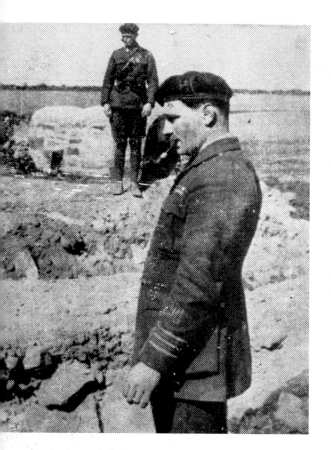

Major J. A. McKinnon (*foreground*). McKinnon commanded H Company of the RIC Auxiliary Division, which was stationed at Moyderwell Technical School, Tralee, Co. Kerry. The IRA assassinated him on 15 April 1921 while he was playing golf. According to Republican lore he called for vengeance with his last breath, ordering his bodyguard to 'Burn Ballymac'. (Given the serious nature of his wounds it is unlikely McKinnon lived long enough to say anything.) Regardless of whether or not he had ordered it, British forces carried out a series of reprisals that night at Ballymacelligot, killing one person and burning seven houses in revenge for McKinnon's death.

Mercier Archives

Right: Threatening graffiti daubed on a house in Wexford. Both the IRA and British used intimidation as a means to try to control their political opponents. The IRA attempted to stem the flow of intelligence information to the British by executing suspected British spies and intelligence agents. According to Ernie O'Malley: 'For the enemy intelligence agents things were made so hot by the threatening and shooting of spies, and even more so by the clearing out of the local RIC garrison, people eventually learned to shut their eyes and close their mouths.' The British, acting under the guise of 'The Anti-Sinn Féin Society', issued public death threats and sent intimidating letters to Republican sympathisers. Unionists who criticised the actions of the British also suffered attacks. The Black and Tans destroyed the business premises of G. W. Biggs, a Protestant Unionist from Bantry who had written a letter to *The Irish Times* pointing out that there was no sectarian persecution of Protestants by the IRA in Bantry. Colonel Westropp, a Unionist in Clare, had his farm buildings burned and received a death threat from the 'Anti-Sinn Féin Gang' after he wrote letters to the press and made speeches condemning Black and Tan atrocities.

Reference: Ernie O'Malley quoted in the documentary *Bóthar na Saoirse – Ernie O'Malley*, Blackrock Pictures, TG4 2011.

Courtesy of Nicholas Furlong; N. Furlong & J. Hayes, *County Wexford in the Rare Ould Times* (Distillery Press, Wexford 2010)

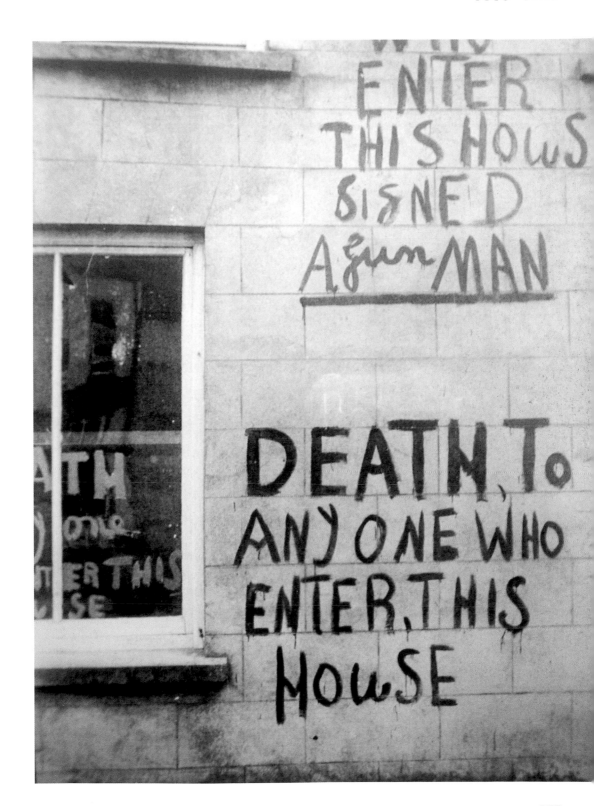

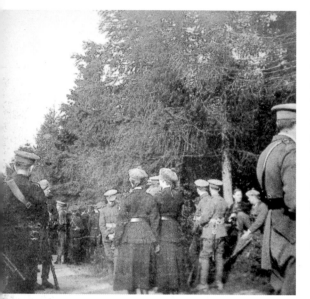

Two 'Lady Police Searchers' on duty with the British forces in Monaghan. Complaints about the sexual harassment of women by the British forces led the RIC to recruit women to conduct searches. During the War of Independence members of the British forces appear to have been responsible for the majority of sexual assaults upon Irish women. However, the number of sexual assaults by Irish soldiers increased following the Truce. In June 1922 members of the IRA were responsible for a brutal sexual assault on a Loyalist woman in Tipperary. During the Civil War three Free State army officers attempted to sexually assault two women in a notorious incident in Kerry.

Author's Collection

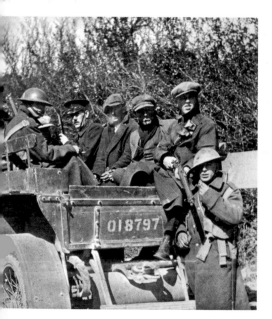

A joint British army and RIC motor patrol. Note the member of the patrol sitting on the tailgate dressed in civilian clothes, wearing a bandolier and carrying a rifle. The British criticised the IRA, claiming their failure to wear military uniform was a breach of the Hague Convention which set out the rules of war at the time. However, this photograph shows that the British forces also dressed as civilians so they could surprise and capture members of the IRA. On 17 April 1921 a raiding party of RIC Auxiliaries dressed in civilian clothes descended on the Shannon View Hotel in Castleconnell, Co. Limerick. As they were wearing civilian clothes, three off-duty RIC men drinking in the hotel bar at the time mistook them for an IRA unit. The RIC men opened fire and one Auxiliary cadet and an RIC sergeant were killed in the ensuing gunfight. Frustrated by the incident, which was entirely of their own making, the Auxiliaries killed the hotel's proprietor, Denis O'Donovan. This 'friendly fire' incident caused major embarrassment to the British forces. Not only did they have to admit that their forces had broken the Hague Convention by dressing in civilian clothes, but in addition that 'dum dum' bullets, also outlawed by the convention, were found at the hotel after the shootings.

Reference: Thomas Toomey, *The War of Independence in Limerick 1912–1921* (Limerick 2010), pp. 569–71.

By kind permission of the Regimental Museum of The Royal Highland Fusiliers

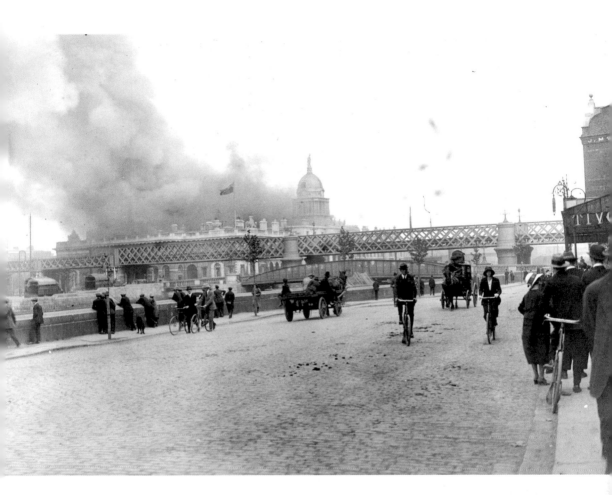

The burning of the Dublin Custom House. In a daring daylight operation on 25 May 1921, the IRA's Dublin Brigade stormed the building and set it on fire. The Custom House was home to a number of British governmental departments for Ireland, including the Inland Revenue, the Estate Duty Control Office and the Stamp Office. Although it made international newspaper headlines and proved a major embarrassment to the British, the operation came at a huge cost to the IRA in terms of manpower and equipment. The operation has proved controversial ever since, mainly because, in a reflection of the later Civil War divide, de Valera had proposed the operation whilst Collins had opposed several aspects of the plan. Although the operation had an important political impact the question remains – why was the attack not carried out at night by a handful of IRA Volunteers, rather than risking over 100 men in a daylight raid?

Mercier Archives

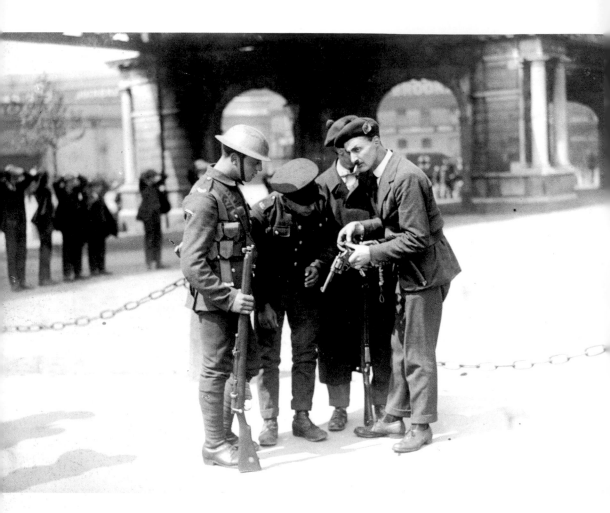

British soldiers with two Auxiliaries examining revolvers captured from IRA Volunteers after the burning of the Custom House. Although the daring daylight operation added to the mounting political pressure on the British to reach a settlement with Republican Ireland, it was a military disaster for the IRA's Dublin Brigade. Five IRA Volunteers were killed and about eighty more were taken prisoner, including many members of 'The Squad'. In addition dozens of revolvers and pistols were captured and this left the Dublin Brigade with a shortage of experienced IRA Volunteers, arms and ammunition necessary to carry out successful military operations.

Mercier Archives

British soldiers searching through the debris of the Custom House.

Mercier Archives

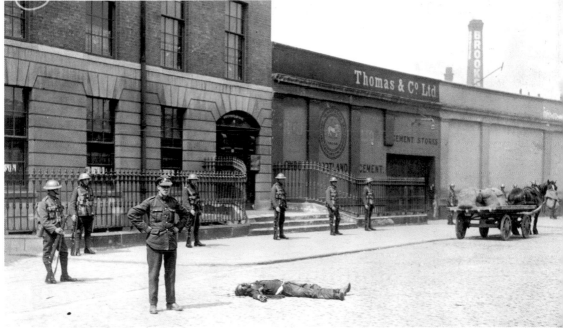

A British soldier from the Royal Army Medical Corps stands over the body of a man killed during the burning of the Custom House. The operation cost the lives of five IRA Volunteers – Stephen O'Reilly, Patrick O'Reilly, Edward Dorrins, Daniel Head and Seán Doyle. Three civilians – Francis Davis, Mahon Lawless and John Byrne – were also killed.

Mercier Archives

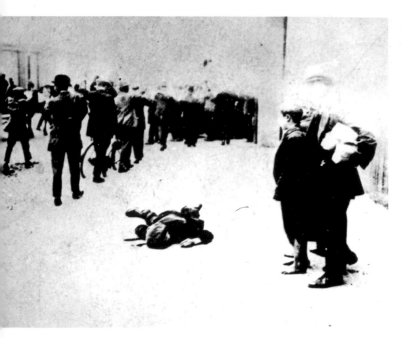

Suspected members of the IRA arrested by the British forces are marched into custody past the body of a man killed in the attack.

Mercier Archives

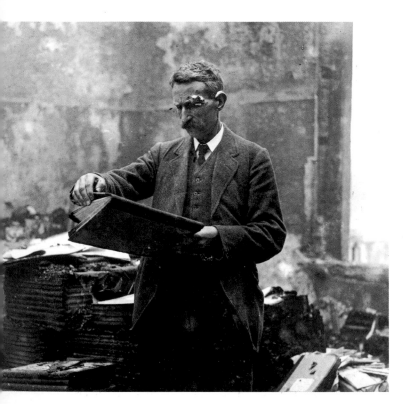

A clerk examines a ledger amidst the ruins of the Custom House. Records and documentation which were of great importance to the British administration in Ireland, including many of those being prepared for the establishment of the new Northern Ireland parliament, were destroyed in the fire.

Mercier Archives

Photograph of Republican prisoners probably taken at Kilmainham Gaol in 1921. Note the prison officer posing for the photograph on the left. Sympathetic prison officers were an important asset and often facilitated the smuggling of IRA communications and other materials into prisons.

Mercier Archives

Below: Republican prisoners at Ballykinlar No. 1 Internment Camp. This photograph shows the violin class which was taught by Frank Higgins and Martin Walton. Walton later set up the Walton School of Music and Walton's Music Shop in Dublin, which are still trading today.

Courtesy of Kilmainham Gaol Museum 19PO IA32 07

Photograph of the body of IRA leader Seán Wall, which was displayed in a number of shops in an effort to establish his identity. Wall was arrested by an RIC patrol near Annacarthy, Co. Tipperary, on 6 May 1921. The IRA attempted to rescue Wall by ambushing the RIC patrol as it returned to Cappawhite RIC Barracks. RIC Sergeant James Kingston was killed during the ambush. In retaliation for Kingston's death, the RIC and Black and Tans killed their prisoner.

Courtesy of Kerry O'Brien

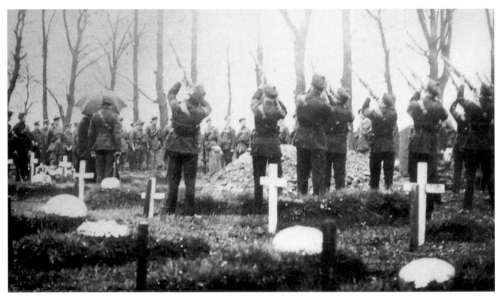

Members of the RIC Auxiliary Division fire a volley at the funeral of a deceased comrade.

An interesting incident happened at the funeral of Thomas Devine, a Catholic Black and Tan from Lancashire who was buried at Lifford, having been fatally wounded in an ambush in 1921. There were only seven people at Devine's funeral – the chaplain, four members of the RIC, the deceased's mother and Miss Heslin, the matron of the local hospital, who remembered that Devine's mother made the following speech at her son's graveside: 'I want the Irish people to know that I did not send my son on this mission to Ireland and that I forgive the people who shot him. I have another son, and if he came on the same mission to Ireland, I should also forgive the people who would shoot him. I have the greatest sympathy with the Irish people and I wish them every success.'

Reference: Bureau of Military History WS 133, pp. 1–2.

Courtesy of The Irish Picture Library/Holliday Collection

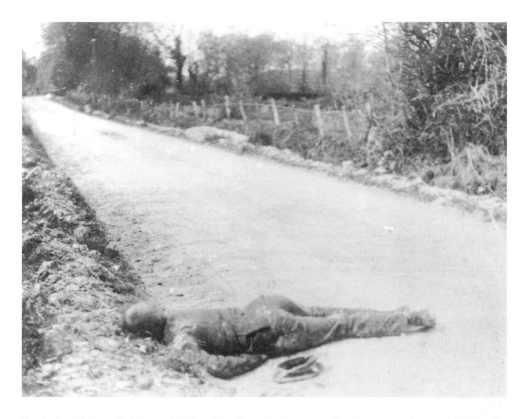

The body of Private Fielding, a British soldier from the East Lancashire Regiment who was killed by the IRA near Liscarroll, Co. Cork, on 26 April 1921. In late 1920 and early 1921 the British army began sending soldiers into the countryside on intelligence-gathering missions posing as deserters. According to Patrick O'Brien this was a particular problem for the IRA in East Cork: 'The Battalion O.C. and myself decided that this should stop … about mid-April – another supposed deserter [Private Fielding], who had moved out about ten miles from Buttevant, was captured in the Freemount area. This man was questioned and it was felt that he was more on intelligence [work] than as a deserter, so it was decided to take drastic action with him. He was taken back and shot within a few miles of Buttevant. This undoubtedly had the effect of rousing the tempers of the enemy, but it also had the effect of stopping any soldiers posing as deserters.' The British army gave the rather implausible explanation that Fielding had left his barracks to go for a leisurely walk in the countryside when he was shot.

References: Patrick O'Brien, Bureau of Military History WS 764, p. 40; 'Record of the Rebellion in Ireland in 1920 –21, *The Irish Sword*, Vol. XXVII, No. 107, p. 102.

Imperial War Museum Q107746

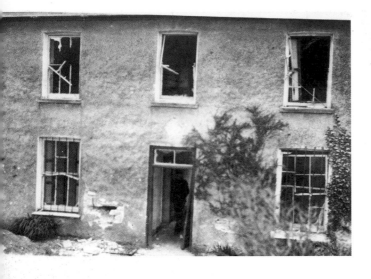

Belgooley RIC Barracks, Co. Cork, showing the destruction caused by the explosion of a mine during an IRA attack. Tom Barry stated: 'The mine was the only weapon the IRA had in its armoury to breach a barrack door or wall. Rifle and revolver bullets were about as useful as snowballs against these strong enemy posts.' Several ambushes and barrack attacks led by Barry were frustrated by the failure of defective mines. However, the IRA perfected the construction of mines as the war intensified. On 1 June 1921 the East Cork Brigade detonated a mine near Youghal which killed seven British soldiers from the Hampshire Regiment and wounded twenty-one others who were on their way to rifle practice. What the US military would today term 'Improvised Explosive Devices' (IEDs) were first used by a guerrilla army during the Irish War of Independence.

Reference: Tom Barry, *Guerrilla Days in Ireland* (Anvil Books, Dublin 1981), p. 75.

Mercier Archives

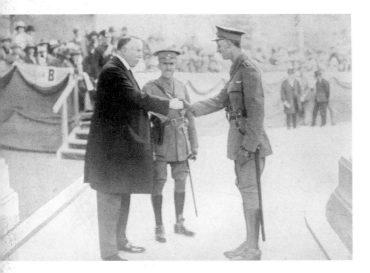

Sir James Craig (*left in dark suit*), the first prime minister of Northern Ireland, at the opening of the Northern Ireland Parliament at Stormont, Belfast, on 22 June 1921. The conciliatory speech by King George V at the opening of the parliament was seen as an overture to the Republicans to begin peace negotiations. Lloyd George seized upon the goodwill created by the King's speech to issue an invitation to de Valera to begin negotiations. However, from mid June onwards the British government ordered thousands of extra British soldiers to be sent to Ireland as reinforcements. Some of the British army regiments had been sent to Ireland from their posts occupying Germany, Egypt and India. While the British were prepared for peace, they were also ready to continue the war with a military surge against the IRA in the summer of 1921 if necessary.

Courtesy of Kilmainham Gaol Museum 19PC IB51 04

British soldiers examining an array of captured IRA weaponry including rifles, revolvers, pistols and artillery shells. The IRA's Dublin Brigade was particularly hard-pressed for arms and ammunition following the seizures at the Custom House and the discovery of a series of IRA arms dumps by the British forces. Some IRA units in Dublin were so short of ammunition that they began cutting rifle bullets down to size in an attempt to use them as revolver ammunition.

Mercier Archives

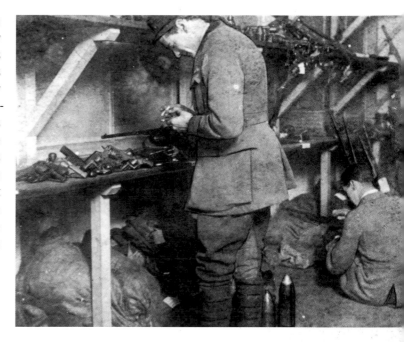

IRA-manufactured hand grenades captured by the British army in a raid on the IRA engineering department's grenade factory at the Heron & Lawless Cycle Shop. The IRA's ability to manufacture hand grenades was a major technological advancement.

Courtesy of Kilmainham Gaol Museum 19PC IB51 03

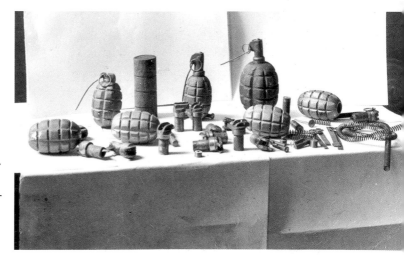

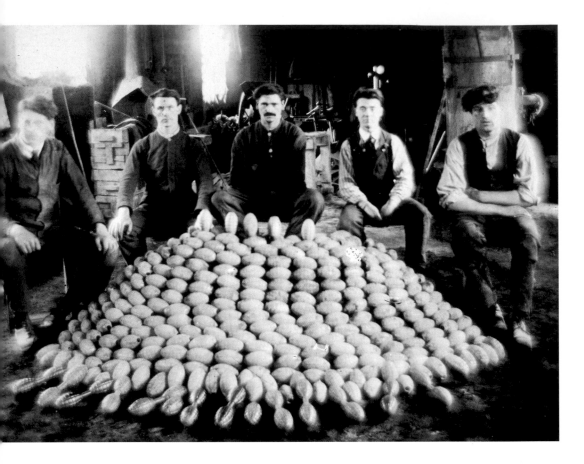

An IRA grenade factory in Cavan 1921. The 1st Cork Brigade of the IRA established a secret grenade factory at Knockraha in East Cork which could produce up to ninety grenade casings each night. These were shipped to Cork city where the grenades were finished by filling them with explosive and fitting detonators. The output of these grenade factories hugely increased the IRA's military capabilities as the Truce approached. There was a huge increase in the number of IRA attacks on the British forces in Cork throughout May and June 1921 as IRA engineers, working in these secret factories, honed their skills.

Reference: John Borgonovo, 'The Guerrilla Infrastructure: IRA Special Services in the Cork Number One Brigade 1917–1921', *The Irish Sword*, Spring 2010, Vol. XXVII, No. 107, pp. 214–15.

Courtesy of the National Museum of Ireland

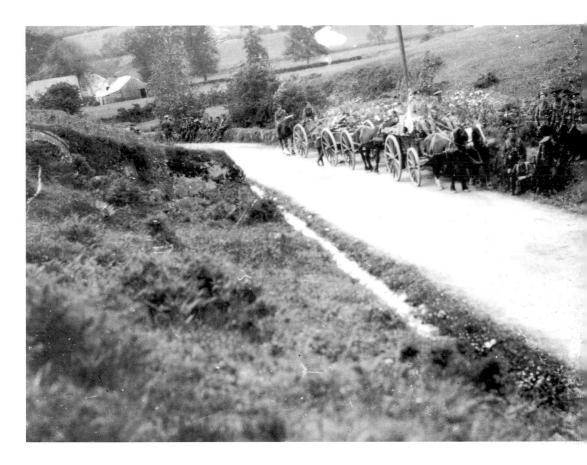

'Major Percival's flying column.' Members of the Essex Regiment resting by the roadside in West Cork in the summer of 1921. The British military had initially relied on their numerical superiority, heavy weaponry and technology to gain an advantage over the IRA in the War of Independence. Towards the end of the conflict the Essex Regiment and other British army units in Cork started using large mobile patrols who could take to the countryside in an imitation of Republican tactics. This was an initiative to use mobility and surprise, rather than technology, to defeat the IRA. One British officer in Cork outlined the objective of the British 'flying columns': 'With regard to objectives for flying columns: remember we have two moral objectives, i.e. to hearten the morals [sic: morale?] of the Loyalist and waverer and to dishearten the morals of the gunman.' The British were unsuccessful in both of these objectives.

Reference: Captured letter sent from H.Q. 16th Infantry Brigade Fermoy 17/6/21, O'Donoghue Papers National Library of Ireland MS 31,223.

Mercier Archives

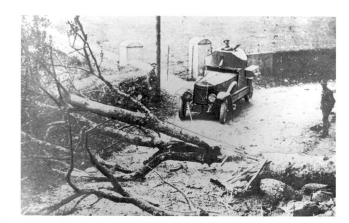

A British motor patrol finds its path blocked by a tree felled by the IRA. Republican roadblocks caused increasing disruption and difficulties for the British forces in the spring and summer of 1921.

Mercier Archives

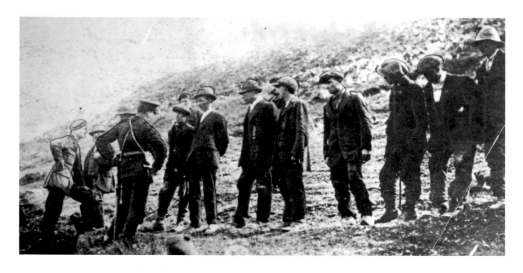

British forces questioning civilians during a British army 'drive'. In the spring and early summer of 1921, the British developed a new tactic of organising 'drives' or 'sweeps' of large sections of countryside. The objective of these was to try to trap IRA flying columns within a ring of military steel and destroy them as this ring closed about them. These operations yielded mixed results for the British because of their inability to distinguish members of the IRA from civilians who had been captured. The British army's 6th Division stated that the identification and separation of active Republicans from civilians was 'one of the greatest difficulties to be overcome in all drives … Owing to large numbers of the RIC being murdered, and others moved to new districts, they became of less and less assistance in this matter, and it sometimes was necessary to detain and move about enormous numbers of men about whom nothing definite was known.'

Reference: 'The Irish Rebellion in the 6th Divisional Area', *The Irish Sword*, Vol. XXVII, No. 107, p. 119.

Mercier Archives

IRA Volunteers Paddy Dunne, Patrick Quinn, Michael O'Hanrahan, P. Nixon and an unidentified fifth member of the Kilkenny IRA, photographed shortly after the Coolbawn ambush. On 18 June 1921 British soldiers surprised an IRA unit preparing an ambush position for a British military convoy expected to travel between Castlecomer and Athy. Two members of the IRA, John Hartley and Nicholas Mullins, were killed in the fighting that followed. A few days after this the IRA burned the house of Miss Florrie Draper, a local woman whom they suspected had warned the British army of the planned ambush.

Mercier Archives

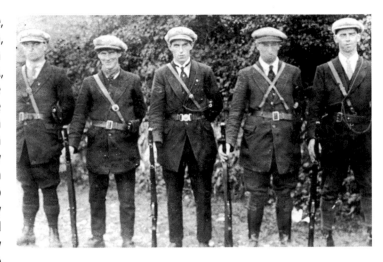

Lieutenant Richard Crawford Warren, MC. Warren was leading a patrol from the Oxford and Buckinghamshire Light Infantry when it was ambushed by the IRA at Tulla, Co. Clare, on 28 June 1921. The British soldiers immediately sent a carrier pigeon with the message shown on the left calling for medical aid for Warren and military reinforcements. Lieutenant Warren died of his wounds later that day. Two other British soldiers were wounded in the attack.

Courtesy of Oxford & Buckinghamshire Light Infantry – Soldiers of Oxfordshire Trust

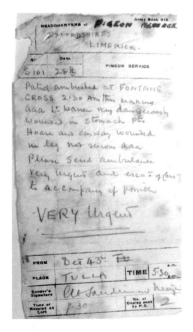

Photograph of the West Mayo flying column taken at Skirdagh by Jack Leonard of Crossmolina in July 1921 just a few days before the Truce.

Back row L to R: Michael Kilroy, T. Ketterick, E. Moane, J. Gibbons, J. Walsh, P. J. Cannon, P. Lambert, J. Kelly, J. Doherty, B. Malone, J. Rush, J. Ring. *Middle row L to R*: M. Naughtan, J. Hogan, J. Hearney, D. Sammon, J. Keane, J. Connolly, R. Joyce, P. McNamara, W. Malone. *Front row L to R*: D. Gavin, T. Heavey, J. Duffy, J. McDonough, P. Kelly, J. Moran, J. Flaherty, B. Cryan, M. Staunton. *In front*: Dr J. A. Madden.

The possibility that the IRA in western counties like Galway and Mayo could become active and organised enough to realise their full military potential like IRA units in Counties Cork, Limerick and Clare was a real danger for the British. The longer the war continued the more likely it became for these counties and inactive IRA units in the midlands to grow in strength. Vice-Commandant Patrick Joseph Cannon claimed: 'The Truce found us in good form and our morale high … We had about 100 rounds per rifle. In fact we had more arms than we had ammunition for. We could put more men under arms by re-distributing the ammunition and this was our intention had it come to a resumption of fighting. However we were very glad to get a decent rest, a good clean up and regular meals once again.'

Reference: Patrick Joseph Cannon, Bureau of Military History WS 830, p. 14.

The mayor of Dublin greets General Nevil Macready as he arrives at the Mansion House in Dublin on Friday 8 July 1921 to arrange a truce with the IRA. Macready travelled to the meeting armed: 'The complementary effusions in the Irish Press on my sudden appearance were rather damped when the efforts of the press photographers were given to the public, because in one picture the outline of my trusty automatic in the right hand pocket of my coat was painfully conspicuous, and drew down upon my head the wrath of an editor who considered that I should not have spoiled such an occasion by want of confidence in the people. I learnt many things in the years I spent in the Emerald Isle, but confidence in its people was not one of them.'

Reference: The Right Honourable General Sir Nevil Macready, *Annals of an Active Life*, Vol. II (Hutchinson, London 1924), pp. 571–7.

Author's Collection

The bodies of four British soldiers, who were abducted and executed by an IRA patrol in Cork on 10 July 1921, just hours before the Truce came into effect. The four were off duty and unarmed when they were captured. The previous night the British army abducted and killed Dennis Spriggs an unarmed IRA Volunteer captured during a raid on his family home.

Imperial War Museum Q107745

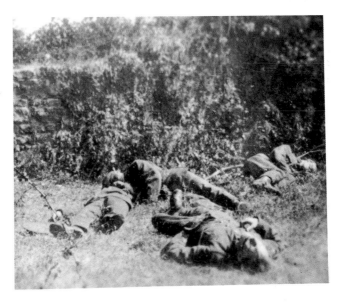

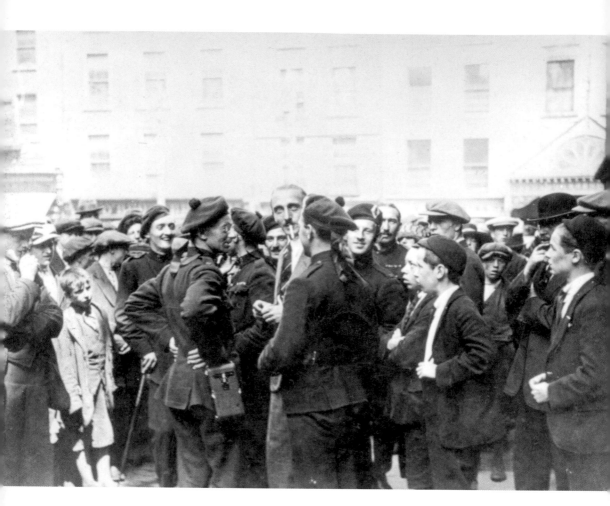

The scene outside Dublin Castle a few moments after the Truce came into effect at noon on 11 July 1921. The RIC Auxiliaries have a jovial air and all appear to be unarmed. The laughing Auxiliary on the left is holding a golf club and his comrade to the right has a camera. The young boys on the right are transfixed by the novelty of being able to study the infamous Auxiliaries so closely. By contrast, most of the adults in the photograph are far more cautious and maintain a distance.

Mercier Archives

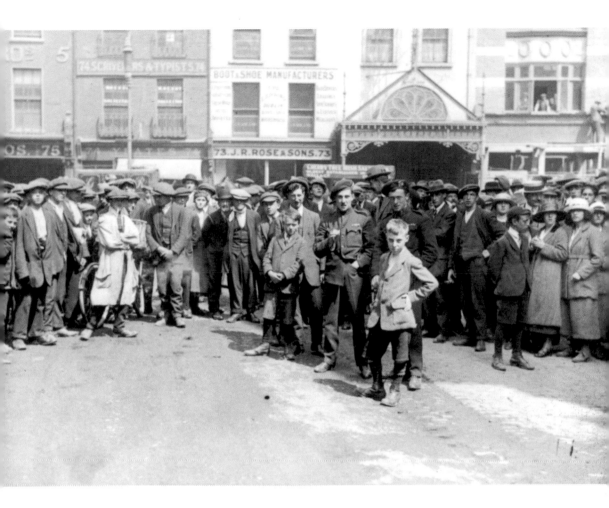

As the beginning of the Truce approached, a large crowd gathered at the gates of Dublin Castle, expecting some formal announcement or ceremony to mark the beginning of the ceasefire. However, there was nothing to mark this momentous occasion other than the appearance of a number of unarmed RIC Auxiliaries who mingled with the crowd. The moment was captured on film by a number of press photographers.

Mercier Archives

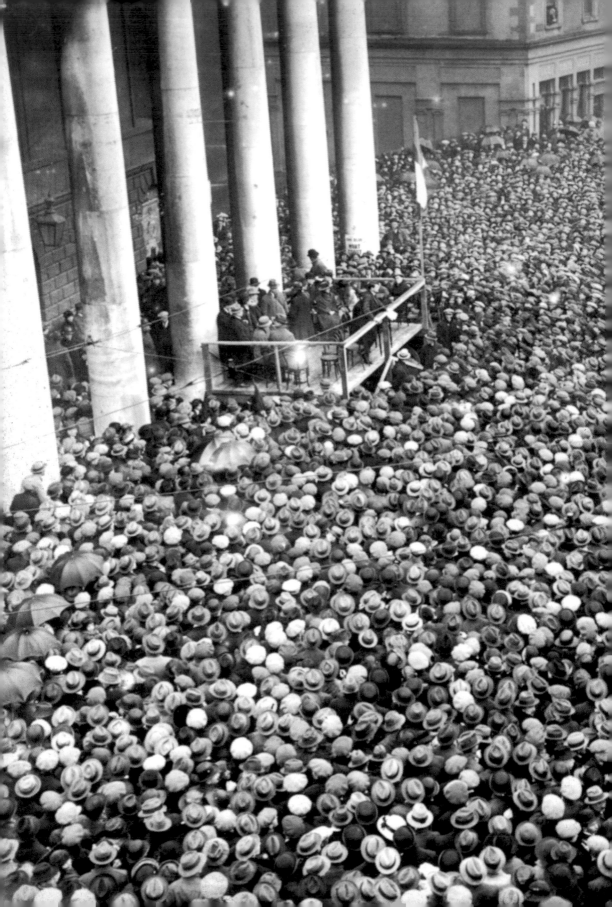

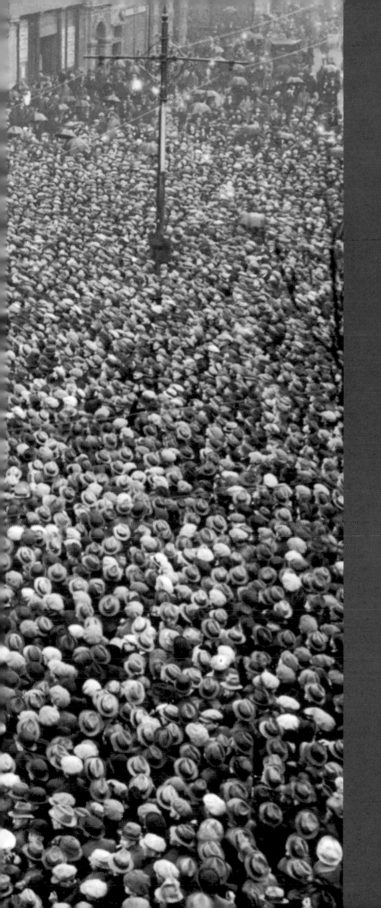

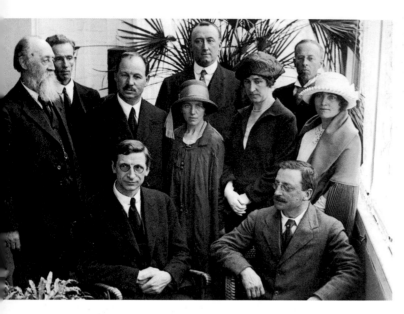

The Irish government team which took part in the first round of negotiations in London, July 1921, photographed at the Grosvenor Hotel.

Standing L to R: Count Plunkett, Erskine Childers, Laurence O'Neill, Lily O'Brennan, Dr Robert Farnan, Mrs Farnan, Robert Barton, Kathleen O'Connell.

Seated L to R: Éamon de Valera, Arthur Griffith.

Mercier Archives

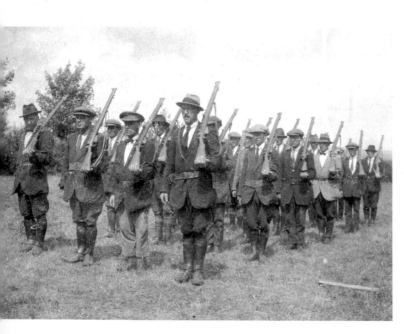

An IRA unit in training during the Truce. Although lacking military uniform, the group pictured appear to be well armed and well trained – the nucleus of a modern military force. All the men pictured are armed with British army issue Lee Enfield rifles. Most members of the IRA believed that the Truce was a temporary measure and regarded it as a 'breathing space' they could use to train and re-arm. They were convinced that the conflict with the British would resume within a short time.

Courtesy of Irish Military Archives, BMH

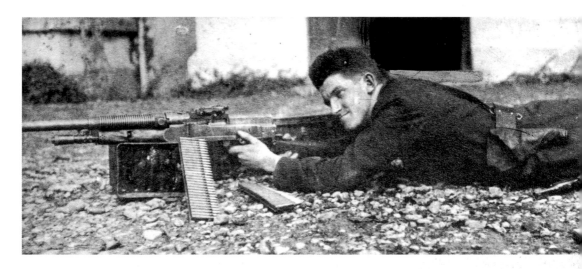

Seán 'Jack' Sharkey training with a Hotchkiss machine gun during the Truce. Sharkey was the intelligence officer for the 5th Battalion, 3rd Tipperary Brigade. During the Truce many senior Republicans, including IRA intelligence officers and others who were previously unknown to British intelligence, became publicly identified as members of the IRA. Sharkey, a native of Clonmel, was a keen amateur photographer who took many photographs in the War of Independence–Civil War period.

Mercier Archives

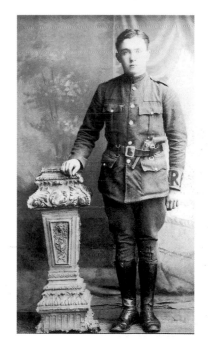

John Gannon from Westport, Co. Mayo, a member of the Irish Republican Police (IRP), taken around 1922. Gannon later took the pro-Treaty side during the Civil War and joined the Free State army. He emigrated to the United States in the late 1920s and served briefly in the American army during the Second World War.

As the Dáil courts gained popular support in 1920, they needed a body to enforce their rulings. Initially the IRA performed these duties, but in June 1921 the IRP was organised as a separate police force under the command of Simon Donnelly. The IRP enforced the writ of the Dáil courts, maintained public order, acted as stewards at large gatherings, enforced licensing laws and were generally tasked with detecting and punishing criminals. This is an exceptionally rare photograph of a member of the Republican Police in uniform. Note the letters IRP on Gannon's left sleeve.

In March 1922 the Provisional Free State Government replaced the IRP with a new police force, the Civic Guard, which later became an Garda Síochána.

Reference: Gregory Allen, *The Garda Síochána. Policing Independent Ireland 1922–82* (Gill and Macmillan, Dublin 1999), pp. 9–10.

Courtesy of John Gannon's grandnephew John Francis Gannon. © John Francis Gannon

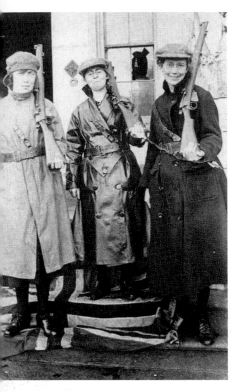

Cumann na mBan members. *L to R*: May Burke, Eithne Coyle and Linda Kearns. This photograph was taken at an IRA training camp in Duckett's Grove, Carlow, in late 1921. These three women had escaped from Mountjoy Jail along with Aileen Keogh on 31 October 1921 and even though the Truce was in effect they were in hiding at the time the photograph was taken. Kearns had been sentenced to ten years imprisonment after she was arrested at a British military roadblock in Sligo driving a car full of arms for the IRA. Although Republican women carried out dangerous and important duties in intelligence work and in transporting arms, they were generally kept out of the firing line and often confined to a more traditional role by the IRA, providing meals and administering first aid. However, Republican women appear to have played a more direct military role during the attack on Kilmallock RIC Barracks in Limerick, when members of a Cumann na mBan contingent used a rifle to fire on the barracks.

References: Sinead McCoole, *No Ordinary Women – Irish Female Activists in the Revolutionary Years* (O'Brien Press Ltd, Dublin 2003), pp. 83–4; James Maloney, Bureau of Military History WS 1525.

Author's Collection

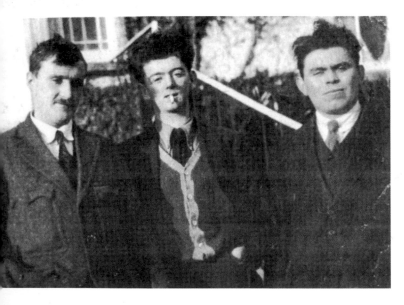

Three of the IRA's most prominent leaders in Munster. *L to R*: Liam Deasy, commander of the IRA's 3rd West Cork Brigade, Tom Barry, leader of the 3rd West Cork Brigade's flying column and Dan Breen, commandant of the 3rd Tipperary Brigade, photographed after the Truce. All three were to take the Republican side during the Civil War and later wrote books about their experiences in the War of Independence.

Mercier Archives

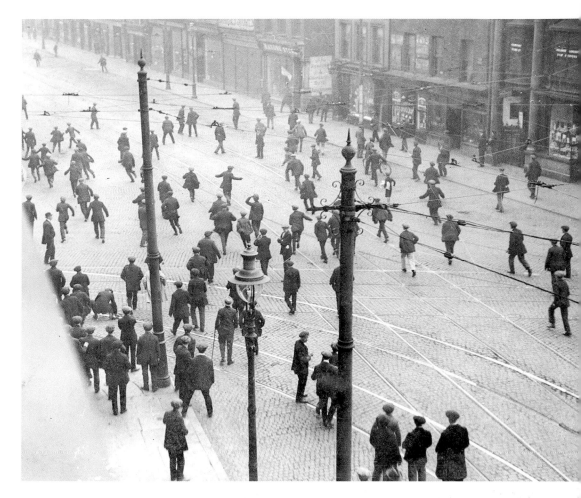

'The Battle of York Street' sectarian riot in Belfast. Protestant Unionist workers (*foreground*) driving Catholic Nationalist workers (*background*) along York Street. During the War of Independence and throughout the Truce sectarian rioting periodically erupted in Belfast. Approximately 450 people were killed and another 1,100 were wounded in the city between July 1920 and June 1922. Over 600 houses and business premises were destroyed, the majority of them in arson attacks. Over 6,000 Catholics and 1,000 Protestants were forced from their homes by intimidation and sectarian attacks in the same period. Although Catholics made up only 24% of Belfast's population, they accounted for almost 70% of those killed and a similar number of those wounded during political violence in the city.

Reference: Robert Lynch, *The Northern IRA and the Early Years of Partition* (Irish Academic Press, Dublin 2006), p. 29.

Courtesy of Kilmainham Gaol Museum 19PO IA32 17

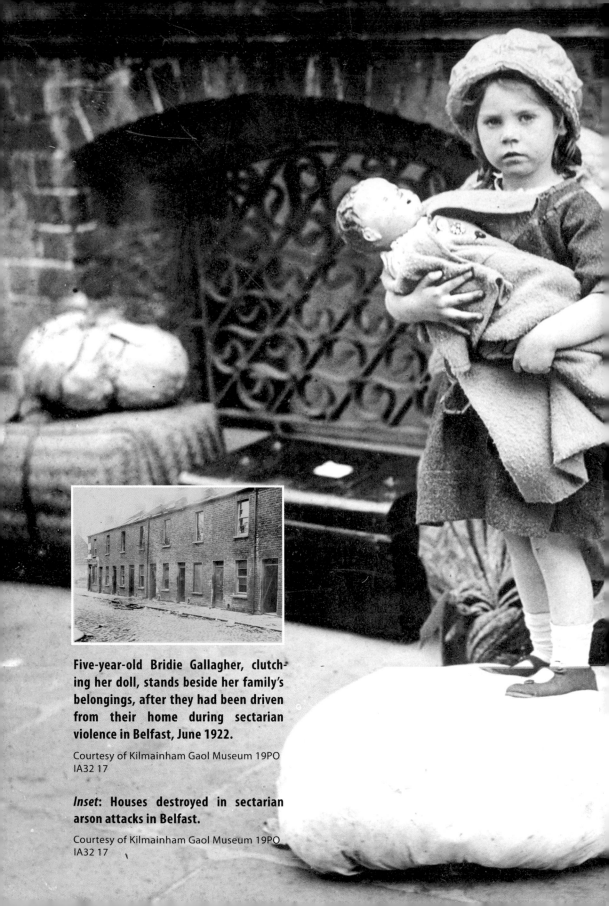

Five-year-old Bridie Gallagher, clutching her doll, stands beside her family's belongings, after they had been driven from their home during sectarian violence in Belfast, June 1922.

Courtesy of Kilmainham Gaol Museum 19PO IA32 17

Inset: **Houses destroyed in sectarian arson attacks in Belfast.**

Courtesy of Kilmainham Gaol Museum 19PO IA32 17

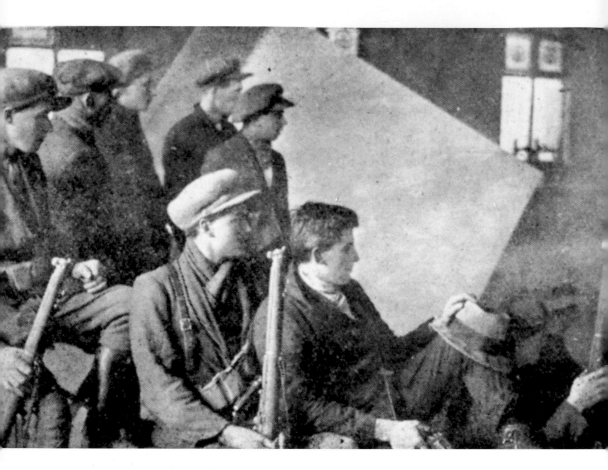

'Men of the South'. This photograph was taken in the autumn of 1921 at Seán Keating's studio, when he was working on his famous painting 'An IRA Column', better known as 'Men of the South'. The idea for the painting began as a suggestion by Albert Wood, a member of the Irish bar, that Seán Moylan should have his portrait painted by Keating. Keating felt that the painting would have more historic and artistic value if a group of men could be depicted. IRA Volunteers from the North Cork Brigade's flying column sat for the painting and this photograph. The painting, now hanging in the Crawford Municipal Art Gallery in Cork, was actually a second version of the work. Ironically, the original painting featuring Moylan was never completed. Keating later stated: 'Revolutionaries should remember that they are making history, and that history belongs to posterity and should be documented in paint as well as print.'

Included in this photograph are: D. O'Sullivan, Meelin; John Jones, Ballydesmond; Roger Kiely, Cullen; Dan Browne, Charleville; James O'Riordan, Kiskeam; Denis O'Mullane, Freemount and James Cashman, Kiskeam.

Reference: *An Introduction to the Bureau of Military History* (Irish Military Archives 2002), pp. 49–51.

Mercier Archives

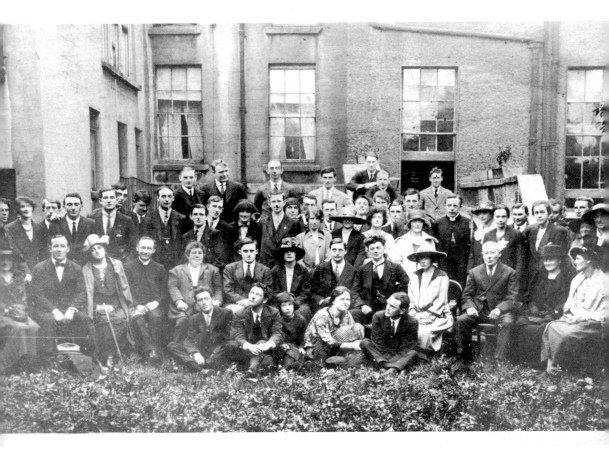

Wedding photograph of Tom Barry and Leslie Price, 22 August 1921. Barry was the commander of the 3rd West Cork Brigade's flying column. Price was a leading member of Cumann na mBan and had been part of the GPO Garrison in 1916. *Seated on ground L to R*: Dick Cotter, Éamonn Price, Eva Price, Phyllis Ryan and Gearóid O'Sullivan. *Front row seated L to R*: Máirín McCavock, Harry Boland, Jenny Wyse Power, Archdeacon O'Callaghan, Mrs Price, Liam Deasy, Leslie Price, Éamon de Valera, Tom Barry, Nancy Wyse Power, Mr Price, Mary MacSwiney, Countess Markievicz. *First row standing L to R*: Seán Lehane, Kathleen Kerrigan, Jack Price, Pete Kearney, Jim Hurley, Ted Sullivan, Michael Collins, Seán McCarthy, Mick Crowley, Richard Mulcahy, Mrs O'Donovan, Eoin O'Duffy, Mrs Tom Cullen, Kathleen Phelan, Liam Tobin, Emmet Dalton, Marie O'Reilly, Tom Cullen, Aoife Taffe, Rory O'Connor, Susan Column, Seán MacSwiney, Fr Tom Duggan, Fiona Plunkett, Theresa Ní Mhodhráin, Tadhg Sullivan, Seán Buckley, Eileen Colum, Agnes Sharpe. *Second row standing L to R*: the hotel proprietor, Seán Hales, Liam Devlin, Vincent Gogan, Paddy Dalton, Mick Price and Joe O'Reilly.

This was one of the last occasions that such a gathering of Irish Republican leaders occurred before the split over the Treaty and the Civil War that followed. Several of those pictured were killed a short time later. Boland was shot by Free State soldiers and died on 2 August 1922; the IRA in Dublin assassinated Hales on 7 December 1922; O'Connor was executed by the Free State army at Mountjoy on 8 December 1922; and Michael Collins was killed in an ambush at Béal na mBláth, Cork, a year to the day the photograph was taken.

Mercier Archives

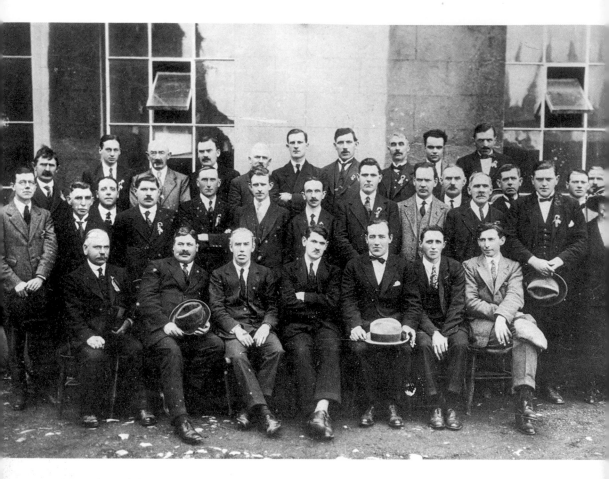

Members of the IRA's 4th Northern Division accompanied by members of IRA General Headquarters at a meeting to organise the commemoration of the sixth anniversary of the 1916 Rising, in Armagh, September 1921.

Front row L to R: Michael Garvey, Armagh; Seán Ua Murthille, Cork; Éamonn Donnelly, Armagh; Michael Collins; Harry Boland; Tom Cullen, Collins' bodyguard; Joseph Dolan.

Middle row L to R: Charles Rooney; George Murnaghan, Omagh; Michael Short, Cornelius MacElroy, Patrick Feagan, Armagh; Eoin O'Duffy, Monaghan; Seamus Reilly, Thomas Duggan, Armagh; Samuel Johnston; Peter Hughes, Dundalk; Malachy Kearney; Patrick Teigue, Dr Walter McKee, Armagh; Seamus McGuill, Dromintee; John Garvey, Armagh; Mrs Seamus McGuill, Dromintee.

Back row L to R: James Mallon, Armagh; Frank McKee; Edward Fitzpatrick; Charles Garland; — McStavrick; Liam Healy; Patrick Lenagh, Milford; James Trodden, Armagh; Joseph McKelvey; John H. Collins, Newry.

Courtesy of Kilmainham Gaol Museum 19PO IA22 25

Sinn Féin leaders watching the 1921 All-Ireland Hurling Final at Croke Park, September 1921. *L to R*: Arthur Griffith, Éamon de Valera, Laurence O'Neill and Michael Collins. Limerick won the match, defeating Dublin.

Mercier Archives

Emmet Dalton, head of a special unit which acted as Michael Collins' bodyguard during the Treaty negotiations in London. He had purchased an aeroplane which was constantly on standby to fly Collins back to Ireland in case the talks collapsed and war resumed. Dalton was an ex-British soldier who had fought in the Royal Dublin Fusiliers during the First World War, for which he was awarded a Military Cross. He joined the IRA in 1919, became the assistant director of training and played a leading part in the attempt to free Seán MacEoin from Mountjoy. Dalton took the pro-Treaty side during the Civil War and became director of military operations in the Free State army. He convinced the Provisional Government to use artillery against the IRA garrison in the Four Courts and was with Michael Collins when he was killed at Béal na mBláth. In later life he worked as clerk of the Seanad, was employed as an agent for Paramount Films and became a professional gambler, before founding Ardmore Film Studios in Wicklow.

Reference: *Dictionary of Irish Biography*, Vol. 3 (Cambridge University Press, Cambridge 2009), pp. 7–9.

Mercier Archives

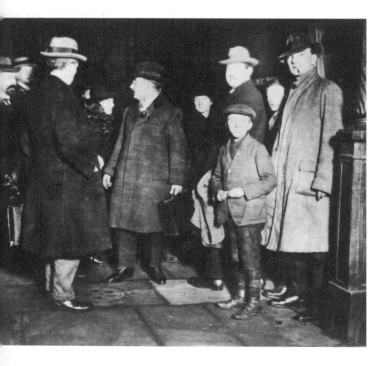

Some of the Irish plenipotentiaries photographed at Hans Place, London, during the Treaty negotiations. *L to R*: Gavan Duffy, Erskine Childers (*back to camera*), Arthur Griffith (*holding briefcase*) and Michael Collins. The final draft of the Treaty was signed at 2.10 a.m. on the morning of 6 December 1921, following two months of negotiations. The negotiations were on the point of breaking down when at a decisive moment British Prime Minister Lloyd George compelled the Irish delegation by threatening 'immediate and terrible war' if they did not sign the Treaty that night.

Courtesy of Irish Military Archives

David Lloyd George, British prime minister 1916–1922. Although many aspects of the Treaty, in particular the issue of partition, proved divisive in Ireland, the key issue which split the Republican ranks was the oath of allegiance to the British monarchy. Supporters of the Treaty claimed that the oath was merely a formality and that they had forced the British negotiators to accept a very weak form of oath. Opponents of the Treaty considered the oath a betrayal of everything they had fought for, as they had sworn allegiance to the Irish Republic and were prepared to die to defend it. Lloyd George told the British government: 'the terms of the oath to be taken by members of the Irish Free State are remarkable and are better in many respects than the terms of the oath of allegiance ordinarily required in Great Britain'. However, British Conservative discontent with the Treaty was one of the factors that contributed to his overthrow in October 1922.

Reference: Frances M. Blake, *The Irish Civil War and what it still means for the Irish people* (Information on Ireland, London 1988).

Mercier Archives

Seán Moylan (*left*) and Gearóid O'Sullivan, en route to the Dáil debate on the Treaty, find their path impeded by an IRA roadblock that had been constructed during the War of Independence. In a speech on 22 December 1921, Moylan drew attention to the fact that for all the talk of British troops being withdrawn from Ireland they were being reinforced in the six counties: 'This Treaty is a sham. Take the wrapping from it and what do you find? A weapon fashioned, not to exterminate, but to consolidate British interests in Ireland. Apply one simple test. As we stand here today – we are a Republic. Approve of this Treaty, and you re-establish and re-entrench the forces and traditions of the Pale behind a new frontier – the frontier of Northern Ireland. And you abandon your own people in the north in the same loathsome way ... The enemy forces depart from the North Wall and Dun Laoghaire, but they disembark on the Lagan and the Foyle.'

Reference: *Official Report, Treaty Debate* (Stationary Office, Dublin).

Courtesy of Aideen Carroll

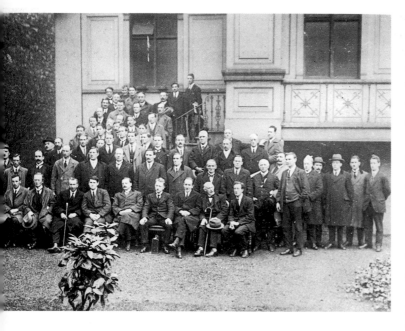

The Provisional Government of the Irish Free State at the Mansion House, Dublin. On 7 January 1922 Dáil Éireann voted to ratify the Treaty by 64 votes to 57. Following the vote de Valera resigned as president and was replaced by Arthur Griffith, who then appointed a new cabinet of pro-Treaty Sinn Féin TDs. In protest, de Valera led his followers out of the assembly. Under the terms of the Treaty, the Free State was to come into existence on 6 December 1922, the first anniversary of the signing of the Treaty. Until then, the British government would hand over power, in stages, to the Provisional Government. The government met for the first time on 14 January. Its members consisted of the pro-Treaty Sinn Féin TDs and a handful of Unionist MPs representing Trinity College.

Courtesy of Kilmainham Gaol Museum 20PO 1A35 16

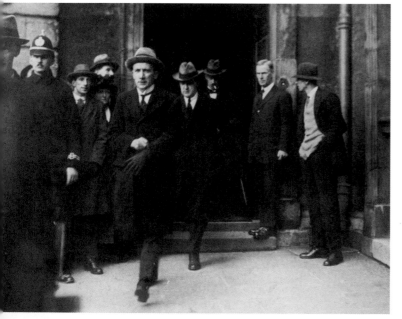

Kevin O'Higgins, Michael Collins and Éamonn Duggan leaving Dublin Castle, for centuries the seat of British government in Ireland, after it was formally handed over to the Provisional Government on 16 January 1922.

Mercier Archives

Richard Mulcahy (*left*) inspects Free State troops at Beggars Bush Barracks January 1922. With the formation of the Provisional Government, the British army began to withdraw British troops from their barracks in the Free State. As the British forces withdrew, their former barracks were taken over by both pro-Treaty and anti-Treaty units of the IRA. Each unit moved into the evacuated barracks in their area, regardless of their political loyalties on the issue of the Treaty. The first barracks to be evacuated by the British was Beggars Bush Barracks in Dublin, which was taken over by pro-Treaty members of the IRA's Dublin Brigade who were fitted with new uniforms for the occasion. Now the political split between the pro-Treaty and anti-Treaty IRA became clearly visible. The pro-Treaty former IRA units, wearing their new green uniforms, formed the nucleus of the Free State army, while the anti-Treaty units continued as the Irish Republican Army.

Mercier Archives

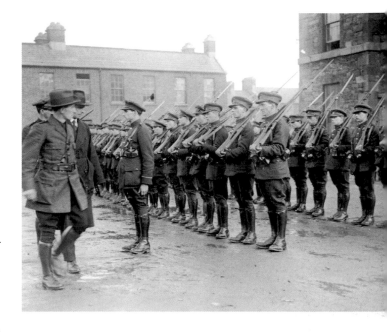

Eoin O'Duffy (*left in civilian clothes*) and Richard Mulcahy (*on O'Duffy's right in uniform*) presenting the Tricolour to Paddy O'Daly, the commanding officer of the new garrison of Beggars Bush Barracks. O'Daly, a veteran of the 1916 Rising and member of 'The Squad' during the War of Independence, earned an infamous reputation during the Civil War when the Dublin Guard killed a number of Republican prisoners in Kerry.

Mercier Archives

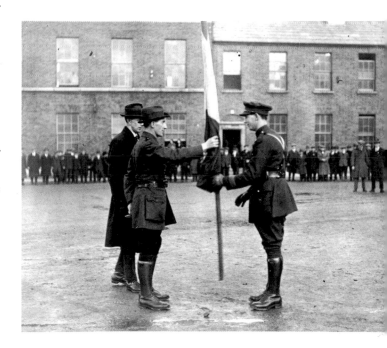

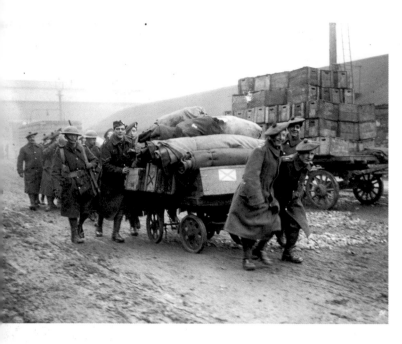

British soldiers from a Scottish regiment hauling luggage to a quayside in Dublin, January 1922.

Mercier Archives

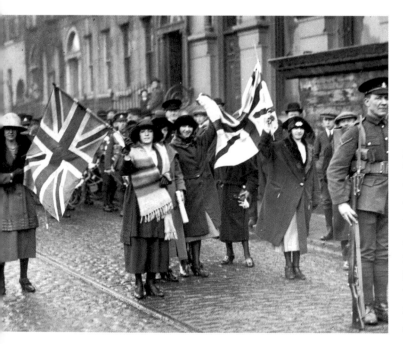

Unionist women cheering British soldiers on their way to the North Wall, Dublin, for evacuation back to Britain. While the majority of the population in southern Ireland were by that time pleased to see a British military withdrawal, southern Unionists had strong social and business connections with the British army whom they saw as a protective force.

© RTÉ Stills Library

British army vehicles being loaded onto a ship during the evacuation.

Mercier Archives

British soldiers leaving Letterkenny, Co. Donegal.

Courtesy of the McGinley Collection

As they wait to take over their new barracks, a Free State army officer and his men salute the withdrawing British troops. The salute is returned with a look of grudging respect by a passing British officer. The practicalities of the new political and military situation brought about by the Treaty led to a low level of co-operation between the British and Free State armies.

Courtesy of Kilmainham Gaol Museum 19PC IB51 04

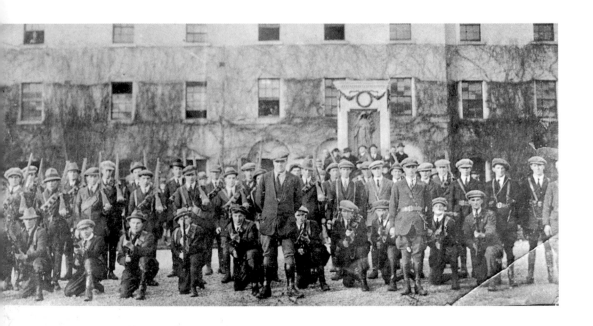

The new IRA garrison at Clonmel Barracks 1922. The giant of a man standing at the front is Commandant Paddy Dalton, known as 'the Armoured Car'; the other IRA officer standing to the right of Dalton is Vice-Commandant Seán Morrissey. Paddy Dalton was killed during the Civil War fighting Free State troops at Donohill, Tipperary, on 26 October 1922. Courtesy of Kilmainham Gaol Museum 19PC IB51 04

Four nephews of Michael Collins. *L to R*: Sergeant Finian O'Driscoll, Private Fachtna O'Driscoll, Quartermaster Sergeant Seaghan Powell and Private Michael Powell. Personal and family connections were often as important as politics and ideology for those who had to choose sides during the Civil War. The split within IRA units at the time was often determined by local, non-political factors and loyalty to the local leadership. Michael Collins' personal popularity was hugely influential in winning support for the Treaty and the fledgling Free State with many declaring: 'If it's good enough for Mick Collins, then it's good enough for me.'

© RTÉ Stills Library

Sinn Féin's Ulster delegates arrive at the Sinn Féin Ard-Fheis in February 1922.

Mercier Archives

REVOLUTION

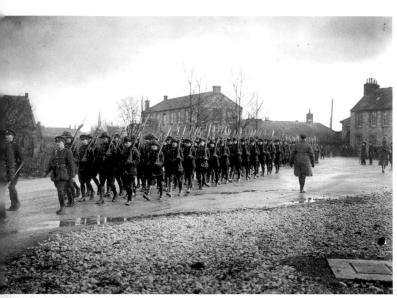

Free State troops arriving to take control of Victoria Barracks, Athlone, from the British army, 1 February 1922.

Mercier Archives

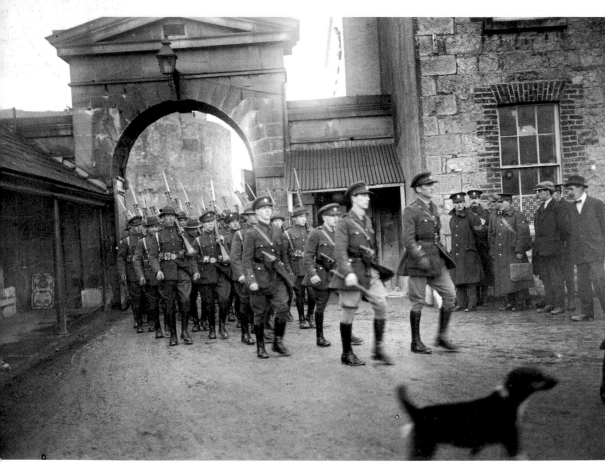

Commandant Seán MacEoin, 'The Blacksmith of Ballinalee', addressing troops at the handing over of Athlone Barracks. MacEoin was the leader of the North Longford Brigade flying column during the War of Independence. Along with Michael Brennan from Clare and Donnchadh O'Hannigan from Limerick, MacEoin was one of the most successful IRA leaders to support the Treaty.

Mercier Archives

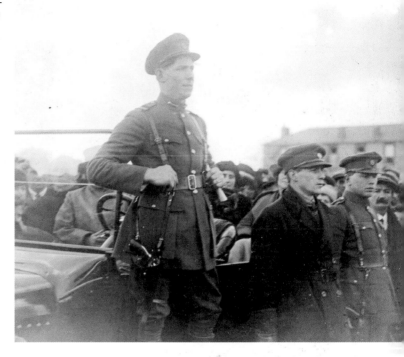

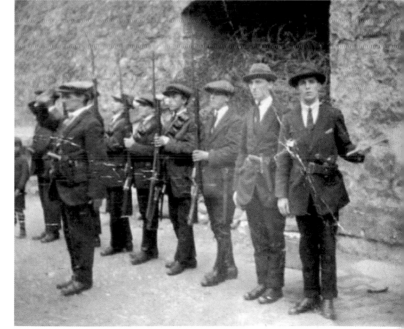

An armed IRA guard after taking control of Kilmainham Gaol from the British.

Courtesy of Irish Military Archives, BMH P8

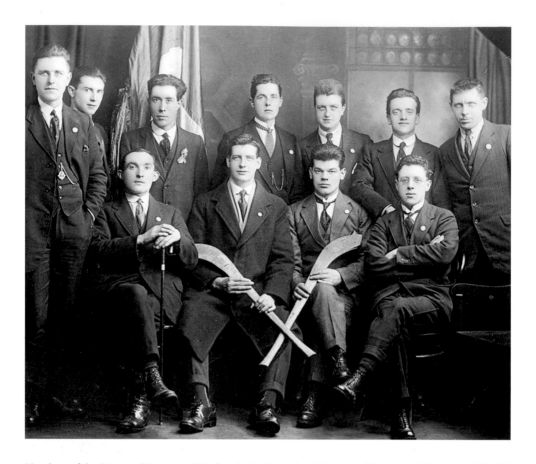

Members of the Liverpool Company IRA after their release from Dartmoor Prison on 14 February 1922. IRA brigades located in British cities, with large first- and second-generation Irish communities, played an important role during the War of Independence. They smuggled arms and explosives to Ireland, carried out acts of industrial sabotage, gathered intelligence information on members of the British forces who were serving in Ireland and carried out arson attacks on their homes. IRA brigades in Britain were often more active in carrying out attacks and military operations than their counterparts in some parts of Ireland. Seated on the far right is Volunteer John A. Pinkman. Pinkman went to Dublin after his release, joined the Dublin Guard unit of the Free State army, and fought in several major battles in the Civil War. He later emigrated to the United States and became a Labour activist and Trade Union organiser. His memoir, *In the Legion of the Vanguard,* is one of the few published accounts of the Civil War written by an ordinary Free State soldier.

Courtesy of Kilmainham Gaol Museum 19PC 1B51 04

IRA reinforcements arriving in Limerick city, March 1922. Tensions between the IRA and the Free State army grew as both jostled to gain the military advantage by occupying military barracks as the British withdrew. In February 1922 Richard Mulcahy ordered Commandant General Michael Brennan and the 1st Western Division of the Free State army to enter Limerick city and take over military barracks that the British army were due to evacuate. Officially the Provisional Government's policy was that the local force would take over any evacuated barracks in their brigade area, regardless of whether that force was IRA or Free State army. However, Limerick city was regarded as a key military position and this was the first time that a Free State army unit had been ordered to take control of military barracks in an IRA brigade area. The stand-off between Michael Brennan's Free State troops and the IRA units in the city commanded by Ernie O'Malley, Seamus Robinson and Tom Barry created a powder keg ready to explode and ignite civil war.

Courtesy of Limerick Civic Museum

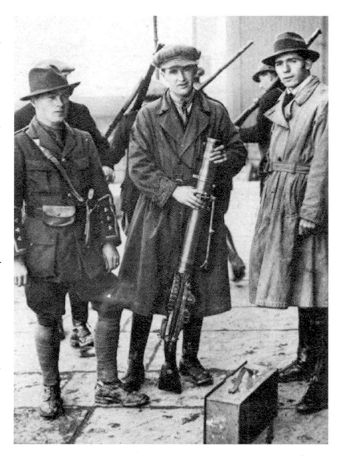

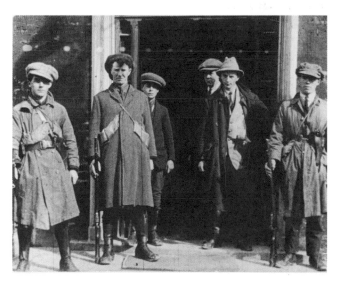

IRA Volunteers in Limerick city during the crisis in the city, March 1922.

Mercier Archives

197

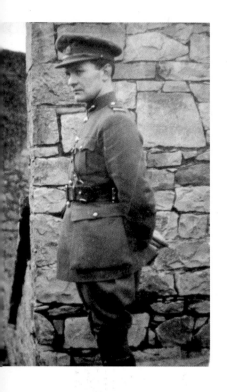

Commandant General Michael Brennan, commander of the Free State army in Limerick, at King John's Castle, Limerick, March 1922. On 10 March 1922 an agreement was reached in Dublin between IRA leaders Liam Lynch and Oscar Traynor and the leadership of the Free State army, Michael Collins, Richard Mulcahy and Eoin O'Duffy. Under this agreement, Michael Brennan would withdraw all Free State troops from Limerick and the military barracks already evacuated by the British were to be garrisoned by a force of local IRA Volunteers. Oscar Traynor travelled to Limerick with news of the agreement. Traynor's arrival calmed the situation and the agreement postponed the start of the Civil War: 'In King John's Castle we saw Brennan who tried to bluster as he said he was going to fight and he was puffed out in his uniform like a peacock … We had an awful job with [Tom] Barry … We saw fellows lying in numbers with rifles sticking out … We were successful in getting people to call it off. Eventually they marched off singing and carrying their guns. We had to try and impress on Barry that there would be fighting at some time.'

Reference: Oscar Traynor, UCDA EOMN P17B/95.

Author's Collection

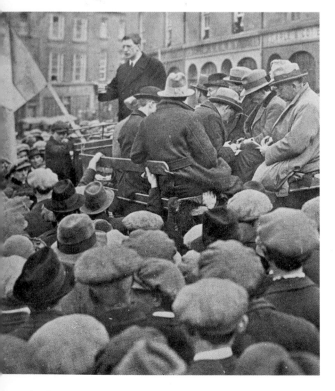

Éamon de Valera addressing a public meeting in Wexford, around March 1922. At Killarney de Valera told his audience, 'if we continue on that movement which was begun when the Volunteers were started, and we suppose this Treaty is ratified by your votes, then these men, in order to achieve freedom, will have to march over the dead bodies of their brothers. They will have to wade through Irish blood.' His opponents claimed this speech was a bloodthirsty incitement to civil war; de Valera claimed the speech had been misrepresented and that he had been warning of the danger of civil war if the Treaty was accepted. Regardless of his intended meaning, this was probably the most controversial speech of de Valera's political career and is still seen by many as an important landmark in Ireland's descent into civil war.

Reference: Calton Younger, *Ireland's Civil War* (Fontana Books, London 1970), p. 250.

Courtesy of Kilmainham Gaol Museum 20PC IA45 22

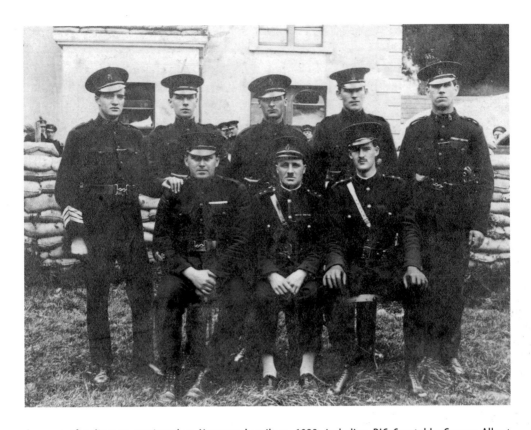

A group of policemen stationed at Newtownhamilton, 1922, including RIC Constable George Albert Crawford (*standing second from left*). When the RIC disbanded in 1922, Crawford transferred to the Ulster Special Constabulary and later to the RUC. Like many former RIC men, Crawford felt he had no choice but to leave southern Ireland. 'I was disbanded from Gormanstown, they paid them [other members of the RIC] off at the rate of about a hundred a day. Well the big majority were from … the Free State … like myself. They could not go home there, lots of men went away and joined the Palestine Police, some of them went across to England and joined the English Police, some of them went to America but very, very few went home to their native place. They had to go away because some men after going home were shot at for going home …'

Recently there has been a debate about whether the flight of Unionists from southern Ireland, many, though not all of whom, were Protestant, amounted to 'ethnic cleansing'. There was a significant drop in the Protestant population of southern Ireland between 1911 and 1926. However, when a multiplicity of factors are taken into account such as economic and voluntary migration, death in the First World War, British withdrawal and negative natural increase, research suggests that those forced to leave accounted for the minority of total Protestant departures. It should be remembered that a number of Catholic Unionists were also forced to leave.

Reference: John D. Brewer, *The Royal Irish Constabulary: An Oral History* (Queens University, Belfast 1990), pp. 118–19.

Courtesy of Constable Crawford's grandson Keith Crawford, New Zealand. © Keith Crawford

Former members of the RIC in their new employment as members of the Palestine Gendarmerie. In March 1922 the British government began recruiting former members of the RIC to serve in the Middle East as members of the British section of this force. Over 450 former Black and Tans, 150 members of the RIC Auxiliary Division and 80 members of the regular RIC enlisted in the new British colonial police force.

Standing L to R: Frank Montgomery Scott (ex-Auxiliary Div.), Lieutenant Lennox, Captain Harold Edward Fitzgerald (ex-Auxiliary Div.), Captain Goodwin, Captain Raymond Oswald Cafferata (ex-Auxiliary Div.), Major Bockett, Lieutenant Shute (ex-Auxiliary Div.), unidentified.

Seated L to R: Major Tyler, Captain Hylton (ex-Auxiliary Div.), Colonel MacNeill, Field Marshal Plumer, Lieutenant Colonel Gerald Robert Foley (ex-RIC), Major Songest, Captain Lawes.

Courtesy of David Bockett, Dublin. © David Bockett

***Right**:* Easter, April 1922. Veterans of the 1916 Rising commemorate the Rising's sixth anniversary by marching through the city. The men marching behind the banner are members of E Company, 4th Battalion, Dublin Brigade, IRA. Most members of this unit had attended Saint Enda's, Patrick Pearse's school in Rathfarnham.

Mercier Archives

Members of the 'Truce Committee', which met at the Mansion House in Dublin on 8 May 1922. Fighting between the IRA and the Free State army broke out in Kilkenny during the first week in May and a Truce Committee of ten senior military leaders – five Free State and five IRA – managed to arrange a truce and temporarily halt the slide into civil war. *L to R*: Seán MacEoin (Free State), Seán Moylan (IRA), Eoin O'Duffy (Free State), Liam Lynch (IRA), Gearóid O'Sullivan (Free State) and Liam Mellows (IRA). This was one of the last photographs taken with the military leaders from both sides pictured together – the Civil War began less than two months later.

Mercier Archives

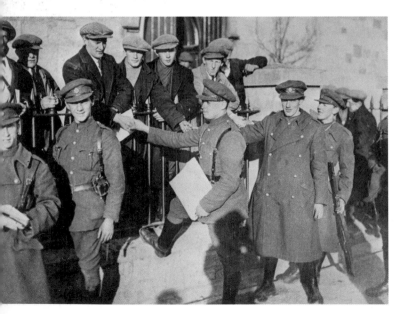

IRA Volunteers (*behind the railings in civilian clothes*) and Free State army troops in Kilkenny shake hands following the ceasefire arranged by the Truce Committee on 8 May.

Courtesy of Kilmainham Gaol Museum 20PC IA45 11

Michael Collins addressing a public meeting at College Green, Dublin, on 20 April 1922. He urged his audience to accept the Treaty as a step towards independence, claiming the Treaty 'gives us freedom, not the ultimate freedom that all nations desire to develop to but the freedom to achieve it'. In the general election in June his supporters won 58 seats, opponents of the Treaty in Sinn Féin won 35, the Labour Party won 17, Unionists 4 and the Farmers Party and Independents won 7 seats each.

Mercier Archives

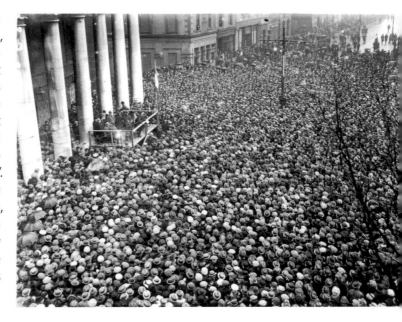

Rory O'Connor (*left*) with Molly Hyland and Muriel MacSwiney at the Wolfe Tone commemoration Bodenstown, Kildare, on 21 June 1922, five days after the general election. An IRA convention in March 1922 appointed an IRA executive under O'Connor's leadership which refused to recognise any civilian authority. The following month, supporters of O'Connor's IRA Executive occupied the Four Courts, Dublin, in defiance of the Provisional Government. The leaders of the new Free State initially managed to ignore this threat to their authority, but given the political and military tensions of the time they could not ignore the IRA's occupation of the Four Courts indefinitely.

Courtesy of Kilmainham Gaol Museum 20PO IA35 21

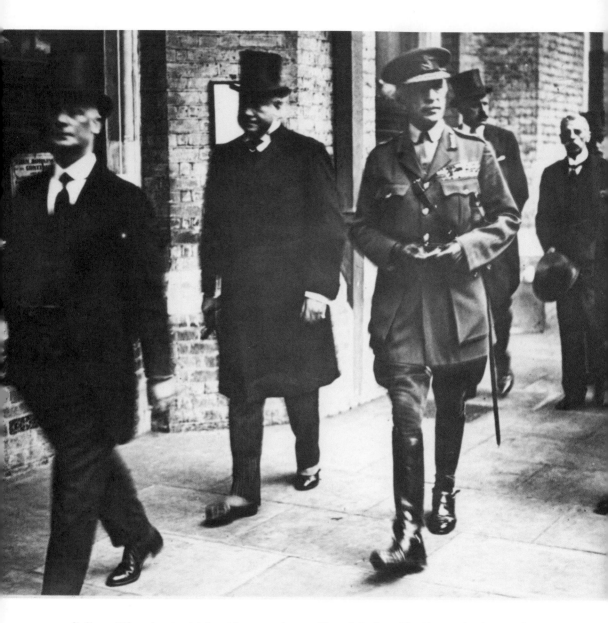

Sir Henry Wilson (*centre right*) on his way to the unveiling of the Great War Memorial at Liverpool Street Station, 22 June 1922. Upon his return to his home a few hours later Wilson was shot dead by two members of the IRA. Wilson's assassination was probably ordered by Michael Collins because of his role as security advisor for the new government of Northern Ireland, where sectarian violence was spiralling out of control. The British government believed that the IRA garrison in the Four Courts was responsible for Wilson's killing and put pressure on the Free State government to take action against it.

Mercier Archives

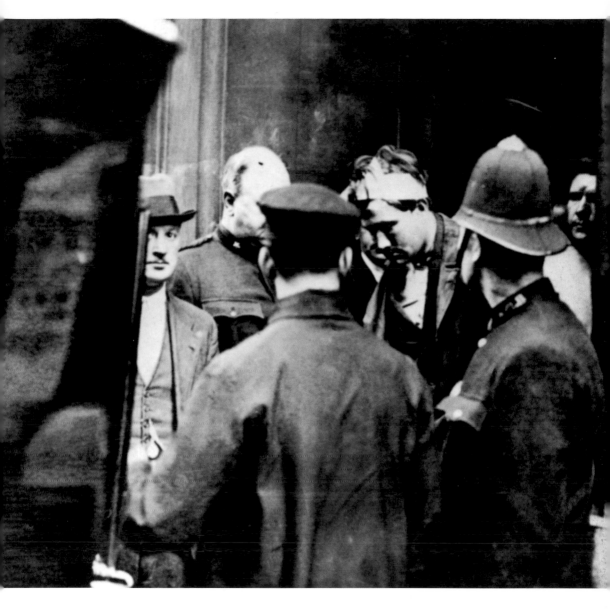

Sir Henry Wilson's killers being taken to trial in June 1922.

Mercier Archives

One of Wilson's assassins, either Reginald Dunne or Joseph O'Sullivan, being taken as a prisoner into Gerald Road Police Court, London, June 1922. Both of Wilson's assassins were former members of the British army. They were captured because O'Sullivan had lost a leg at Ypres during the First World War and could only hobble away after the shooting; Dunne had refused to abandon him. Both men were convicted of Wilson's killing and hanged at Wandsworth Prison on 10 August 1922.

Mercier Archives

Police constable on duty at the scene of Sir Henry Wilson's killing, 36 Eaton Place, London. Note the bullet hole in the door of the house.

Mercier Archives

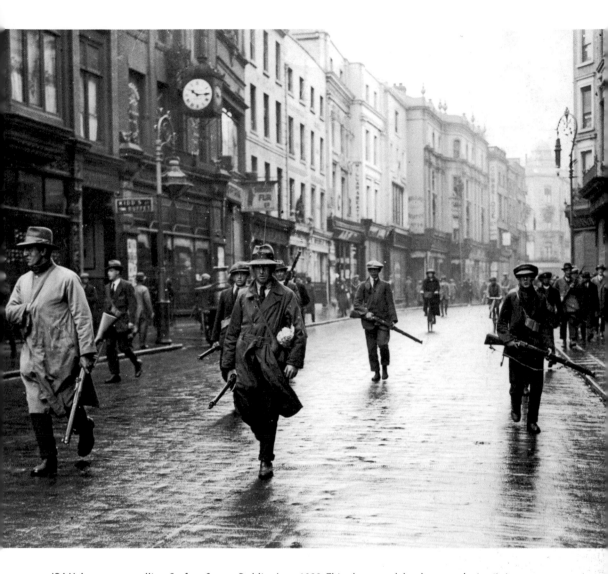

IRA Volunteers patrolling Grafton Street, Dublin, June 1922. This photograph has become the iconic image of the Republican soldier in the War of Independence and Civil War period. By June 1922 the presence of armed IRA units within Dublin was an affront to the authority of the Provisional Government. For several months the Free State had found it politically and militarily expedient to ignore this challenge to their authority, but by June it had become impossible for the Provisional Government to allow the Republicans to continue to undermine the foundations of the fledgling state. The assassination of Sir Henry Wilson in London, the arrest of General O'Connell, deputy chief of the Free State army, by the IRA and mounting pressure from the British government finally spurred the Provisional Government into action on 28 June 1922.

Mercier Archives

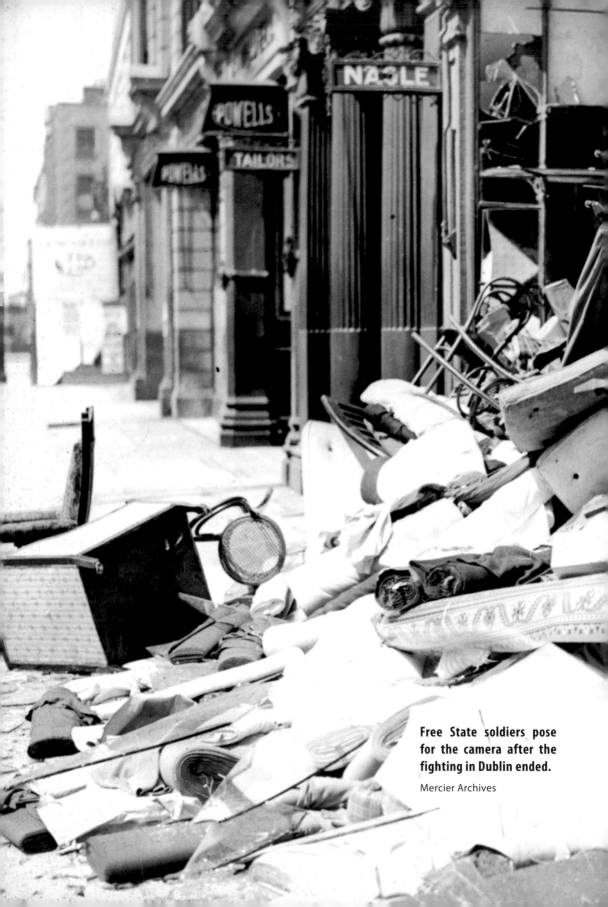

Free State soldiers pose for the camera after the fighting in Dublin ended.

Mercier Archives

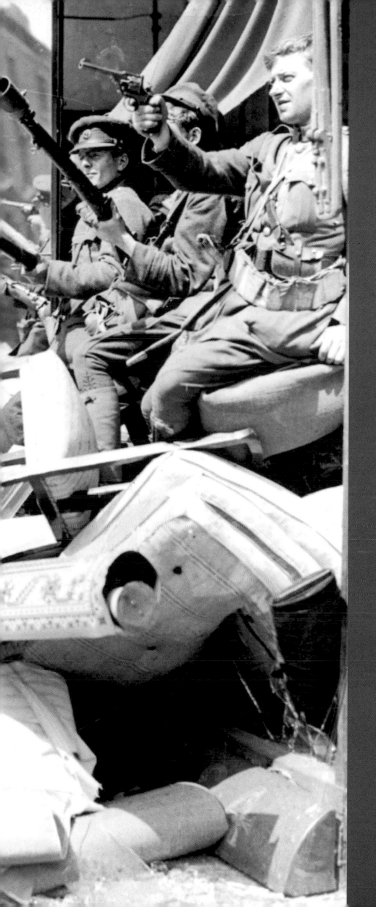

Civil War

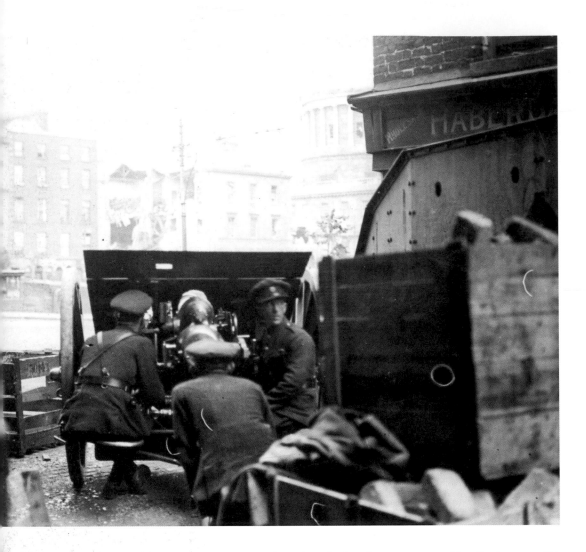

The shelling of the Four Courts, June 1922. On 27 June the Free State army arrested Leo Henderson, an IRA officer from the Four Courts. In retaliation, the IRA arrested J. J. O'Connell, deputy chief of staff of the Free State army. On 28 June the Free State army, acting on Michael Collins' orders and armed with field artillery guns borrowed from the British, issued an ultimatum to Rory O'Connor and the IRA Volunteers inside the Four Courts to leave the building by 4 a.m. and surrender to Free State troops outside. Ernie O'Malley was inside the Four Courts with O'Connor when the deadline arrived: "'Time's up,' said Rory, and as he spoke a machine gun from outside echoed across the night, to be answered by a shout from each of our sections. A heavy boom came next, and we knew artillery was being used; the crash of an eighteen pound shell announced that those who stood in arms for an independent Ireland were to be attacked by some of their former comrades.' After months of careful negotiations by leaders on both sides to avoid open conflict, the first shots in the inevitable Civil War had finally been fired.

Reference: Ernie O'Malley, *The Singing Flame* (Anvil Books, Dublin 1978), p. 97.

Mercier Archives

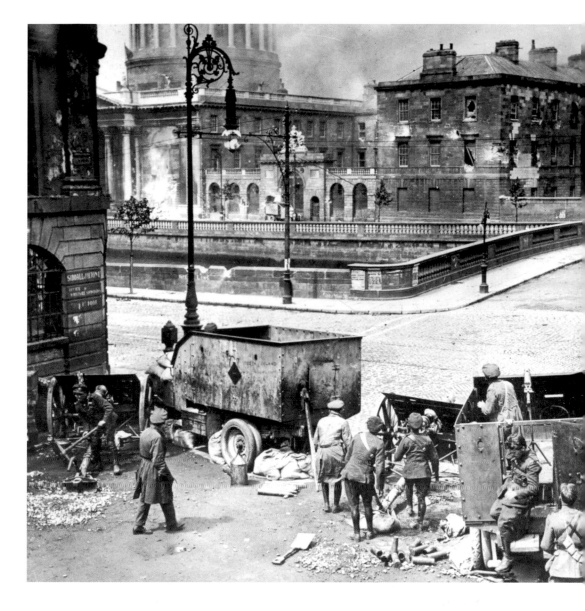

Attack on the Four Courts, 28–30 June 1922. Note the shovel and the cobblestones that have been dug up at the rear of the artillery gun. The force of the recoil caused the guns to skid over the cobblestones scattering the gun crew, so the gun's footplate had to be dug into the street to anchor the weapon. The British army had faced the same problems when they first mounted artillery pieces, designed for the mud of disputed countryside rather than city streets, to shell the GPO in 1916. The British did not supply the Free State army with explosive shells so the Free State army was forced to use shrapnel shells to reduce the building. One of the field guns fired 375 shells at the Four Courts.

Reference: Gun History Sheet, PC 625, Irish Military Archives, quoted in Liz Gillis, *The Fall of Dublin* (Mercier Press, Cork 2011).

Mercier Archives

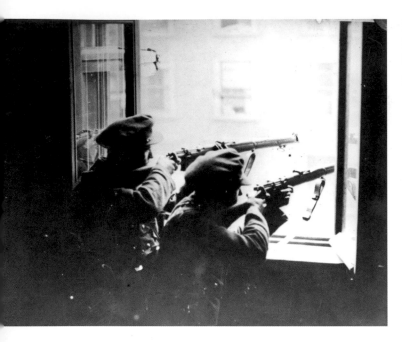

Free State soldiers taking aim from a window during the fighting in Dublin.

Mercier Archives

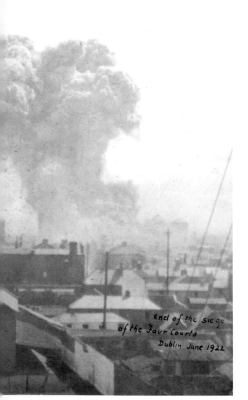

End of the siege of the Four Courts Dublin June 1922

On the morning of 30 June a massive explosion destroyed the records office and a fire soon spread throughout the Four Courts complex. It became clear shortly after this that the IRA garrison inside could not hold out much longer. This photograph was taken by a British soldier from the Oxford and Buckinghamshire Light Infantry who were awaiting evacuation at the North Dublin Union. The members of the regiment watched with glee as their Irish foes started tearing each other apart: 'The North Dublin Union can be recommended to visitors to Dublin as a most suitable position from which to view any fracas that might be going on at the time. We found it excellent for this purpose, and during the whole of the so-called battle of the Four Courts, the windows and fire escapes were thronged with sightseers. This battle was perhaps the most humorous of the many humorous incidents which we witnessed in Ireland ... on the third day the Four Courts were reduced. The "glorious boys" such of them as had escaped through the back door, were shepherded into captivity at Kilmainham Gaol, and the contest resolved itself into a running fight up and down Dublin, culminating in the destruction [of a] large part of Sackville Street.'

Reference: 'The Regimental Chronicle' quoted in Stanley C. Jenkins' article 'The Oxfordshire and Buckinghamshire Light Infantry in Ireland 1919–23', *Soldiers of Oxfordshire Trust, Sword and Bugle* 2009.

Courtesy of Oxford & Buckinghamshire Light Infantry – Soldiers of Oxfordshire Trust

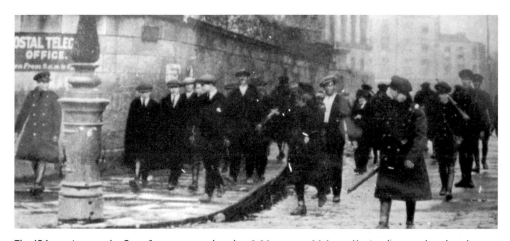

The IRA garrison at the Four Courts surrendered at 3.30 p.m. on 30 June. Having been ordered to destroy their weapons rather than surrender them to their opponents, the men marched outside and were taken prisoner. Ernie O'Malley, who believed it would be humiliating, stopped a press photographer who was preparing to take a photograph of the defeated Four Courts garrison from doing so. While O'Malley managed to spare the main body of his men this indignity, another press photographer captured this group of Republican prisoners as they were marched away to captivity by Free State soldiers.

Reference: Tim Pat Coogan & George Morrison, *The Irish Civil War* (Seven Dials Publishing, London 1999), p. 174.

Courtesy of Kilmainham Gaol Museum 20PC IA45 23

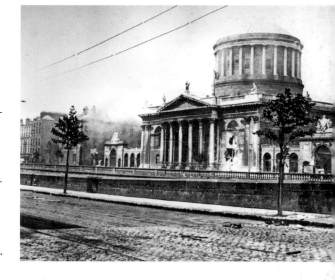

Ruins of the Four Courts after the Republican surrender. One of the most controversial aspects of the fighting in Dublin was the destruction of the records office at the Four Courts which contained thousands of documents relating to several hundred years of Irish history. There has been much debate about whether the IRA delibe-rately destroyed the records office or whether the shelling by the Free State army detonated the munitions stored there by the Republicans. When asked about the destruction of such valuable his-torical records in the House of Commons, Winston Churchill replied, 'When men are fighting about matters so important as the foundations of their country, buildings and records will often suffer ... I will only say this – that a State without archives is better than archives without a State.'

Reference: Churchill Speeches, Vol. IV, p. 3342. Quoted in Francis Costello, *The Irish Revolution* (Irish Academic Press, Dublin 2003), p. 308.

Mercier Archives

IRA honour guard at the funeral of IRA Volunteer Joseph Considine in Clooney church, late June/early July 1922. Considine was travelling to Dublin by car with a group of senior IRA leaders from Clare with arms for the Four Courts garrison. They arrived in Dublin city centre shortly after the fighting had begun and were captured. According to Paddy McMahon who was captured with him, Considine was shot dead by Free State soldiers: 'we were the first to have been arrested. All the Free Staters had a pot shot at us. Joe Considine was killed.' The figure standing at attention on the extreme left of the photograph is IRA Commandant Cornelius McMahon, who was executed by the Free State army at Limerick Prison on 20 January 1923.

Reference: Paddy Con McMahon, UCDA EOMN P17b/130.

Courtesy of Joseph Considine's nephew Shaun Considine. © Shaun Considine

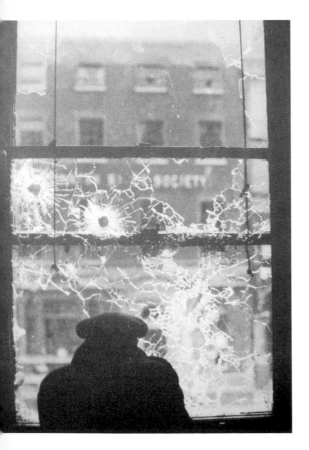

A Free State sniper takes aim from the window of a house opposite the Republican headquarters in Sackville Street. The glass in the window has been broken by a burst of machine-gun fire.

Mercier Archives

A Free State soldier reloads his rifle while his comrade takes aim at the IRA headquarters in the Hamman Hotel in Sackville Street where Oscar Traynor, Cathal Brugha and the other IRA leaders were based. Note the empty bullet casings scattered on the footpath.

Mercier Archives

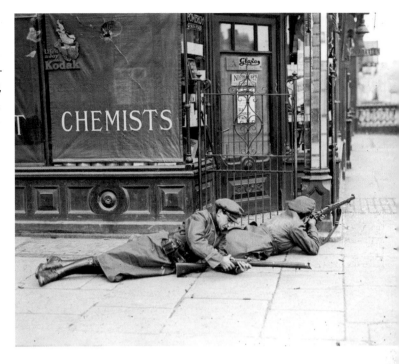

Wounded Free State troops during a lull in the fighting. At least three separate attempts were made to secure a ceasefire during the fighting: the first was made by the bishop of Dublin, a second was made by a group of Republican women led by Maud Gonne and a third by the leadership of the Labour Party. None of them was successful because the Free State government insisted that a ceasefire could only happen if the IRA were willing to surrender their arms.

Mercier Archives

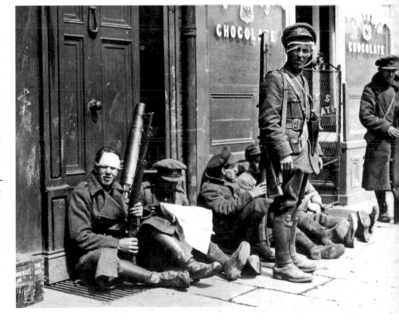

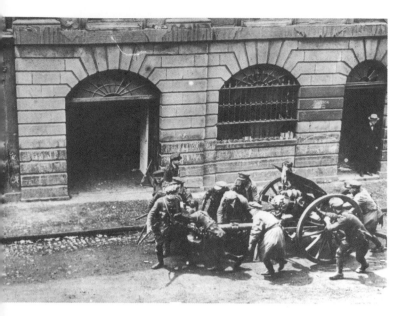

Free State troops manoeuvring one of the artillery guns into position.

Mercier Archives

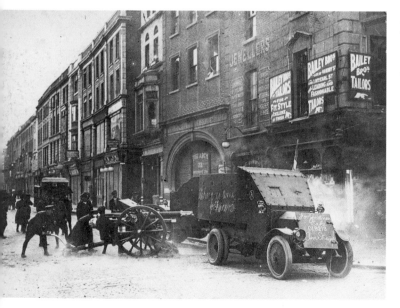

At 8 p.m., Tuesday 4 July 1922, the final assault on the Republican positions in Sackville Street began. An 18-pounder field artillery gun, protected from rifle and machine-gun fire by two Lancia armoured lorries, was positioned at the corner of Henry Street and Sackville Street opposite Nelson's column from where it began shelling the Republican headquarters in the Hamman Hotel.

Mercier Archives

A Free State armoured lorry on which members of the Free State army have chalked the legend: 'We have no time for Trucers'. After the split caused by the signing of the Treaty, both sides accused their opponents of being 'Trucileers' – raw recruits who had taken no part in the War of Independence, but who trumpeted their supposed patriotism and Republicanism afterwards. Liam Tobin estimated that during the Civil War the Free State army was composed of 50% ex-British soldiers, 40% pre-Truce IRA Volunteers and 10% civilian recruits. The IRA during the Civil War was likely to have recruited less ex-British soldiers and to have relied far more on civilian recruits. The front of the same lorry (*visible in previous photograph*) was chalked with the slogan 'For Goodness Sake Aim Straight'.

Reference: Maryann G. Valiulis, *Almost a Rebellion: The Irish Army Mutiny of 1924* (Tower Books, Cork 1985), p. 37.

Mercier Archives

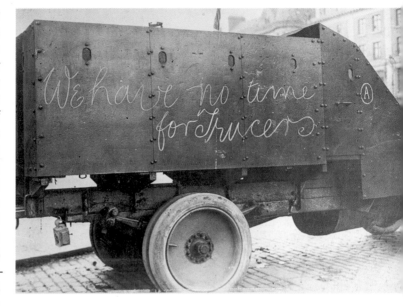

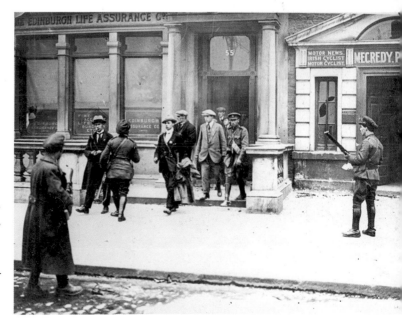

IRA Volunteers surrendering to the Free State army 4–5 July 1922. The Free State's superior firepower, weaponry and armoured vehicles forced most of the Republican positions in city centre to surrender within a short space of time.

Mercier Archives

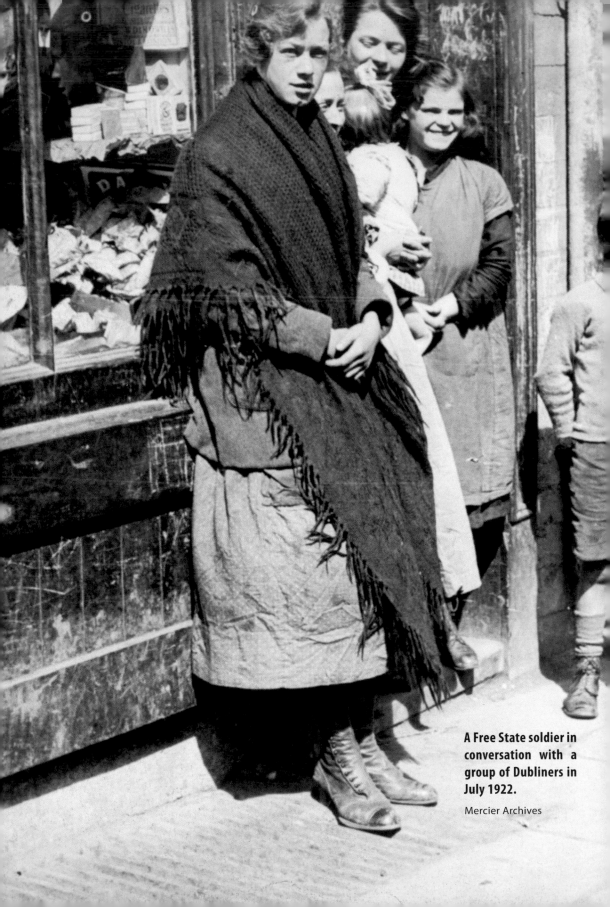

A Free State soldier in conversation with a group of Dubliners in July 1922.

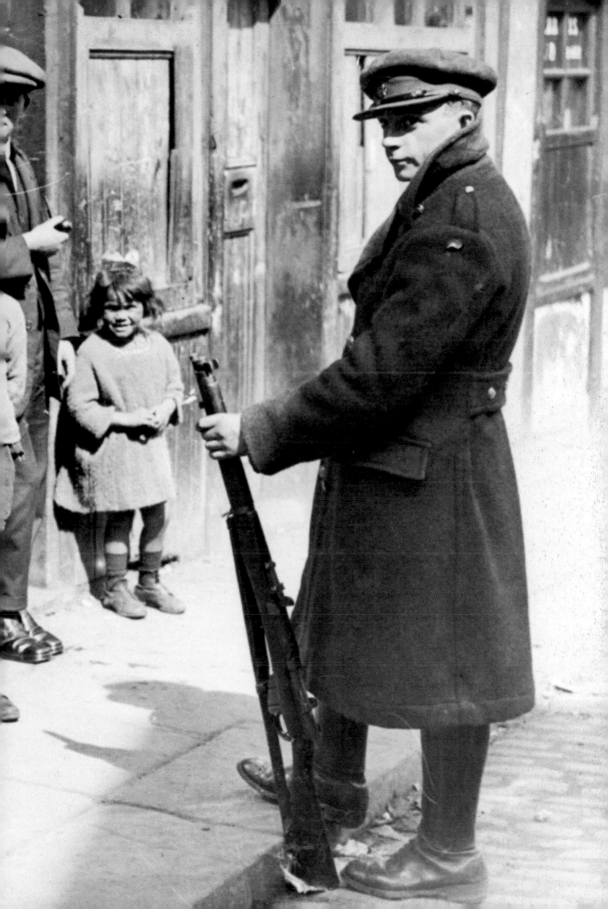

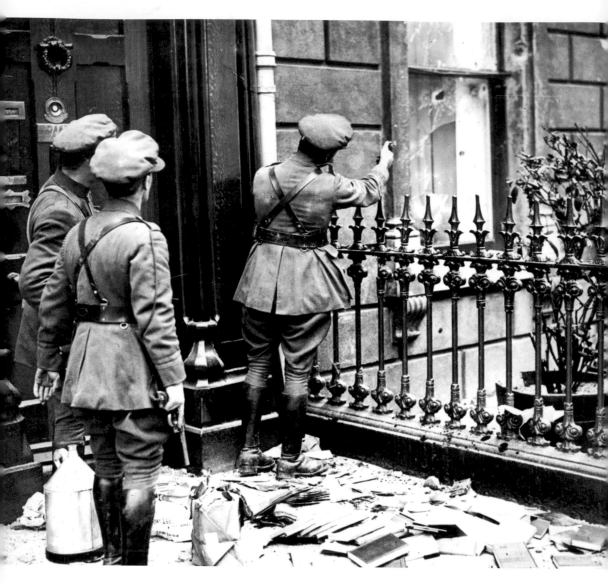

Free State officers firing through a window of the Gresham Hotel on the final day of the Dublin fighting, 5 July 1922. Note the canister of petrol at the foot of the officer on the left. The Gresham Hotel was the last Republican outpost in the centre of Dublin. Rather than attempting to fight their way into the hotel and trying to force the IRA from the building by fighting them room to room, the Free State army tried to force a surrender by setting fire to the building.

Mercier Archives

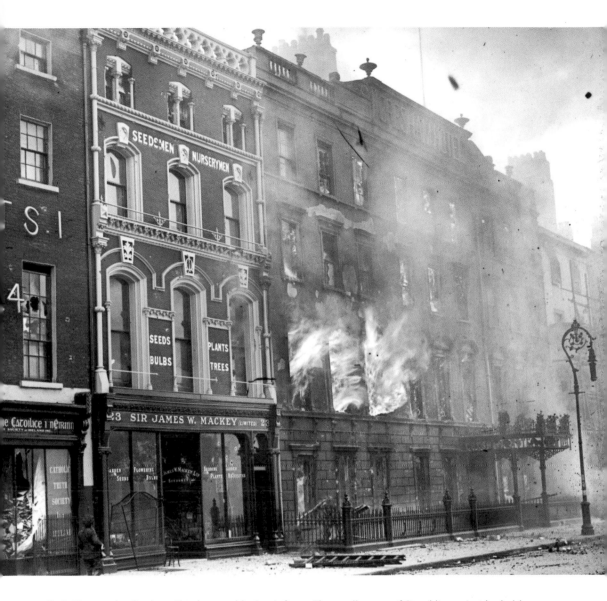

By 2.30 p.m. the Gresham Hotel was a blazing inferno. The small group of Republicans inside, led by Cathal Brugha, were under an almost constant hail of machine-gun fire from Free State armoured cars in the street outside. The Republicans managed to retreat to the Granville Hotel, but by 7 p.m. it too had been almost completely consumed by fire. A white flag was flown from the rear of the hotel and all of the Republicans inside surrendered, except for Cathal Brugha. A short time later, he made a dash from the building towards a group of Free State soldiers and was shot and fatally wounded.

Mercier Archives

REVOLUTION

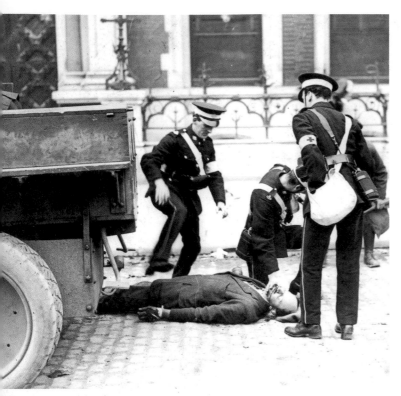

Members of the St John Ambulance Brigade assisting a casualty while a Free State soldier looks on. The St John Ambulance Brigade risked their lives during the fighting to evacuate the elderly, the infirm and the wounded from the battle zone. At least sixty-one people were killed and 274 wounded during the fighting in Dublin city – the majority of them were civilians. At least eleven members of the IRA and six Free State soldiers were killed.

Reference: Liz Gillis, *The Fall of Dublin* (Mercier Press, Cork 2011).

Mercier Archives

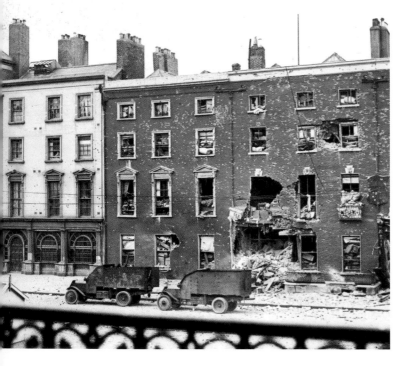

Free State armoured lorries outside the ruins of the Hamman Hotel, which had been the IRA's headquarters during the latter stages of the fighting in Dublin.

Mercier Archives

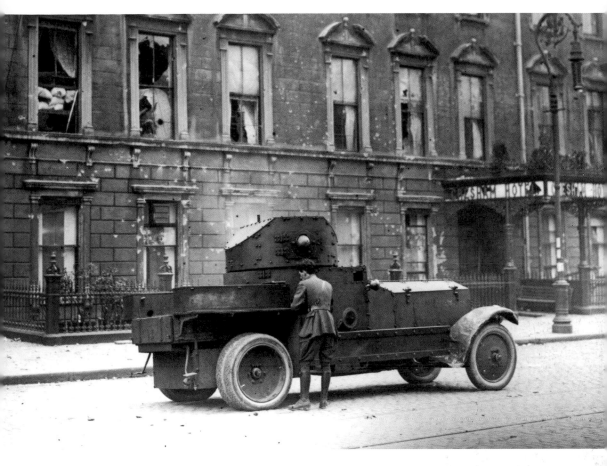

A Free State officer talks to the crew of a Rolls Royce 'Whippet' armoured car outside the Gresham Hotel in Sackville Street. In the final stages of the attack on the Republican positions in Sackville Street, the Free State army used armoured cars with deadly accuracy. John Pinkman, a Free State soldier, saw the effects of the armoured car's machine gun first-hand: 'When I reached the top floor … I discovered a sniper lying full length on a table in front of a window overlooking what is now Parnell Square. He was resting on some pillows with his rifle aimed out of the window and his fingers closed around the trigger. I shouted at him to surrender … we edged closer to get a better look at the poor fellow and to take away his rifle, but we froze when we saw that the top and the front of the sniper's head was a mass of red feathers. As we stared at the dead man we concluded that while he was sniping from his position at the window, the crew of one of our Whippets must have spotted him and sent a burst of machine-gun fire in his direction – the bullets cutting through the pillows and the top of the sniper's head. When we examined the dead sniper's rifle, we found a live round in the breach. He had been killed just as he was about to fire … His tragic mistake was to expose himself to the machine gunner in the Whippet against whose firepower he had no chance.'

Reference: John A. Pinkman, *In the Legion of the Vanguard* (Mercier Press, Cork 1998), pp. 125–6.

Mercier Archives

Cathal Brugha lying in state in the Mater Hospital, Dublin. Brugha, who had survived multiple gunshot wounds during his defence of the North Dublin Union in the 1916 Rising, was ironically killed by a single bullet fired by a Free State soldier on the last day of the fighting in Dublin. Following the signing of the Treaty, he had addressed Dáil Éireann stating: 'I for one would prefer to die by an English bullet or an Orange bullet rather than a bullet fired by one of the men with whom we have been fighting together during the last six years ... I am never going to fire a bullet at any of these men and I hope that I am not going to die by a bullet from any of them.' The woman on the left of the picture is Mrs O'Hanrahan, a sister of Michael O'Hanrahan, who was executed by the British army for his part in the 1916 Rising.

Reference: Brian P. Murphy, 'The Irish Civil War 1922–23: An anti Treaty Perspective', *The Irish Sword*, 1992, p. 298.

Courtesy of Kilmainham Gaol Museum 20PO IA35 17

A Fianna Éireann boy scout laying a wreath near the spot where Cathal Brugha was shot by Free State troops.

Courtesy of Kilmainham Gaol Museum 20PC IA45 16

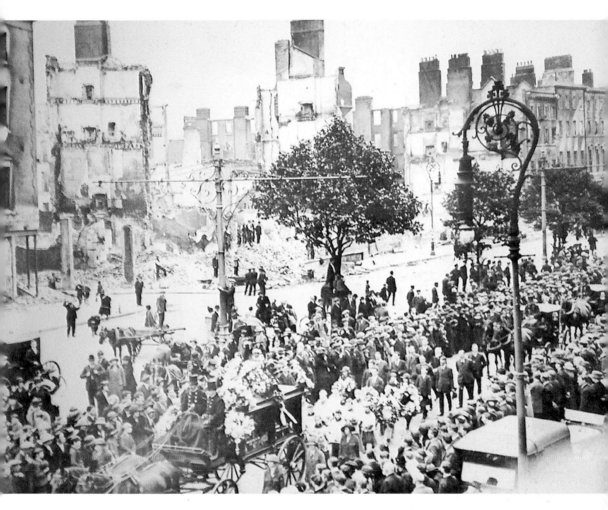

The funeral of Cathal Brugha passing through the ruins of Sackville Street. Brugha was buried in the Republican Plot in Glasnevin Cemetery on 10 July 1922.

Courtesy of Kilmainham Gaol Museum 20PO IA34 14

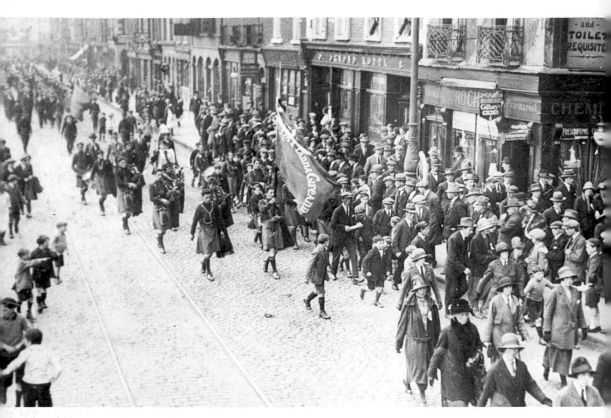

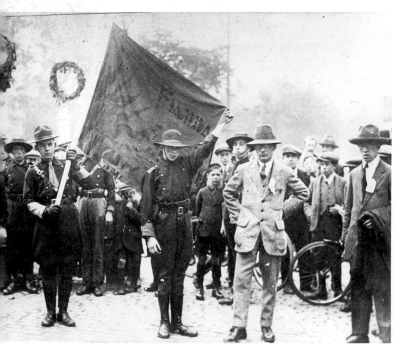

Na Fianna Éireann boy scouts at Cathal Brugha's funeral. Because of the military situation it was impossible for members of the IRA to appear in public to render Republican military honours at the funeral – instead this duty fell to members of Na Fianna Éireann (the Irish Republican boy scouts) and the Republican women's organisation Cumann na mBan.

Courtesy of Kilmainham Gaol Museum 20PO IA34 13 & 20PO IA34 15

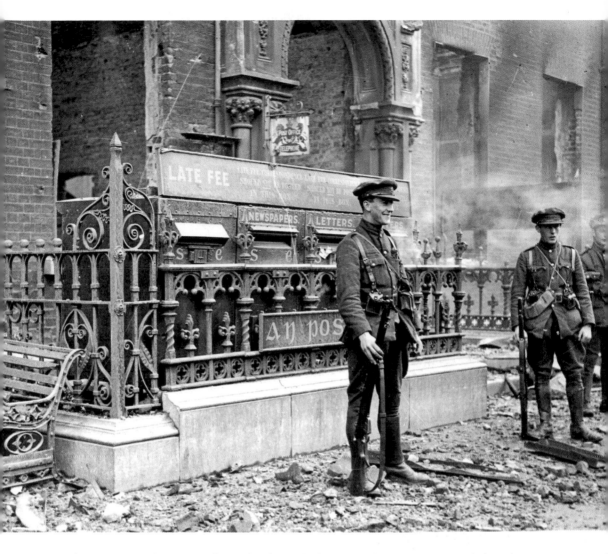

Free State troops guarding a post office in the aftermath of the Dublin fighting. Note the British royal crest still hanging over the postboxes and the new sign beneath in Irish Gaelic script reading 'An Post'. At the time, and for years afterwards, Republicans accused supporters of the Free State of having 'green postbox politics', i.e. the change from British to Free State rule was as superficial as the British imperial red post-boxes that had been painted a Nationalist green throughout southern Ireland on the orders of the new administration. Republicans claimed that the Free State was a thin veneer of Nationalist independence painted over the corrupt core of British colonial rule.

Mercier Archives

Overleaf: A donkey cart being searched at a Free State army checkpoint in Dublin. The Free State soldier searching the cart does not appear to be a great deal older than the young boy sitting on it.

Mercier Archives

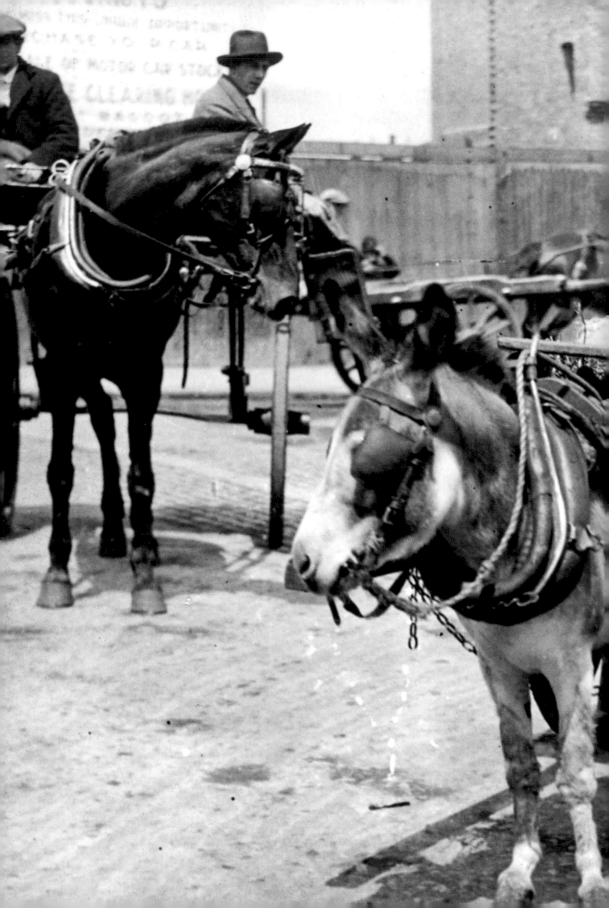

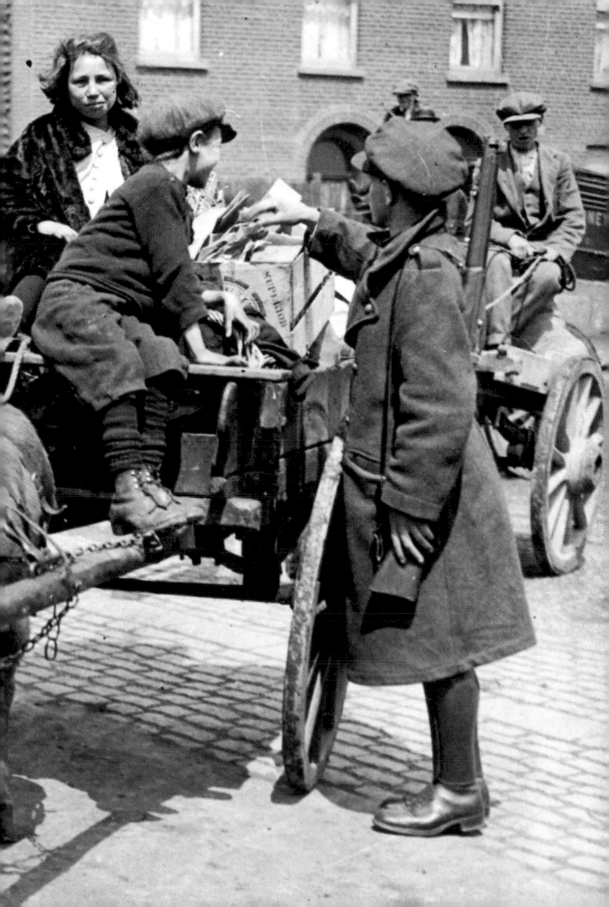

Free State soldiers manning a trench during the fighting in Limerick city. Control of Limerick city was fundamental to the outcome of the war, as its geographical position linked the Republican heartlands in Munster with the west. As long as the IRA held the city they could keep the two most important Free State army commands outside Dublin – General Michael Brennan's in Clare and General Seán MacEoin's in Athlone – isolated from each other. At the outbreak of the conflict, Michael Brennan's troops in Limerick were very poorly armed and greatly outnumbered by the IRA garrison in the city. Brennan negotiated a series of non-aggression pacts with IRA Chief of Staff Liam Lynch, which held until 11 July. Over the next nine days, the Free State poured reinforcements into the city, but they were unable to force the IRA from any of the city's barracks until heavy artillery arrived.

Courtesy of Limerick Civic Museum

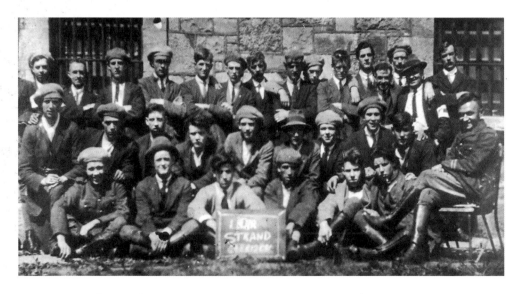

IRA garrison at the Strand Barracks, Limerick, photographed shortly before the Civil War. Their leader Connie McNamara is seated on the chair to the right. The garrison successfully resisted three different attacks on the barracks before Free State artillery reached the city. On the morning of 20 July the Free State army placed an artillery gun directly across the Shannon from the Strand Barracks and sent McNamara a message stating that they would begin shelling if the IRA garrison did not surrender. McNamara replied that he 'would not surrender while he still had ammunition or cover'. Over thirty shells were fired at the barracks, and two Free State officers were wounded in a failed attempt to storm the barracks, before the building caught fire due to the shelling and McNamara was forced to surrender.

Courtesy of Connie McNamara's grandson, Jim Corbett

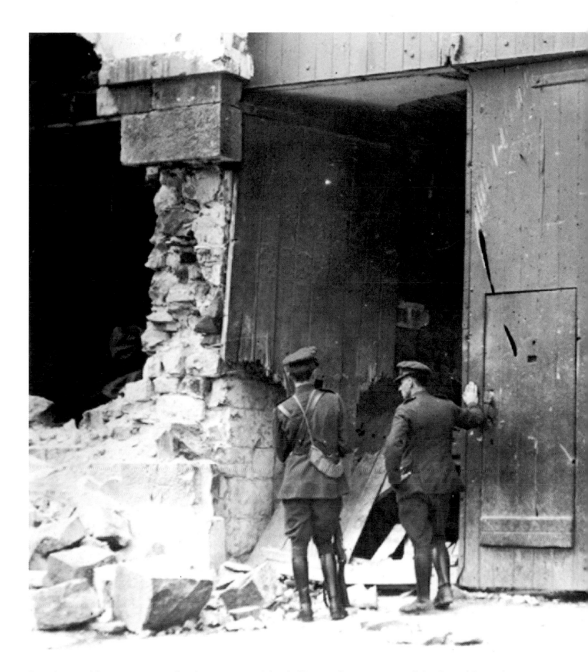

Free State soldiers inspecting the damage caused by shelling to the main gate of the Strand Barracks, Limerick, after its garrison had surrendered. According to the *Limerick Leader*: 'The front gate was blown away with a shell and two large holes forged in the masonry work, one of which was sufficient to admit a horse and cart to pass through.'

Reference: *Limerick Leader* quoted in Jim Corbett, *Not While I Have Ammo* (Nonsuch Publications, Dublin 2008), p. 93.

Courtesy of Limerick Civic Museum

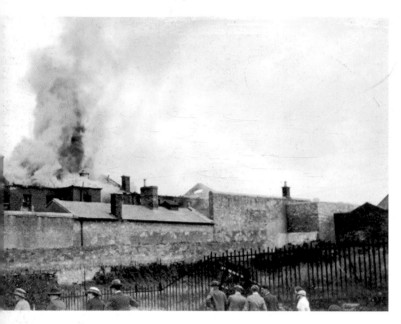

The destruction of the New Barracks, Limerick, photographed on 21 July 1922. The IRA had set fire to the barracks when they retreated from the city the previous night. At least five members of the IRA, one Fianna Éireann boy scout, six Free State soldiers and eleven civilians died because of the fighting in Limerick city. Undoubtedly the fatalities would have been far greater if the IRA had made a more stubborn defence instead of destroying their remaining barracks and retreating.

References: Pádraig Óg Ó Ruairc, *The Battle for Limerick City* (Mercier Press, Cork 2010), pp. 139–42; Tom Doyle, *The Summer Campaign in Kerry* (Mercier Press, Cork 2010), p. 31.

Courtesy of Limerick Civic Museum

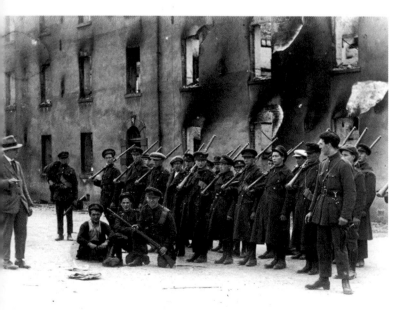

Free State soldiers in the ruins of the New Barracks, Limerick. In July and August 1922 the IRA had a 'scorched earth' policy of burning military barracks and large buildings which might be used by the Free State army, whenever they were forced to retreat from a town or city. The military rationale behind this was that it would deprive the advancing Free State army of accommodation and possible bases of operation.

Courtesy of Limerick Civic Museum

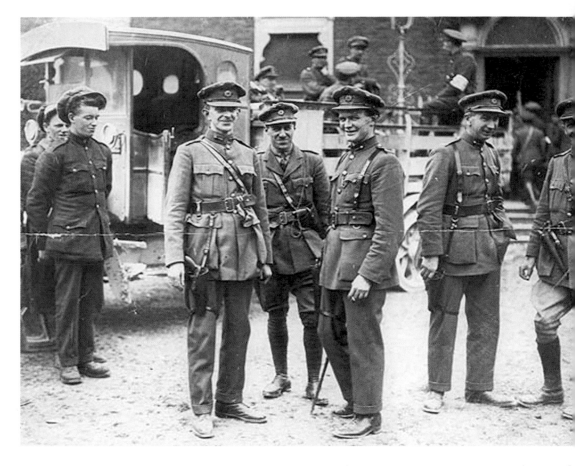

Free State army generals photographed after their victory in Limerick.

Centre group, L to R: Eoin O'Duffy, William Murphy and Michael Brennan. Brennan had commanded the IRA's East Clare Brigade during the War of Independence. He led several ambushes and barracks raids and on one occasion led a handful of men into O'Brien's Bridge in broad daylight and shot dead two RIC men. John Ryan, who was under Brennan's command that day, commented: 'I believe that on the same day Brennan was in the mood that if this opportunity had not presented itself he would have gone right into the RIC barracks rather than leave the place without getting one of the enemy.' The fourth Free State army general involved in the capture of Limerick was Donnchadh O'Hannigan (*not pictured*). O'Hannigan led the IRA's East Limerick Brigade and had commanded them during the Dromkeen ambush on 3 February 1920 which resulted in the deaths of eleven members of the Black and Tans and RIC. Brennan and O'Hannigan were two of the most experienced and successful IRA leaders to join the Free State army during the Civil War.

Reference: John Ryan, Bureau of Military History WS 1136.

Courtesy of the National Library of Ireland

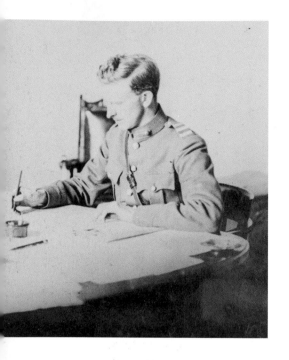

General Eoin O'Duffy, who commanded the Free State army in the south-west after the capture of Limerick city. O'Duffy, a native of Monaghan, had joined the IRA in 1917 and earned a reputation for the destruction of Ballytrain RIC Barracks in February 1920. His subsequent fighting record in the IRA was far less spectacular, comprising mainly executions of suspected British spies, a few on somewhat dubious grounds. However, his subsequent military career was even less spectacular. After the Civil War, O'Duffy became leader of the Irish Fascist movement, 'the Blueshirts', and founded the Fine Gael party in 1933. He led an Irish brigade to fight for Franco during the Spanish Civil War, but it was a disastrous affair marked by infighting, mutiny and military blunder. O'Duffy offered to lead a similar expedition to fight for Nazi Germany on the Russian Front – the offer was declined. He suffered from alcoholism and died in political obscurity in 1944.

Courtesy of the National Library of Ireland HOG 114

A commandeered steam-powered truck, belonging to the Condensed Milk Company, is used to transport an 18-pounder artillery gun from Limerick to Kilmallock on 29 July 1922. As with the fighting in Dublin and Limerick city, the use of artillery by the Free State army proved a decisive factor in the battle for Kilmallock. Mary Hartney, a member of Cumann na mBan, was killed by shell fire while working at the Republican field hospital at the Dunraven Arms Hotel at Adare on 4 August 1922. She was the only member of Cumann na mBan killed in action in the Civil War. When the Free State army captured this Republican outpost, they reported, 'all the rooms in the building were found to be bespattered with blood, showing that there must have been fairly severe casualties amongst the irregulars'.

Reference: The Publicity Department, South Western Command, quoted in John O'Callaghan, *The Battle for Kilmallock* (Mercier Press, Cork 2011).

Courtesy of Martin and Norma Naughton

General William R. E. Murphy, who was appointed by O'Duffy to lead the Free State advance through Limerick into Counties Cork and Kerry. Murphy was raised in Belfast and worked as a schoolteacher on the Falls Road. During the First World War he joined the South Staffordshire Regiment of the British army and fought in the battles of Somme, High Wood and Deville Wood. In 1917 he was promoted to captain and awarded the Military Cross. He retired from the British army with the rank of lieutenant colonel in 1919 and returned to Ireland to work as a school's inspector. In 1922 Murphy was headhunted by Michael Collins and given a commission in the Free State army on the merit of his career in the British army. His leadership and military experience were important factors in the Free State's military victory at Kilmallock.

Courtesy of the National Library of Ireland HOG 64

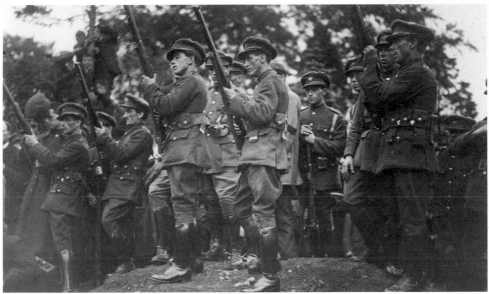

Funeral of a Free State soldier. During the fighting at Kilmallock, the bodies of three Free State soldiers from Kerry, Private John Quirke, Private Murphy and Corporal Con Sullivan, were found at Pouladragoon Bridge near Kilmallock on 24 July. It is not clear whether they were killed in action or shot by the IRA, having been captured. Multiple fatalities were uncommon in these types of clashes during the early part of the Civil War. Yet a similar incident occurred a few days later. On 30 July four Free State soldiers from Cork, Captain Power, Private Pat Murphy, Private P. Carey and Private D. O'Mahony, were found dead in a field near Ballygibba Cross, Bruree. Although they may have been killed in action during the fighting, this seems unlikely and the circumstances of these soldiers' deaths were highly suspicious. It is possible that the IRA shot these men as reprisal killings.

© Topical Press Agency / Hulton Archive / Getty Images

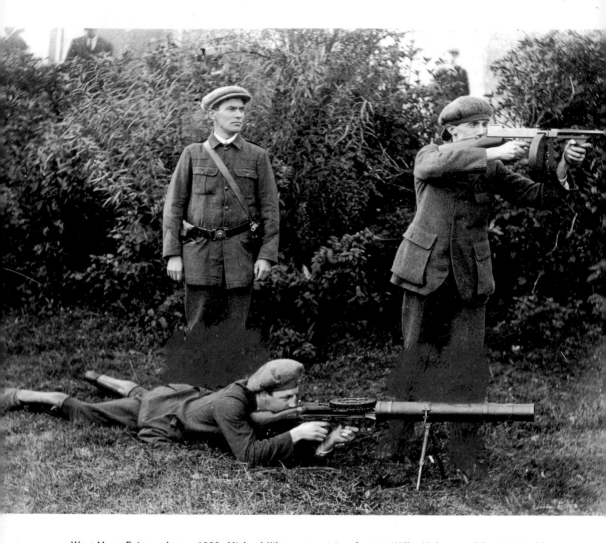

West Mayo flying column, 1922. Michael Kilroy supervising Captain Willie Malone and Dr J. A. Madden test firing Lewis and Thompson machine guns. The Free State army was overstretched in Counties Galway, Mayo and Sligo, where the IRA were staunchly anti-Treaty. However, Republican control of the west was challenged when the Free State army landed 400 soldiers, an 18-pounder field artillery gun and an armoured car at Westport, Mayo, on 24 July 1922. This was the first of several coastal landings by the Free State army during the war, and the Republicans were taken completely by surprise. Despite the Free State's early successes, Michael Kilroy organised several flying columns in the area that were amongst the largest and most active Republican forces during the Civil War. Kilroy's columns retook Ballina from the Free State army, capturing 100 rifles and 20,000 rounds of ammunition in the process. The following month Clifden was recaptured by the Republicans. However, the IRA units led by Kilroy had no definite military policy and these military successes were not built upon. The level of IRA attacks on the Free State army in Mayo decreased significantly after Kilroy's capture in November 1922.

Copyright J.J. Leonard, courtesy of Anthony Leonard

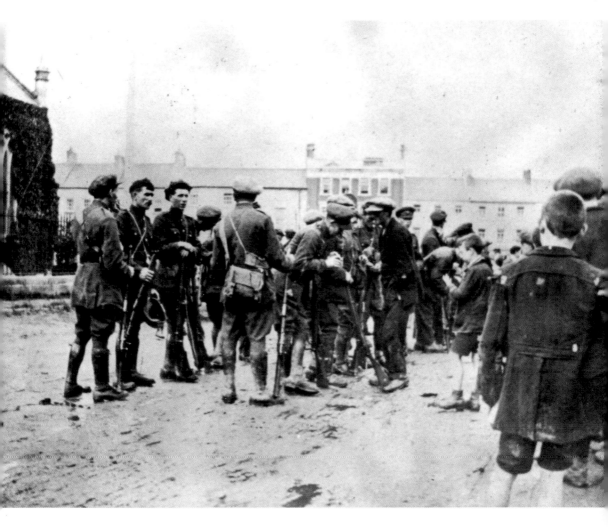

Free State soldiers arrive in Listowel, 3 August 1922. On 2 August 1922 the Free State army landed 450 men, an 18-pounder field artillery gun and an armoured car at Fenit, Co. Kerry, from the ship *Lady Wicklow*. Although Fenit pier, which the *Lady Wicklow* had docked at, had been mined by the IRA in anticipation of a seaborne landing, the command wires connecting the mines to the IRA's detonator had been cut by the local harbour master. The Free State army initially encountered little resistance and captured Fenit with ease. However, they met much sterner resistance when they marched on Tralee, and eleven Free State soldiers were killed and fourteen wounded in the fighting. On 3 August a second force of 240 Free State troops landed at Tarbert and soon the Free State army had captured Listowel and Kenmare, but the IRA in Kerry maintained a dogged resistance until the very end of the Civil War.

Reference: *The Irish Times*, 9 August 1922.

Mercier Archives

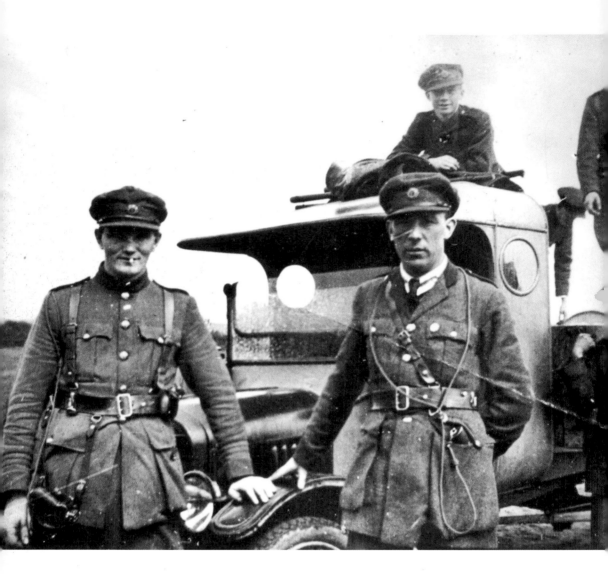

Captain Matthew McGrath (*left*) and Captain O'Grady photographed at Listowel. A short time after this photograph was taken McGrath was killed in an accidental shooting. He had played a prominent part in the Kerry landings, commanding a quarter of the Free State troops involved.

Mercier Archives

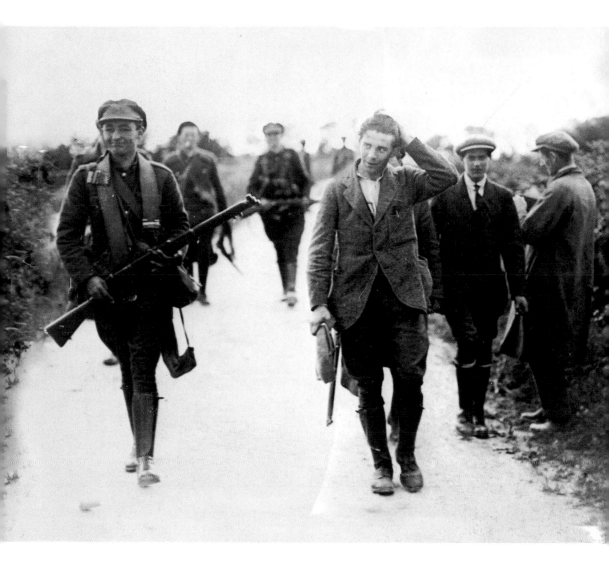

An IRA Volunteer being marched into custody, having been captured by the Free State army at Kilmallock. Note the cameraman on the extreme right filming the Free State soldiers for a cinema newsreel. The majority of the IRA units stationed in Kilmallock during the fighting were from Cork and Kerry. When news reached Kilmallock of the Free State landings in Kerry and Cork, most of the IRA left Kilmallock to protect their own areas. In a matter of days the Republican resistance to the Free State advance evaporated and Free State troops captured the town with relative ease on 5 August.

Courtesy of the National Library of Ireland HOG 106

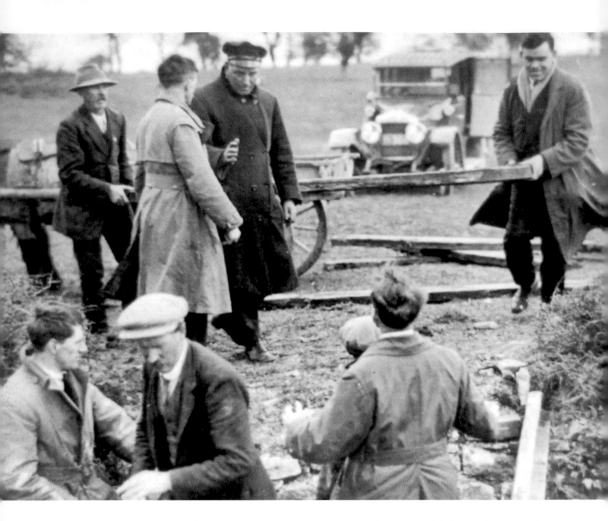

IRA leaders Seán Moylan (*bottom left in trench*) and Dan Breen (*extreme right*) during the retreat from Kilmallock helping to bridge a trench cut across the road.

Courtesy of Aideen Carroll

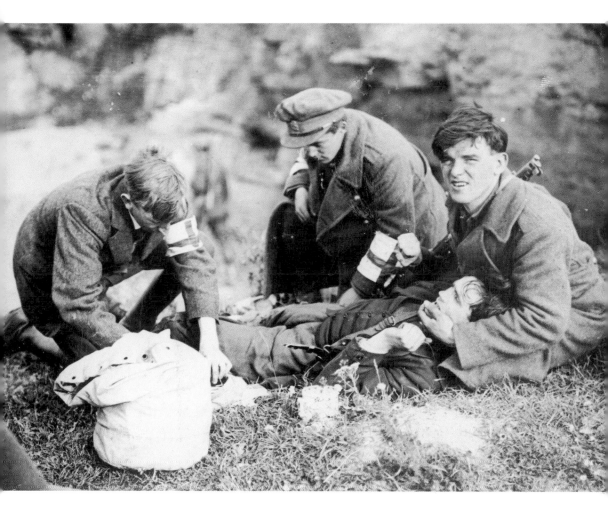

A Free State Red Cross unit treating a wounded soldier at Kilmallock. The prolonged fighting in the Kilmallock, Bruff, Bruree, Patrickswell and Adare area of Co. Limerick between 21 July and 5 August 1922 was one of the hardest fought military campaigns of the Civil War. The Free State army's attempts to dislodge the Republicans from these towns resulted in the only 'line fighting' of the conflict, with the opposing armies facing each other in a well-defined battle line of trenches and outposts. An area of 'no man's land' between the IRA and Free State army positions varied between a hundred yards and a mile wide. At least seven Free State soldiers, six IRA Volunteers, one member of Cumann na mBan and one civilian were killed during the fighting there.

Reference: John O'Callaghan, *The Battle for Kilmallock* (Mercier Press, Cork 2011).

Courtesy of the National Library of Ireland HOG 216

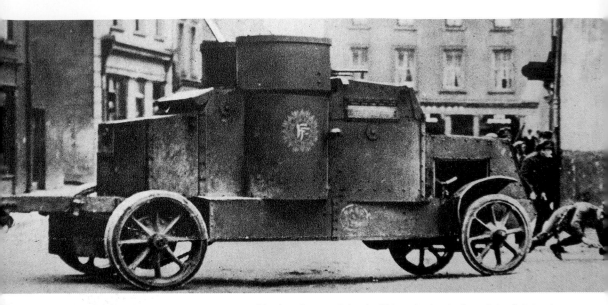

An armoured car protects Free State soldiers under attack by the IRA at the beginning of the fighting in Cork. At approximately 2 a.m. on 8 August 1922, the Free State army landed 450 soldiers from ships which docked at Passage West just south of the city. The local IRA units guarding the coastline in case of a marine landing were taken completely by surprise and offered little resistance. However, the Free State army encountered much stiffer resistance from the IRA when they tried to advance into the city itself.

Courtesy of the Gerard McCarthy Collection

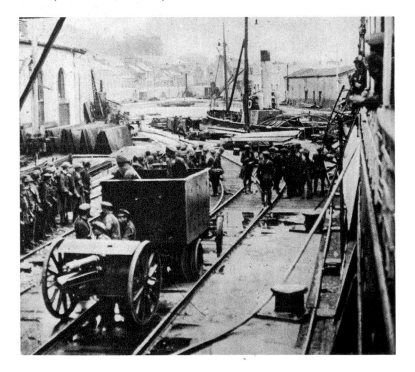

Free State troops, armoured vehicles and artillery guns are prepared for the advance from Passage West to Cork. As in Dublin and Limerick the use of artillery and armoured vehicles played an important role in the Free State's swift victory over the Republicans in Cork.

Courtesy of the Gerard McCarthy Collection

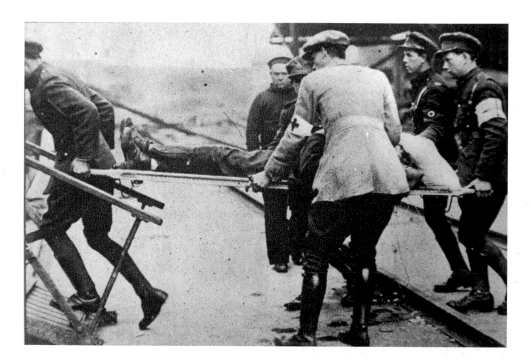

Above: A Free State soldier wounded during the fighting in Cork is taken for medical treatment. At least ten Free State soldiers and eight IRA Volunteers were killed during the fighting for the city.

Reference: John Borgonovo, *The Battle for Cork July–August 1922* (Mercier Press, Cork 2011).

Courtesy of the Gerard McCarthy Collection

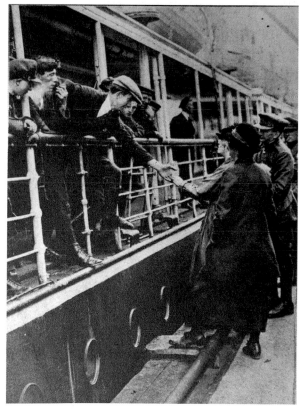

Republicans captured by the Free State army in Cork say goodbye to their relatives before being transported to Dublin for imprisonment.

Courtesy of the Gerard McCarthy Collection

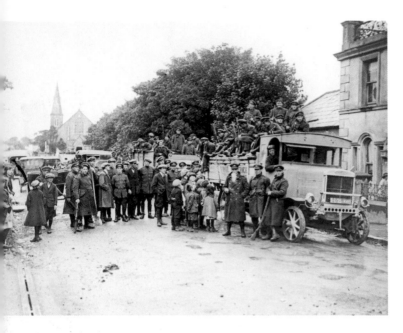

Free State soldiers photographed at Bruff, Co. Limerick, after they had captured the town from the IRA.

Courtesy of the National Library of Ireland HOG 124

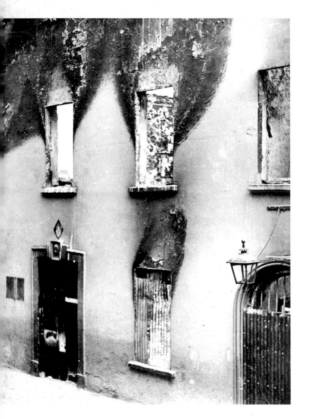

The ruins of Tuckey Street Police Barracks, Cork city. When the Free State army were about to capture the city, the IRA set fire to all the police and military barracks they held in Cork, before retreating westwards.

Mercier Archives

IRA Volunteers John O'Gorman and Patrick O'Dea of the IRA's West Clare Brigade, photographed during the Truce. O'Gorman was fatally wounded during an attack on the Free State outpost at Kildysart Barracks and died on 11 August 1922. O'Dea was shot dead during an IRA attack on the Free State army at Kilrush. Although Clare had been one of the most active counties in terms of Republican operations during the War of Independence, the anti-Treaty IRA in the county were unable to offer much more than a token resistance to the Free State army during the Civil War. Clare suffered relatively little violence in that conflict when compared to the neighbouring counties of Kerry and Limerick.

Courtesy of Clare County Library

Free State troops filling sandbags near Listowel, Co. Kerry. Note the careless soldier on the truck working the bolt of his rifle which is pointing directly at the soldier seated on the sandbags a few feet away. Fatal accidents involving carelessness, horseplay, faulty munitions and poor discipline were relatively common during both the War of Independence and Civil War. At least nine Free State soldiers were killed in Kerry in accidental shootings or grenade explosions during the Civil War.

Mercier Archives

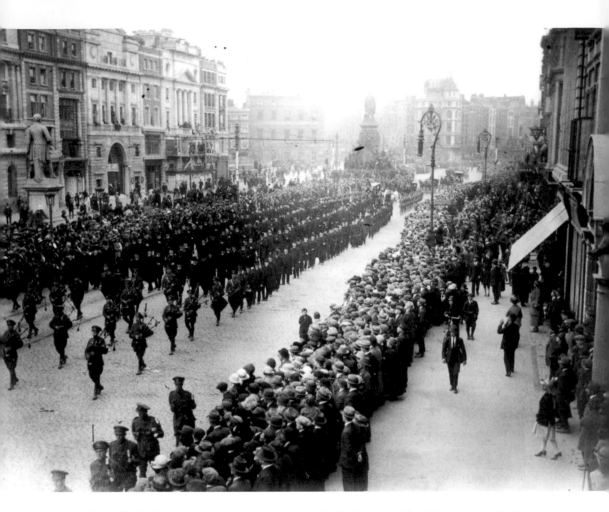

Arthur Griffith's funeral procession passing down Sackville Street, Dublin. After a string of military successes, the supporters of the Treaty suffered a blow when Griffith died suddenly as the result of a brain haemorrhage on 12 August 1922. He was buried at Glasnevin Cemetery, Dublin.

Mercier Archives

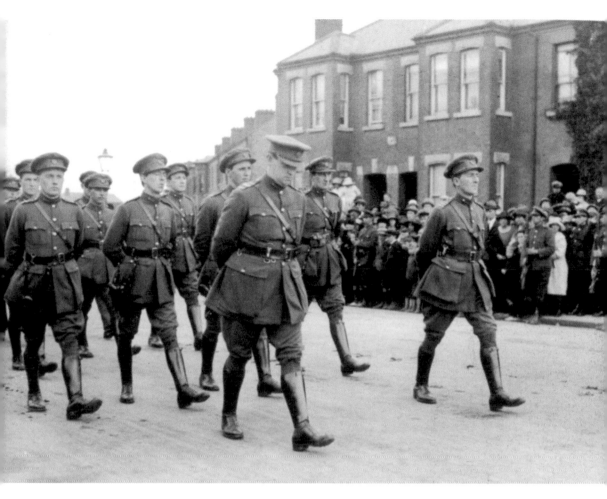

Michael Collins (*centre*) and Richard Mulcahy (*right*) at Arthur Griffith's funeral. Griffith had become a father figure to his younger colleagues in the Provisional Government. However, in a short time Griffith was almost completely forgotten, his death and political legacy overshadowed by the death of Michael Collins only days later.

Mercier Archives

REVOLUTION

Michael Collins inspecting Free State troops in Newcastle West, Limerick. On 20 August 1922, a few days after this photograph was taken, Collins arrived in Cork to uncover IRA funds hidden in accounts in the city's banks. While they had controlled the city, the Republicans had collected £100,000 in customs revenue and hidden it in the bank accounts of Republican sympathisers. Collins knew from his experience as Minister for Finance during the War of Independence that the IRA could use this money to finance a prolonged guerrilla campaign in the Republican heartland of Munster. When he had completed this task, Collins decided to tour West Cork on 22 August 1922. Although his visit to Cork is usually attributed to involvement in covert peace talks with the IRA, there are no surviving records of negotiations taking place at this time. Collins appears to have grown complacent about his personal safety during this trip and told his former comrade Florrie O'Donoghue, 'I've been all over this bloody country but no one has said a bloody word to me.'

Reference: Florrie O'Donoghue, Ernie O'Malley Notebooks, quoted in John Borgonovo, *The Battle for Cork* (Mercier Press, Cork 2011).

Mercier Archives

Collins' remains arrive at North Wall, Dublin, by boat from Cork at 11.30 p.m. on 24 August 1922. Collins was killed in an IRA ambush at Béal na mBláth on 22 August 1922 as he was returning from Bandon. Despite being a veteran of both the 1916 Rising and the War of Independence, Collins had very little personal experience of combat. Rather than driving at speed through the ambush position when attacked, he made the fatal mistake of ordering his men to stop and fight. He then threw caution to the wind during the fighting, left cover and was shot dead. Although a myriad of conspiracy theories have been proposed about his death, the IRA report of the ambush signed by the adjutant, 1st Southern Division, implies that the battle was relatively straightforward: 'I have since learned that Ml. Collins was shot dead during the engagement. Our casualties were nil ... The greatest praise is due to the nine men who stuck to their positions under such heavy fire ... During the journey Ml. Collins travelled in the touring car and made himself very prominent.'

Reference: Brian Hanley, *The IRA — A Documentary History* (Gill and Macmillan, Dublin 2010), p. 50.

Author's Collection

Free State soldiers searching a car at a checkpoint. When the Free State army captured Limerick, Waterford, Kilmallock and Cork in quick succession, the IRA were forced to resort to guerrilla warfare. By August, when the Cork towns of Bandon, Clonakilty, Fermoy and Skibbereen fell to the Free State army, the IRA no longer held a single military installation. A Free State victory now seemed assured, but intense fighting continued in some parts of the west. The Civil War dragged on for another nine months before the Republicans were willing to admit defeat.

Mercier Archives

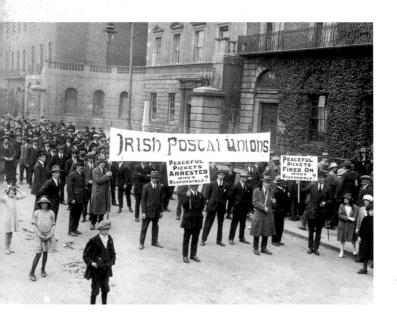

A demonstration during the Irish postal strike, September 1922. The strike was caused by the removal of the postal workers' 'cost of living' bonus by the Free State government. The Free State army was used to help put down the strike, often using brutal methods to break up protest meetings – note the placard reading 'peaceful pickets fired on – who's responsible?'

Mercier Archives

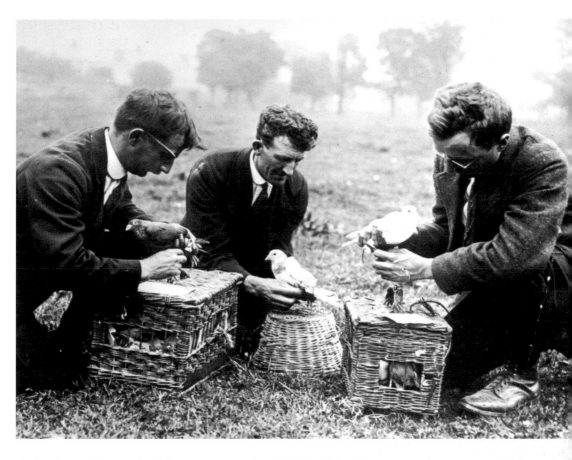

Carrier pigeons being used to deliver messages during the Irish postal strike.

Mercier Archives

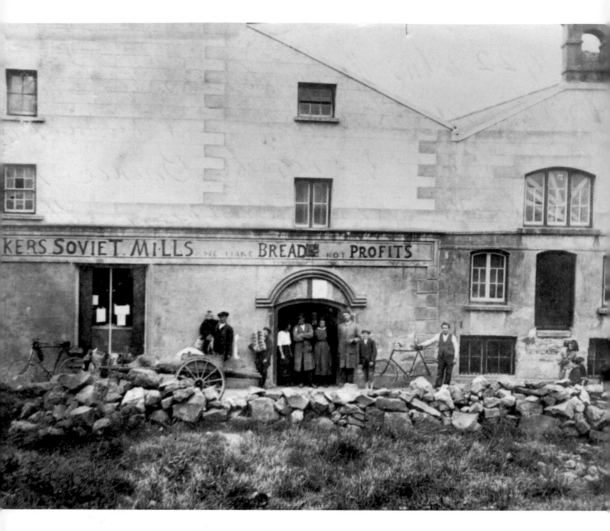

Labour unrest, strikes and factory occupations were common in some areas during the War of Independence and Civil War. However, social questions were often forced to take a back seat while battles raged over the question of national independence. Whilst some IRA Volunteers and Republican leaders were in sympathy with striking workers and considered themselves Socialists, the majority were usually far more conservative. The IRA in East Limerick, for example, had a record of suppressing such disputes and siding with employers and business owners. In some cases, striking workers set up soviets and commandeered their places of employment. This photograph shows workers at the Bruree Mills who went on strike in response to a proposed reduction in wages. Note the slogan painted on the building: 'BRUREE WORKERS SOVIET MILLS. We make BREAD not PROFITS'. The strike only held for a few days.

Mercier Archives

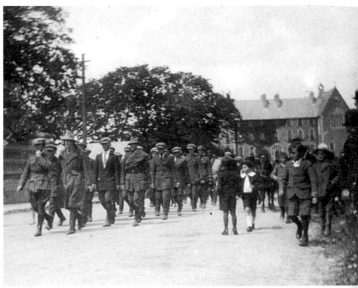

IRA 'guard of honour' and firing party at the funeral of John McSweeney. McSweeney, a lieutenant in the IRA's West Clare Brigade, was mortally wounded in an attack on the Free State army barracks at Kildysart, Co. Clare, and died in September 1922.

Courtesy of Clare County Library

Private Timothy Hickey, a dispatch rider in the Free State army during the Civil War. Hickey had been a member of D Company, 1st Battalion, Dublin Brigade, IRA, during the War of Independence.

Courtesy of Kilmainham Gaol Museum
20PO IA21 20

IRA Divisional Adjutant Brian MacNeill. MacNeill, a son of Eoin MacNeill, was killed on the slopes of Benbulben Mountain, Sligo, on 20 September 1922. Nine IRA Volunteers were killed in a Free State sweep of the area. MacNeill died in suspicious circumstances along with three other members of the IRA: Seamus Devins, Joseph Banks and Paddy Carroll. The local Free State army intelligence officer reported that MacNeill had been shot through the forehead, Devins through the heart and that 'Banks and Carroll were absolutely mangled by machine gun fire'. MacNeill's death was withheld from the press by the Free State army for 'diplomatic reasons'.

Reference: Michael Hopkinson, *Green Against Green. The Irish Civil War* (Gill and Macmillan, Dublin 1988), p. 215.

Courtesy of Irish Military Archives CD 6/51/1 to 15

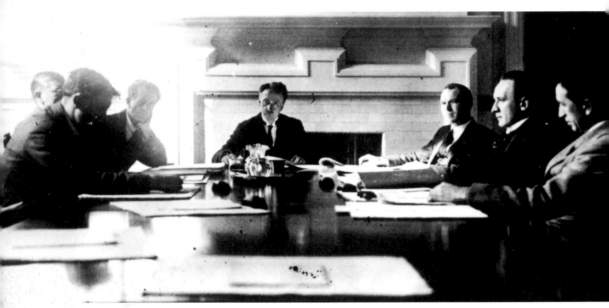

The Executive Council of the Provisional Free State Government 1922.

Clockwise L to R: Joseph McGrath, Minister for Industry and Commerce; Hugh Kennedy, the Executive's legal advisor, Desmond Fitzgerald, Minister for External Affairs, William T. Cosgrave, President of the Executive Council; Ernest Blythe, Minister for Local Government, Kevin O'Higgins, Minister for Justice, and J. J. Walsh, Minister for Posts and Telegraphs. Cosgrave described the difficulties of his administration in the Civil War as: 'Seven men in a room trying to build a state amongst the ruins of an empire, with madmen screaming through the keyhole.' After Collins' death a more severe policy was taken against the IRA, influenced by Kevin O'Higgins and Richard Mulcahy. On 28 September 1922 the Free State government passed the Public Safety Act, which established military courts with the power to impose the death penalty. Following this, the possession of arms would carry a mandatory death sentence and any Republican prisoners who were armed when captured would be tried by military court martial and could be sentenced to death and executed by firing squad.

Courtesy of Kilmainham Gaol Museum 20PO IA35 16

General Seán Hales, photographed when the Free State army captured Kinsale, Cork, on 12 August 1922.

Hales had been leader of the IRA's Bandon Battalion during the War of Independence and was the only IRA brigadier in Cork to support the Treaty. He led the Free State army campaign in West Cork and captured Bandon, Clonakilty and Skibbereen in August 1922. On 7 December 1922 Hales was assassinated by the IRA in Dublin. His killers were acting on the orders of Liam Lynch and the IRA Executive, who had directed the IRA to kill pro-Treaty TDs and senators who had voted for the Public Safety Act.

In reprisal for Hales' assassination the Free State government ordered the execution of four leading Republicans – Richard Barrett, Joseph McKelvey, Rory O'Connor and Liam Mellows – who were being held prisoner in Mountjoy Jail, as a 'solemn warning' against further assassinations. The four had been held without trial since the surrender of the Four Courts. This was before the Public Safety Act came into effect and so the four were not eligible for execution under its terms. They were not afforded the due legal process of trial or conviction. Instead they were sentenced to death by order of the Free State cabinet and informed of their fate only a few hours before they faced the firing squad. The executions were widely criticised and denounced as 'official murder' by Labour TDs and a number of foreign newspapers, including *The Times* of London.

Author's Collection

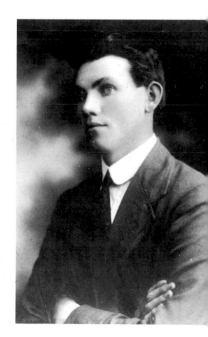

Richard Barrett, a native of Ballineen, Cork, was a prominent Irish language activist and GAA organiser in that county before joining the IRA in 1917. He had been appointed quartermaster of the IRA's 3rd West Cork Brigade during the War of Independence and was arrested by the British and interned in March 1921. Ironically Barrett had been a close friend of Seán Hales during the War of Independence and had been strongly opposed to the IRA leadership's policy of targeting pro-Treaty politicians who had voted for the Public Safety Act.

Mercier Archives

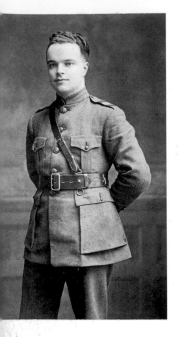

Joseph McKelvey, the son of an RIC constable from Belfast, had been commander of the IRA's 3rd Northern Division during the War of Independence. Following the split in the IRA, McKelvey had taken part in a number of unsuccessful initiatives to try to bring about army unity.

Courtesy of Kilmainham Gaol Museum 20PD IK42 25

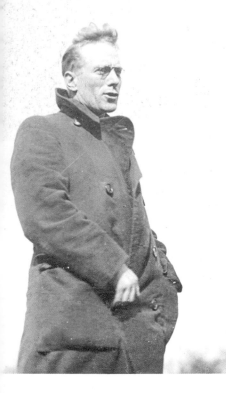

This is one of the last photographs of Liam Mellows, taken at the Wolfe Tone Commemoration, Bodenstown, Kildare, in June 1922. Mellows was born in Lancashire, England, to Irish parents and was reared in Dublin and Wexford. A leading member of Na Fianna Éireann and the Irish Volunteers, he led the 1916 Rising in Galway. During the War of Independence, he was elected TD for Galway East and appointed IRA director of arms purchases. Mellows had been heavily influenced by the political writings of James Connolly. While imprisoned in Mountjoy during the Civil War he had in turn influenced a group of young Republican prisoners interested in socialism, including Peadar O'Donnell. While there, he was appointed a member of the Republican government and began devising a socialist programme for an independent Ireland. Ernie O'Malley stated that Mellows was 'our greatest loss. One thought of him as a clear flame, steadfast, burning of its own strength.' Peadar O'Donnell wrote of Mellows' execution that the 'richest mind our race had achieved for many a long day had been spilled'.

Reference: *Dictionary of Irish Biography*, Vol. VI, pp. 477–9.

Courtesy of Kilmainham Gaol Museum 20PO IA35 21

Rory O'Connor (*right*), a native of Dublin, was a veteran of the 1916 Rising and IRA director of engineering. During the War of Independence he had also held the post of IRA director of military operations in England. He planned several prison escapes of IRA members from English jails and orchestrated a campaign of sabotage in British cities. O'Connor was Kevin O'Higgins' best man just fourteen months before O'Higgins voted in favour of his execution. When allegations emerged that the Free State Government had been motivated by revenge in ordering Republican executions, O'Higgins vehemently denied this – 'Personal spite, great heavens! Vindictiveness! One of those men was a friend of mine.'

Reference: *Dictionary of Irish Biography*, Vol. VII, p. 274.

Courtesy of Kilmainham Gaol Museum 20PO IA35 21

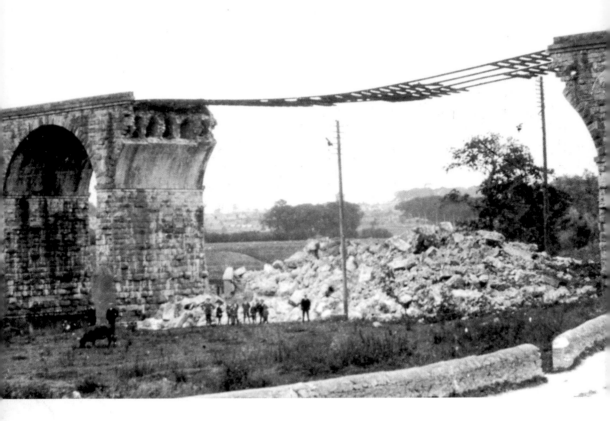

Mallow viaduct destroyed by the IRA. During the guerrilla phase of the Civil War, the IRA targeted the railway network, derailing trains, blowing up bridges and destroying railway stations. The Republicans hoped they would gain the military advantage by restricting the Free State army's movement and communications. However, the IRA's war on the railways caused widespread disruption to the public and proved counter-productive.

Mercier Archives

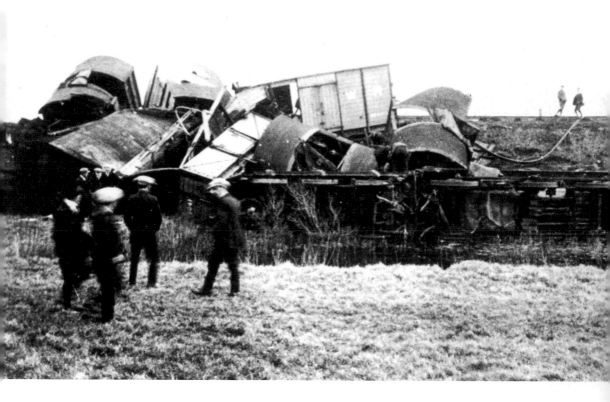

A freight train derailed by the IRA at Liscahane Bridge, Co. Kerry. On 18 January 1923 the IRA's North Kerry Brigade received information that a train carrying Free State troops would be travelling from Limerick to Tralee. They decided to derail the train, by removing a section of the track, and ambush the soldiers on board. However, the military train did not arrive in Kerry on schedule and a freight train was scheduled in its place. The locomotive, drawing twenty-six wagons, with a crew of three, jack-knifed and tumbled down the embankment. The train's driver, Patrick O'Riordan from Tralee, and its stoker, Daniel Crowley from Cork, were pinned beneath the locomotive and crushed to death.

Mercier Archives

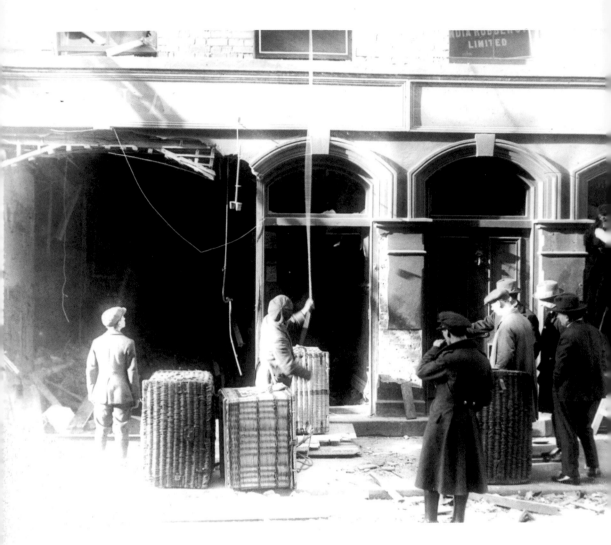

IRA attack at Seán McGarry's shop, St Andrews Street, Dublin. McGarry, a pro-Treaty TD for Mid Dublin and a captain in the Free State army, was a particular target of anti-Treaty hostility during the Civil War. Two days after the execution of Mellows, O'Connor, McKelvey and Barrett at Mountjoy, McGarry's home had been destroyed in an IRA arson attack. McGarry's seven-year-old son, Emmet, died shortly afterwards of injuries sustained in this attack. In February 1923 McGarry's business, an electrical fittings shop, was bombed by the IRA.

Mercier Archives

IRA leader Dinny Lacy. Lacy was one of the leaders of the 3rd Tipperary Brigade during the War of Independence. He was deeply embittered by the execution of Republican prisoners during the Civil War and in January 1923, when the Free State army threatened to execute Liam Deasy, Lacy kidnapped five brothers of Free State army officers and threatened to execute them in the event of Deasy's execution. The Free State army responded by threatening to kill every male member of the Lacy family in Tipperary. However, Deasy was spared execution and none of the threatened reprisals took place.

Lacy was surprised by Free State troops during a search operation at Ballydavid, Tipperary, on 18 February 1923. During a running battle, Lacy and his comrades attempted to escape by crossing the Aherlow river but found themselves trapped. Lacy was shot through the head by the advancing Free State troops and died instantly.

Mercier Archives

Liam Lynch, chief of staff, IRA 1922–1923. Militant Republicanism aimed to establish a Republican democracy but had no established tradition of political control and during the Civil War the IRA considered itself the final arbiter of the national will. Whilst de Valera was often blamed by his political opponents for either starting or prolonging the Civil War, he had practically no control and very little influence over the IRA during that conflict. The real Republican leader at this time was Liam Lynch. Lynch was a dogmatic Republican who, having committed to the Republican struggle, was prepared to see it through to the bitter end. He had stated this bluntly in a letter to his brother after he joined the Irish Volunteers in 1917: 'We have declared for an Irish Republic and will not live under any other law.' Believing that a Republican military victory was still possible, he refused to countenance the idea of surrender and urged IRA units to keep fighting against impossible odds in the spring of 1923. Lynch's death in the Knockmealdown Mountains on 10 April 1923 was the key factor in allowing the Republicans to suspend their military campaign against the Free State.

Reference: Lynch private family papers as quoted in Meda Ryan, *The Real Chief* (Mercier Press, Cork 2005), p. 24.

Mercier Archives

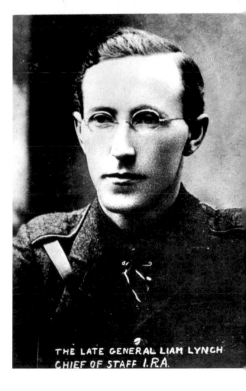

THE LATE GENERAL LIAM LYNCH CHIEF OF STAFF I.R.A.

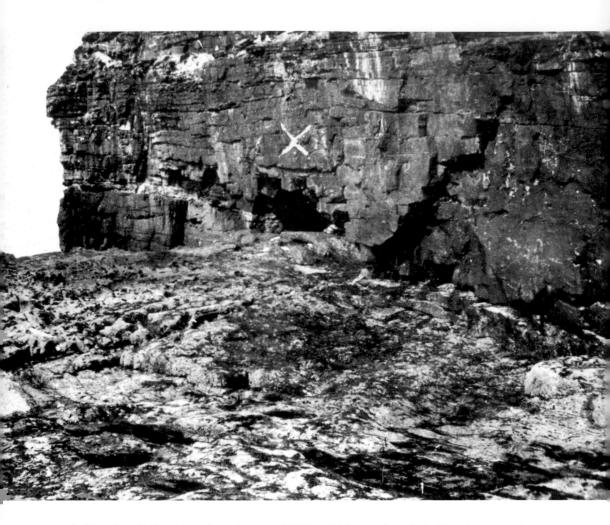

Dumfort Cave, Clashmealcon, Kerry. On 14 April 1923 an IRA flying column led by Timothy Lyons ambushed a unit of the Free State army who were searching the area for them. Following the ambush Lyons and five other members of the column took refuge in Dumfort Cave. On 16 April Free State soldiers surrounded the cave. The IRA men inside killed two of them and a siege ensued. Two IRA men, Tom McGrath and Patrick O'Shea, attempted to climb out of the cave under the cover of darkness, but they lost their footing and fell to their deaths. On 18 April Lyons emerged and announced that he would surrender. A rope was lowered down the cliff face to the cave's entrance but as he was climbing up, the rope snapped and he also fell to his death. The three members of the IRA still in the cave, James McEnery, Edward Greaney and Reginald Hathaway, surrendered shortly afterwards and were taken to Ballymullen Barracks. They were sentenced to death and executed by a firing squad at Tralee a week later, on 25 April. 'Reginald Hathaway' (real name Walter Stennings) was an Englishman who came to Kerry during the War of Independence as a member of the East Lancashire Regiment of the British army. He had defected to the IRA and had fought on the Republican side during the Civil War.

Mercier Archives

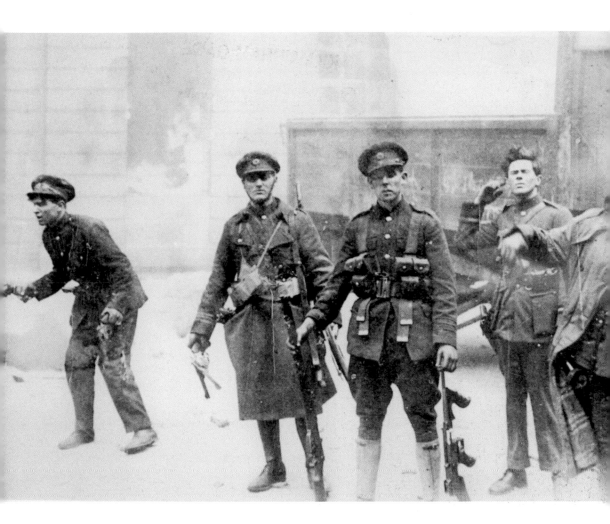

Free State soldiers photographed with captured Republican weaponry during the fighting in Dublin. Note the soldier on the right trying to clear the ringing in his ears from gunfire. The soldier centre right is holding a Thompson machine gun captured from the IRA. The Thompson machine gun or 'Tommy Gun' was invented as a trench-clearing weapon for use by the US army, but came into production too late to be used during the First World War. Irish Republican sympathisers bought the first batch of the weapons and attempted to smuggle them into Ireland in 1921. Customs officials at New York seized the main consignment of 500 guns in June 1921. A handful of weapons did reach Ireland before the Truce and were used to ambush trains carrying British troops in Dublin in June and July 1921. The Irish War of Independence was the first war where the Thompson gun was used. The weapon came into much more widespread use by the IRA during the Civil War.

Courtesy of Kilmainham Gaol Museum

Captain Noel Lemass, IRA. Lemass was arrested in Dublin city and killed on 3 July 1923 by members of the Criminal Investigation Department, a detective branch of the Free State's new police force, the Civic Guard, known to Republicans as 'The Oriel House Gang'. His body was found lying in a ditch on the side of Featherbed Mountain, Co. Dublin, on 12 October 1923. Harry McEntee, another Dublin IRA officer was abducted in the same month and found shot dead in August 1923.

Reference: Martin O'Dwyer, *Death Before Dishonour* (Cashel 2010), pp. 293–9.

Courtesy of Irish Military Archives CD 6/51/1 to 15

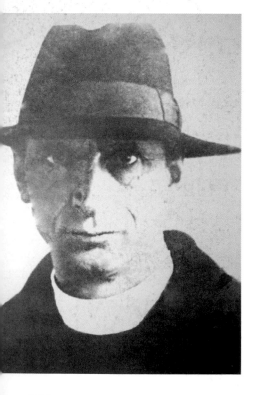

Éamon de Valera disguised as a priest in an effort to evade capture during the latter stages of the Civil War. Whilst the disguise was effective, de Valera does not seem to be overly pleased with having his photograph taken in clerical garb. Ironically he used this disguise while staying with the Cunninghams, a Church of Ireland family who lived at No. 8 Palmerstown Villas, Rathmines, Dublin.

Reference: Oylegate-Glenbrien Journal Society, *Oylegate–Glenbrien, A Look Back in Time* (Enniscorthy 2008), p. 125.

Courtesy of Nicholas Furlong; N. Furlong & J. Hayes, *County Wexford in the Rare Ould Times* (Distillery Press, Wexford 2010)

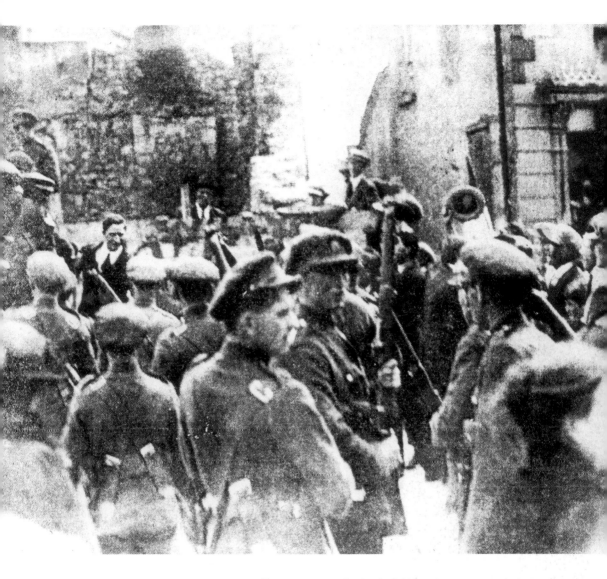

De Valera's arrest at Ennis, 15 August 1923. Following Liam Lynch's death, de Valera sent out peace feelers to the Free State government to try to negotiate an end to the fighting, but these were rejected. On 24 May Frank Aiken, the new IRA chief of staff, announced an IRA ceasefire. De Valera was still in hiding following the ceasefire when the Free State government called a snap election in August. De Valera stood as a Sinn Féin candidate in Clare and decided to address an election rally in Ennis. It was in his interests to be arrested whilst addressing a public meeting, allowing his supporters to claim that the Free State opposed freedom of speech. As soon de Valera began his speech, Free State soldiers, supported by an armoured car, rushed into the square and began firing over the heads of the assembled crowd. De Valera was seized by the soldiers and taken to Limerick Prison in the armoured car. He was interned for over a year, being held prisoner in Kilmainham Gaol and Arbour Hill Prison, Dublin.

Courtesy of Kilmainham Gaol Museum

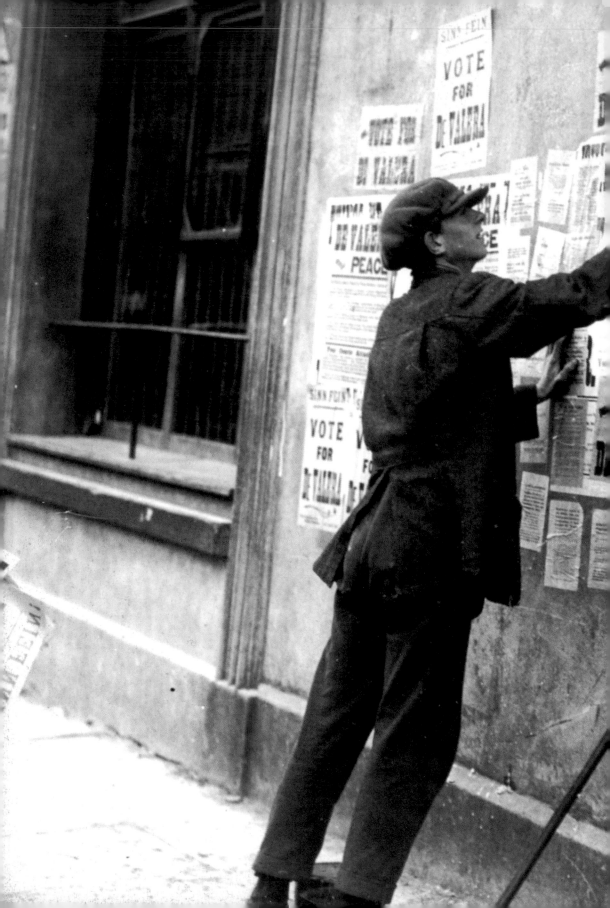

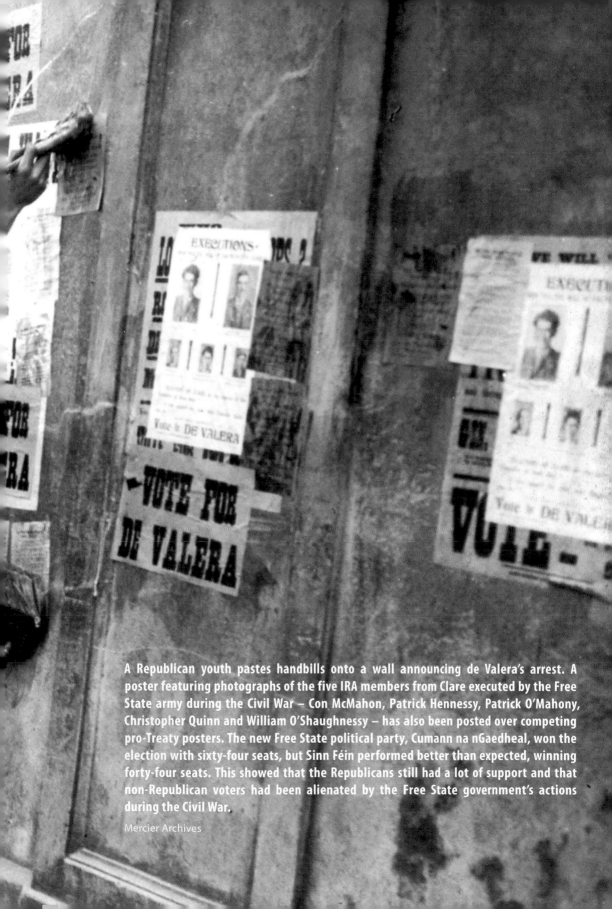

A Republican youth pastes handbills onto a wall announcing de Valera's arrest. A poster featuring photographs of the five IRA members from Clare executed by the Free State army during the Civil War – Con McMahon, Patrick Hennessy, Patrick O'Mahony, Christopher Quinn and William O'Shaughnessy – has also been posted over competing pro-Treaty posters. The new Free State political party, Cumann na nGaedheal, won the election with sixty-four seats, but Sinn Féin performed better than expected, winning forty-four seats. This showed that the Republicans still had a lot of support and that non-Republican voters had been alienated by the Free State government's actions during the Civil War.

Mercier Archives

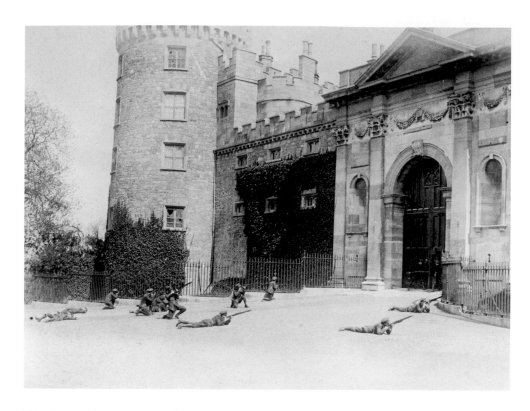

This photograph purporting to show the capture of Kilkenny Castle by the Free State army in July 1922 was in fact staged afterwards for propaganda purposes. General John Prout, an Irish-American general in the Free State army, was in command of Free State troops during the fighting in Kilkenny. The Earl of Ossory lived in Kilkenny Castle during the Civil War and he and his wife were present when Prout had this photograph staged:

> We had just turned into the road leading to the Castle when we stopped in consternation. There in the centre of the highway lay three or four bodies, contorted in all the hideous agonies of death. Beyond these grim looking figures we noticed a line of stern Free State soldiers, standing, kneeling and lying. All had their rifles levelled at the Castle ... 'Oh Lord!' I said, 'don't tell me they are starting another battle.' Then we spotted the cameramen. All was explained. General Prout, not content with adulations of the Old World, was determined that the fame of his exploits should cross the Atlantic to the land from whence he came. He therefore hit upon the expedient of reconstructing the scene (or should I say crime?) ... To crown all, General Prout said he would like a close-up of us both being 'rescued'. So to the click of the cameras, our faces registering resignation if not gratitude, we clasped our 'rescuer' by the hand.

Reference: The Earl of Ossory, 'The Siege of Kilkenny Castle', *Blackwoods Magazine*, September 1936, reprinted in *The Journal of the Butler Society*, Vol. 1, 1968.

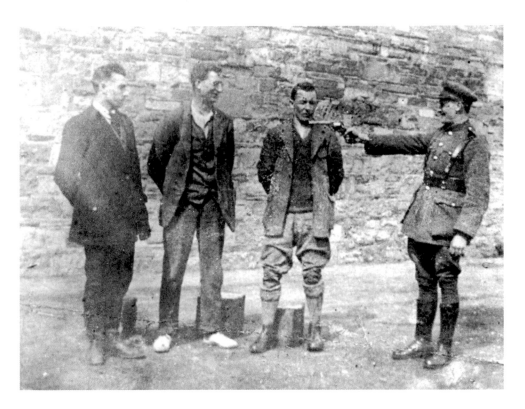

Arbour Hill Prison 1924. Jack Keegan from Mohill, Leitrim, Éamon de Valera and Austin Stack pose for a photo-graph with one of their guards. Although this photograph was clearly staged as a joke, there were Free State soldiers like John Pinkman who would have been glad to find de Valera in their gun-sights for real: 'We didn't plan to make de Valera a prisoner; we intended to shoot him if we got the chance to do so ... Personally, I had no qualms about shooting Dev whom I believed was so largely responsible not only for the outbreak of the Civil War, but also for its prolongation.'

Reference: John A. Pinkman, *In the Legion of the Vanguard* (Mercier Press, Cork 1998), p. 168.

Mercier Archives

Overleaf: Sinn Féin party headquarters, Dublin, photographed after the end of the Civil War, around August 1923.

Mercier Archives

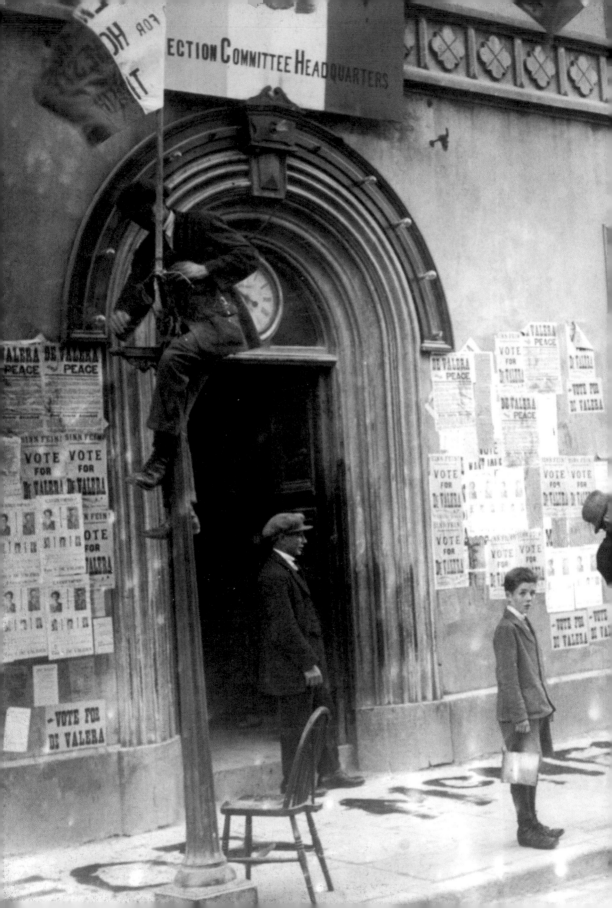

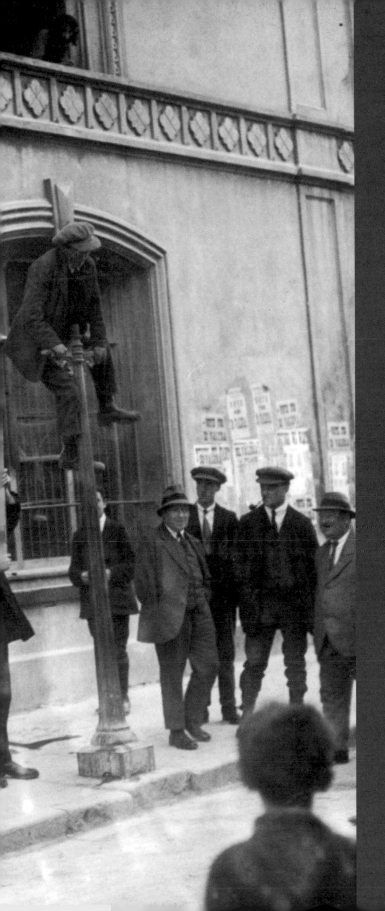

Aftermath

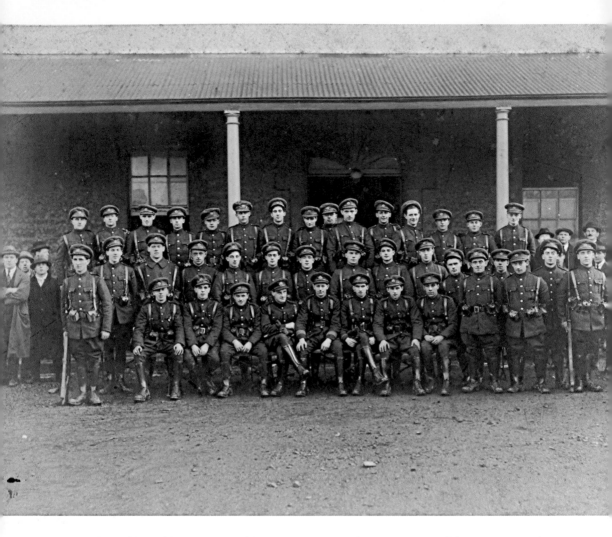

Members of the Dublin Guard unit of the Free State army, who were veterans of the 1916 Rising, photographed at Beggars Bush Barracks on 1 February 1922. No sooner had the signing of the Treaty caused the split that eventually led to the Civil War than both sides asserted their claim that they were the legitimate successors to the executed leaders of the 1916 Rising. This argument about who inherited the legacy of the 1916 Rising continues up to the present day.

Courtesy of Kilmainham Gaol Museum 20PO IA35 19

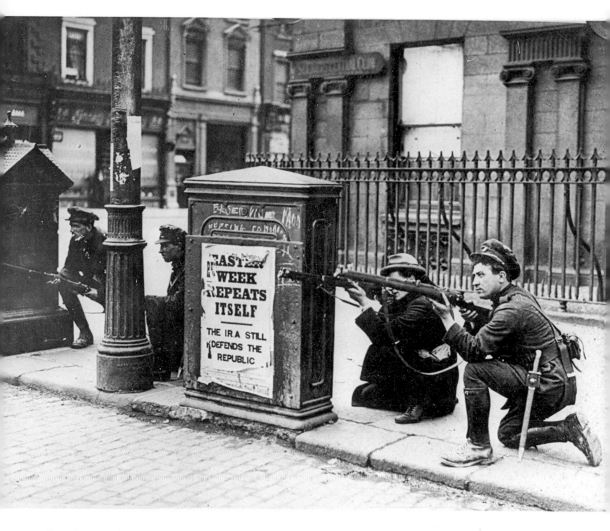

This photograph, which purports to show Free State soldiers in action during the fighting in Dublin at the beginning of the Civil War, seems perhaps more likely to have been a propaganda photograph staged at the time. Note the Republican poster at the centre of the photograph with the legend: 'Easter Week Repeats Itself – The IRA Still Defends the Republic.'

Courtesy of Kilmainham Gaol Museum 20PO IA34 26

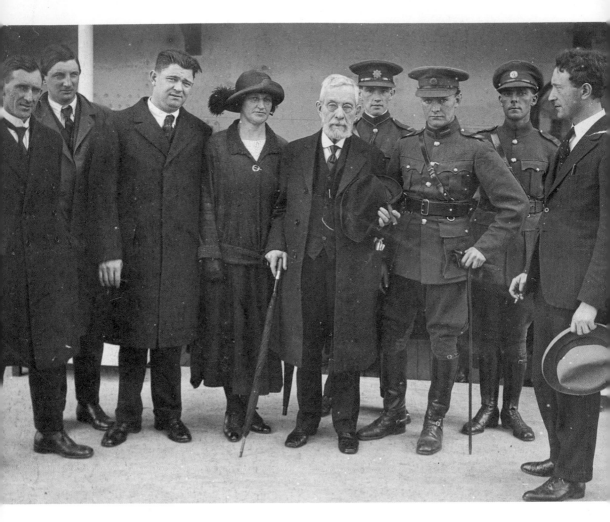

L to R: Richard Mulcahy, Diarmuid O'Hegarty, H. Conyham, Mrs Powell (sister of Michael Collins), John Devoy, General Michael Brennan and Desmond Fitzgerald (*the two officers in the background are unknown*). Devoy had been imprisoned for Fenian activities between 1866 and 1871. After his release, he was forced into political exile in America and became the leader of Irish-American political support for Irish independence. Devoy visited the new Irish Free State between July and September 1924 and was treated as an elder statesman by members of Cumann na nGaedheal. This apparent endorsement by a senior Republican like Devoy, 'the greatest of the Fenians', was used by Cumann na nGaedheal to give the Free State a Republican pedigree. However, Devoy later expressed suspicion of what he termed the Free State's 'imperialist' policies.

Courtesy of Kilmainham Gaol Museum 20PO IA58 10

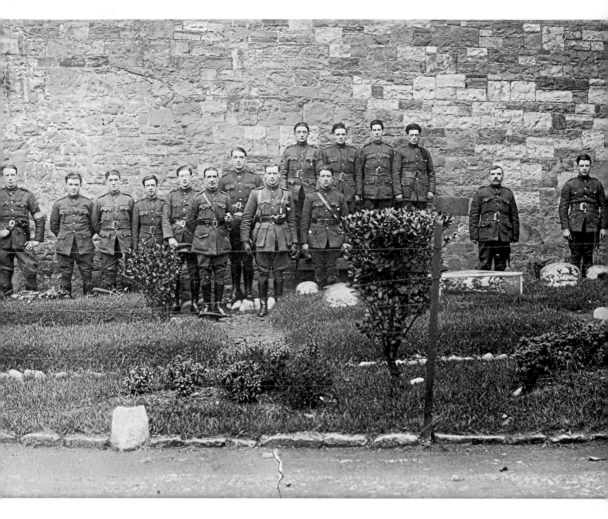

A Free State army commemoration at the graves of Kevin Barry, Patrick Doyle, Bernard Ryan, Thomas Bryan, Frank Flood, Thomas Whelan, Patrick Moran, Michael Edmond Foley, Thomas Traynor and Patrick Maher, who had been executed by the British during the War of Independence and buried in the grounds of Mountjoy Jail. In 2001, the Fianna Fáil/PD government had the bodies of 'the Mountjoy Ten' exhumed and reburied with state funerals and full military honours. Whilst the men were unquestionably deserving of the honours accorded in death, the timing of the ceremonies to coincide with that year's Fianna Fáil Ard-Fheis was criticised at the time for being exploitative and politically opportunistic.

Courtesy of Kilmainham Gaol Museum 20PO IA35 23

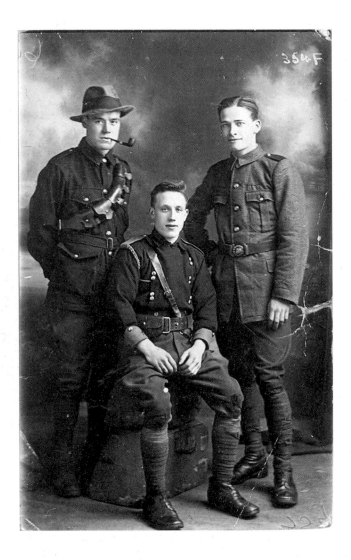

Joe Good, John 'Blimey' O'Connor and Ernie Nunan photographed before the 1916 Rising. Today the boast 'My granddad was in the GPO in 1916' is so frequently heard that it is a wonder the Republicans who fought in the Rising were ever outnumbered. False claims about the supposed role a family member played in the struggle for Irish independence are nothing new. (Although the phenomenon will undoubtedly get worse as the centenary of the Rising approaches!) Joe Good, who was a member of the GPO garrison, remembered: 'an officer had been appointed mainly because his brother had supposedly fought in the GPO. I knew that the brother had not been in the GPO – but I did have the mortification of attending a ceremony at the alleged hero's grave. I told our brigadier that I knew the man and his whereabouts during Easter Week – which was a long way from the GPO.'

Reference: Joe Good, *Enchanted by Dreams* (Brandon Press, Dingle 1996), p. 186.

Courtesy of Kilmainham Gaol Museum KMGLM 2012.0107

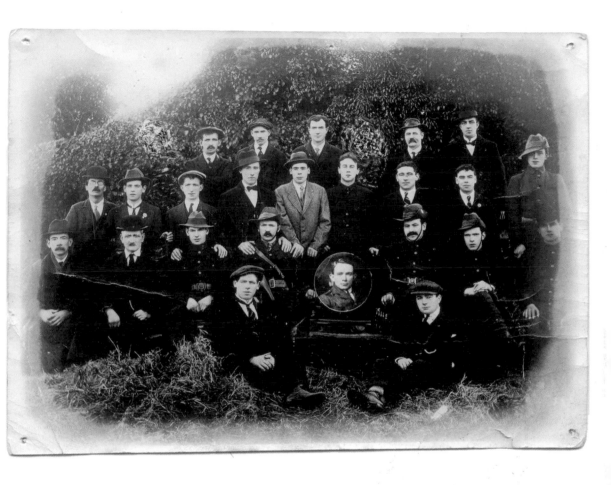

Republican veterans of the Marrowbone Lane garrison who fought in the 1916 Rising. This photograph was taken around 1917. An image of Con Colbert, who had been executed, has been superimposed in the empty chair. Note that two figures in the back row, J. McCarthy and J. Gargan, have been airbrushed/painted out of the photograph because of later Civil War divisions. This type of photographic manipulation is more commonly associated with Stalinist Russia of the 1950s, but this image shows that the practice was not unknown in 1920s Ireland.

Courtesy of Kilmainham Gaol Museum 20 IA25 25

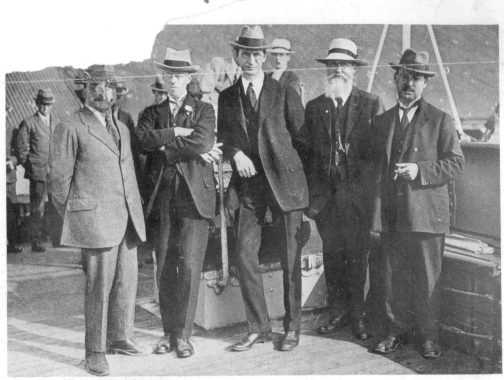

BARTON, DE VALERA, COUNT PLUNKETT, AND LORD MAYOR O'NEILL (OF DUBLIN.)

A second, far cruder, example of photographic manipulation caused by Civil War politics. In this instance, scratching the photograph with the edge of a coin and scribbling over it with a pencil has crudely removed Arthur Griffith's face. Griffith's name has also been obliterated from the caption. Lord Mayor Laurence O'Neill has also been defaced. Though much less effective than airbrushing, this form of photographic manipulation was also common in Stalinist Russia.

Courtesy of Kilmainham Gaol Museum 19PC IB51 04

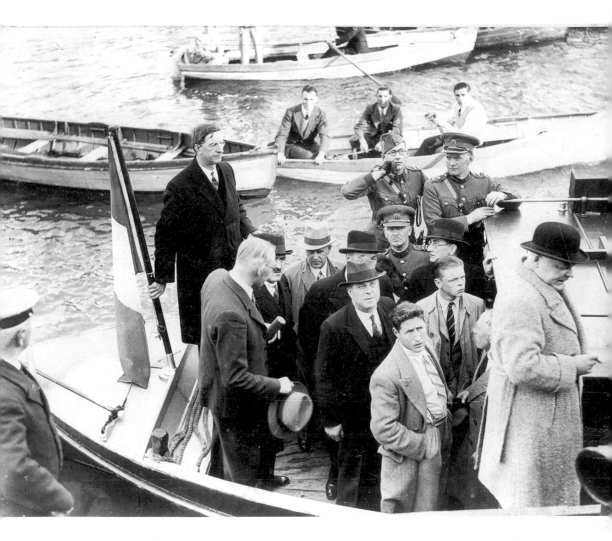

A historic moment as Éamon de Valera arrives at Spike Island, Cork, on 11 July 1938, for the return of Fort Westmoreland, one of the Treaty ports. Included in the picture are Éamon de Valera, standing left on the aft of the boat, and to the right, wearing glasses and uniform, his son Vivion de Valera, with General Michael Brennan standing next to him.

Under the terms of the Treaty the British army and Royal Navy retained military barracks and permanent port facilities at Spike Island and Berehaven in Cork, and Lough Swilly in Donegal. In April 1938 the British government handed over control of the 'Treaty Ports' to the Irish government without conditions. If the British had maintained control of these facilities it is unlikely that Ireland would have been able to remain neutral during the Second World War.

Courtesy of Kilmainham Gaol Museum 21PO IA51 26

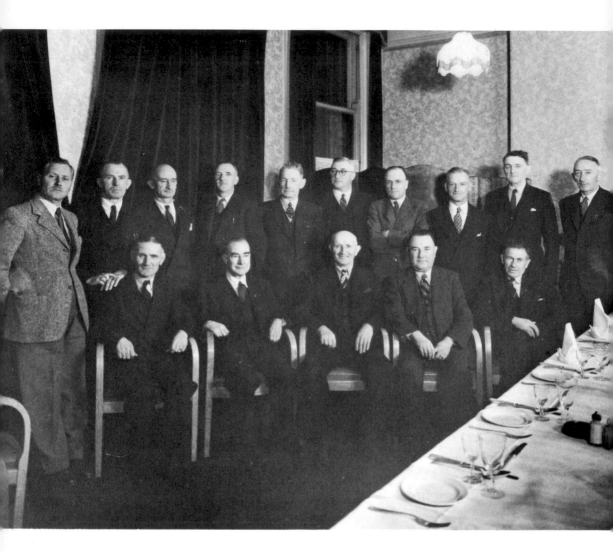

Former members of 'The Squad' and other veterans of the War of Independence photographed at a reunion in 1948. Amongst those pictured standing are: Frank Bolster, Ben Byrne, Frank Saurin, Joe Guilfoyle, Joe Leonard, Seán Ó Tuama and Jimmy Shiels. *Seated L to R*: Vinnie Byrne, Piaras Béaslaí, Mick McDonnell, Frank Thornton and Jim Slattery.

Courtesy of Irish Military Archives, BMH P35 (Frank Thornton Collection)

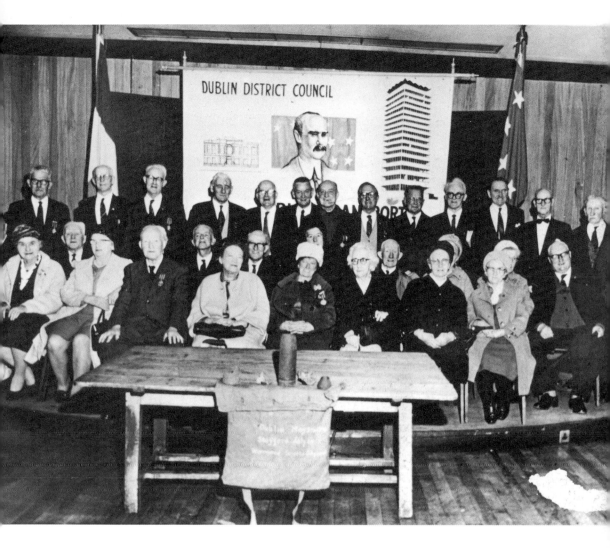

Veterans of the Irish Citizen Army photographed on the fiftieth anniversary of the Rising. For many years the role of the Citizen Army and other Socialists in the struggle for Irish independence was conveniently overlooked at a time when Socialism and Communism were considered taboo.

Courtesy of Kilmainham Gaol Museum 21PO IA36 05

Commemoration held at Kilmainham Gaol by the members of the Kilmainham Gaol Restoration Society. For decades after Kilmainham closed in 1924, unimaginative government ministers and state boards refused calls to have the building turned into a museum. For a period, Kilmainham was used to store equipment for the German electrical company Siemens. At one point, there was a proposal to demolish part of the prison complex to afford Siemens more storage space. Eventually the building was restored and opened as a museum by the Kilmainham Gaol Restoration Society – a voluntary organisation formed by Lorcan Leonard in 1959. Kilmainham Gaol Museum is now managed by the Irish Heritage Service/OPW and is one of the most popular heritage sites and tourist attractions in Ireland. Today when historic sites associated with the 1916 Rising, such as No. 16 Moore Street, face destruction, important lessons should be learned from the successful restoration and development story of Kilmainham Gaol as a heritage site.

Courtesy of Kilmainham Gaol Museum 21PO IB14 06

1916 veteran Seamus Brennan standing outside the prison cell in Kilmainham Gaol in which he received the news that he had been sentenced to death for his role in the Rising.

Courtesy of Kilmainham Gaol Museum 21PO IB14 06

Acknowledgements

I wish to thank the following for their continued support and encouragement.

My parents, Pat and Monica, for their continued love and support. We don't know just yet how far the apple has fallen from the tree, but either way it had great roots! My siblings Deirdre and Kevin who have had to put up with me for longer than anyone else.

Tom Toomey, Thomas Mac Con Mara, Danny McCarthy, Martin 'Bob' O'Dwyer, Donal O'Flynn, Liz Gillis, Cormac Ó Comhraí, Des Long, William Butler, Liam Ó Duibhir, Seán O'Hehir, Jeremiah Hurley, William Sheehan, Gerry White, Robert McDonough, Colin Hennessy, P. J. Donnelan, Niamh O'Sullivan, Sinead McCoole, Kathleen Hegarty Thorne, Terry O'Reilly, Niall Meehan, Commandant Tom O'Neill, Seán Gannon, Dr Ruán O'Donnell, Dr John O'Callaghan, Dr John Borgonovo, Dr Daithi Ó Corrain and all the other historians I know who are so generous with their time, advice and information. Dr Tim Horgan and Cormac K. H. O'Malley for their continued assistance with my efforts to transcribe the O'Malley notebooks – the task would be impossible without you.

Anne Maria – my favourite critic, I owe you so much. Many thanks and all my love. John White, Chris Coe, Liam Hogan, Cyril Wall, Mick Houlihan, Billy McGlynn, Jim Forde, Pat Gunn, Seamus and Barry Welsh, Phil Fitzgerald, Mikie Smith, Eoin Purcell and Helen O'Leary. Dara, Emma and Jade 'Sproggy' Macken. Dan, Mary and Siun 'Iggy' Hickey. My colleagues at the OPW, and all those who have shown me such great friendship and support.

Stanley C. Jenkins and the Soldiers of Oxfordshire Trust. Ian Hook and the Essex Regimental Museum. Anne Marie Ryan and all the staff of Kilmainham Gaol Museum who were hugely helpful in this endeavour. Eamonn P. Kelly, Harry Hackett and the staff of the National Museum of Ireland. The staff of the Clare Library, especially Peter Beirne and Maureen Comber. Brian Hodkinson and the staff of the Limerick Civic Museum. Waterford County Museum. Mike Maguire at the Local Studies Department, Limerick City Library. The members of the Meelick Ambush Commemoration Committee – Johnny White, Tom Gleeson and Cathal Crowe. Garry O'Brien, Gerard McCarthy, Kevin Cross and the Irish Volunteers Commemorative Club. Seán O'Mahony and the 1916–21 Club. Eamonn Dunne and the Lord Edwards Own Re-Enactment Group. Ray and Bridget Murphy and the Enniscorthy Historical society. The Khaki and Green – War of Independence Re-Enactment group.

Commandant Victor Laing, Captain Stephen MacEoin, Private Adrian Short, Hugh Beckett, Lisa Dolan, Noelle Grothier and all the other staff of the Irish Military Archives at Cathal Brugha Barracks who provide a fantastic service and whom I have always found to be friendly, welcoming and helpful. The staff of the National Archives, Dublin. Dean Hanlon and all of the staff at the Public Records Office at Kew in London who provide such an efficient, professional and user-friendly service. The staff of the UCD Archives for all their continued help, courtesy and assistance.

I also wish to thank Tom Malone (Junior), Ger McCarthy Photography (Cork), Kerry O'Brien, Jim Corbett, Keith Crawford, John Francis Gannon, Shaun Considine, Seán Curtin, David Bockett, Mick O'Farrell, Anthony Leonard, Tom Murphy, Martin and Norma Naughton, and Aideen Carroll and the Moylan family for permission to use photographs contained in this volume. And last but certainly by no means least Wendy, Mary, Sarah, Patrick and Sharon, who could be canonised for their ability to suffer with grace my frequent and chaotic whirlwind visits to the offices of Mercier Press.

Index